DATE DUE

MY 16 '99		
MR 11 '00		
OC 18 '01		
NO 26 '01		
DE 18 '01		
MY 8 '02		
JE 10 '02		
NO 13 '02		
DE 21 '02		
FE 6 '03		
MY 28 '03		

DEMCO 38-296

mondrian

mondrian

John Milner

To Christopher and Charlotte Green

Phaidon Press Limited
2 Kensington Square
London W8 5EZ

First published in hardback
1992
First paperback edition 1994

© 1992 Phaidon Press Limited

ISBN 0 7148 3167 0

A CIP catalogue record for this
book is available from the
British Library

Printed in Spain

contents

Victory Boogie-Woogie 1943-4
Oil and scotch tape on canvas, diagonal 177.5 cm
Private Collection

introduction

Mondrian was a man of great simplicity. He had little money and subsisted for much of his life upon the simplest of diets. Even in his middle age, when he was already enjoying some celebrity, his studio was stark and denuded of all but the most necessary comforts. His only indulgence was a gramophone. Some of his furniture was constructed from wooden boxes. Yet he dressed with a restrained neatness approaching elegance. His slim figure, clad in a double-breasted city suit presented an urbane and unassuming appearance to the world. He rarely smiled for his photographs, appearing reserved, austere, preoccupied and a little awkward in company. He amazed people with his love of the tango because this exuberance was exceptional, though he was welcoming and helpful to visitors. He had no wife, no children, to enrich and complicate the simplicity of his daily life, to impose comfort upon him or to upset the stillness of the studio where he lived and found the real measure of his world. By the end of his life he was an artist of international reputation, but his first one-man show preceded his death by only two years.

As his career developed from Dutch landscape painter to artist of international influence upon art and design, Mondrian cultivated the simplicity of his studio life with a growing severity and concentration. When he published his ideas he scarcely ever mentioned another painter, designer or architect. Instead he wrote, in essence, the same article adjusted to the opportunity of the time, repeatedly

refining the message and exploring its basic theme – a method which was much the same as that adopted in his paintings and through them in his life.

After his young days there was no trace of bohemianism. The photographs show mostly reserve. There is in this an unusual dandyism which in retrospect fits the control so evident in his paintings, but this man of the city did not look like a painter and would not have advertised his profession by his clothes. A fastidious individualist and an observer of life, he withdrew to an apartment of cell-like severity. His studios showed no trace of confusion, no detritus, no profusion of possessions, no richness beyond the restrained splendour of his most austere works.

Mondrian was an ascetic of a rare kind. He deliberately reduced his means, in both art and life, to the minimum. The effect of this was extraordinary. It gave him immense concentration and increasing influence. Many visitors recalled the luminous clarity of his studio. After his death his New York studio was recorded on film in all its bareness. Even his arrangement of rectangular cards upon the wall was measured and exhibited as a recognition of his achievement, as if they contained a new theorem, whose elements had long been known but never before arranged so significantly. This enigmatic and impressive man was a philosopher who painted and a painter given to philosophical thought. His influence lay in his

thought and in the example that his paintings provided. Like the influence of a philosophy, its effect lay in changing ways of thinking. His goal was to discern an underlying structure in the world and to indicate this, as a mathematician might, by means of the fewest, clearest elements available, removing all clutter, paring away everything inessential to reveal the barest, most economical solution.

Painting relies upon experience and Mondrian's mature paintings resulted from years of astute and prolonged observation. The man who appeared to reject nature had steeped himself in the study of landscape and flowers. He abandoned illusion for construction to gain greater control of his canvas. In this way discipline became freedom and simplicity became richness. In Mondrian's mature paintings everything is plain to see; yet just as paintings arise from experience, so they also provide experience. The silent stillness of his canvases provides a visual performance so subtle and yet so clear that it is easily missed. They rely upon balance (which is the theme of all his writing), and since they are paintings it is a visual balance, checked and counterbalanced. What Mondrian makes in paintings is movement in stillness, an energy which the viewer can witness in action. They are both sensual and intellectual, personal and impersonal. They operate silently and effectively whenever and wherever they are viewed with attention.

Elements of landscape

1

1 **Self-Portrait** 1900
Oil on canvas, 50.5 x 39.4 cm
Phillips Collection, Washington, DC

As he was both the son of a painter and the nephew of a painter Mondrian's awareness of art developed within his family. He was born on 7 March 1872 into a strictly Calvinist Dutch family, and was soon followed by four younger brothers and a sister. Since his father, Pieter Cornelis Mondriaan, was principal at the Christian Reformist School at Amersfoort and qualified to teach drawing, the young Piet Mondrian[1] grew up surrounded not only by his father's drawings and prints but also by religious devotion and a commitment to teaching. The family moved to Winterswijk in 1880 when Piet's father was appointed headmaster of a primary school there. Mondrian's first commitment was to become a drawing teacher; he was awarded a diploma qualifying him for elementary-school teaching in 1889 and a further diploma for secondary-school teaching in 1892. He appeared to be following in his father's footsteps, yet he never became a teacher. By the age of twenty his intentions were clear. He left Winterswijk for the Academy of Fine Art in Amsterdam with a firm commitment to painting.

If his father initiated Mondrian's commitment to art, it was his uncle, Fritz Mondriaan (1853-1932), who really involved him in painting. In the 1890s uncle and nephew frequently painted and

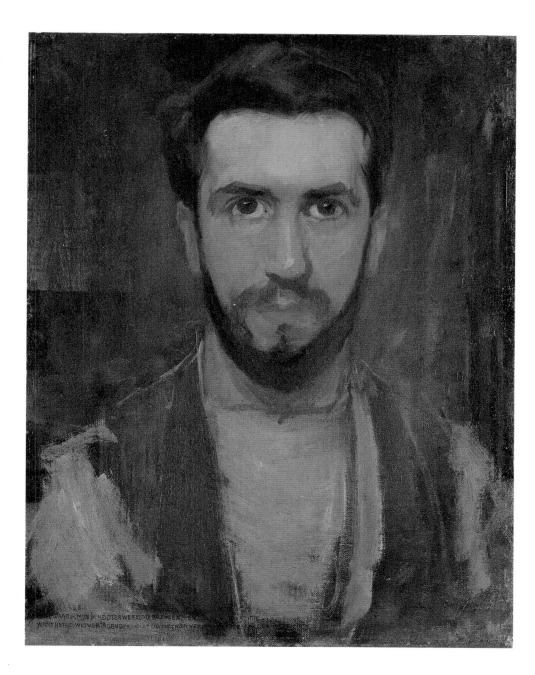

2 Houses with Poplars c.1900
Oil on canvas laid down on panel, 31.5 x 40 cm
Private Collection

drew together in the landscape, producing oil sketches along the river Gein, a theme to which the young Mondrian was to return many times.

Fritz Mondriaan gave Piet his first glimpses of a wider horizon. A pupil of Willem Maris, Fritz provided a direct link with The Hague School which in the later nineteenth century blended French and Dutch techniques into a powerful force in Holland. Its chief exponents were Jozef Israels, Jacob Maris, the brother of Willem, and Anton Mauve. The naturalism of the landscape painters and the narrative strength of Israels had appeared impressive to Van Gogh only a few years earlier, while in Jan Henrik Weissenbruch The Hague School had a painter whose poised and rhythmically constructed interiors cast more than a glance at the achievements of the seventeenth-century Dutch interiors of De Hooch in particular.

Their familiar Dutch imagery of trees and mills towering above the immense flat horizon, or neat but unpretentious interiors was, however, challenged vigorously by new developments in art in the year that Mondrian entered the Amsterdam Royal Academy.

While the young student was settling into the life-class at the Academy, the artistic and literary atmosphere in Holland was changing fast around him. Mondrian was impressed by August Allebe, the Director of the Academy, and by the painter Breitner who had studied under Jozef Israels. But by 1892 symbolist tendencies from France and Belgium were increasingly evident, highlighted in November by the arrival from Paris of the poet Paul Verlaine and the exotic figure-head of the Rosicrucian Salon, the self-styled Sâr Joséphin Mérodack Péladan, intent on spreading the principles of his Ordre de la Rose + Croix. Verlaine and Péladan lectured in Amsterdam, Leiden and the Hague. Péladan, who was dedicated to the death of realism in painting, promoted art that he considered spiritual and symbolic, aesthetic and other-worldly. In his writings and even in his dress he embodied these aims, for he arrived in a black astrakhan hat, a long cloak and boots and a purple silk blouse; the cut of his beard and hair was based on that of Babylonian and Assyrian bas-reliefs.

The visits of Verlaine and Péladan concluded a remarkable year. In May 1892 The Art Circle of The Hague (*Haagse Kunstkring*) mounted the first Dutch exhibition of paintings and drawings by Van Gogh and in December the exhibition moved to Amsterdam. The Dutch artist Roland Holst produced a thoroughly symbolist cover for the catalogue, showing Van Gogh personified as a dying and haloed sunflower before a setting sun. Van Gogh was accepted by Dutch symbolists as a vital link with the development of an art that was expressive of emotion yet thoroughly informed of recent techniques; he was revealed as a uniquely informed Dutch painter working in France.

A prime mover in the organization of the Van Gogh exhibition was Jan Theodoor Toorop who became a central figure in symbolist circles in Holland. Toorop had studied in Brussels and had joined the exhibition society *Les XX* at The Art Circle of The Hague in June and July of 1892. The following year Toorop executed his most celebrated work, *The Three Brides* **4**, a symbolist painting that had nothing in common with the Dutch painters of The Hague School. Three brides were symmetrically arranged across the canvas; to the right, the bride of Christ; to the left, the bride of Satan, the *femme fatale*; between them, the human bride. Toorop's painting depicts no particular time or place but symbolizes three spiritual states, with the calculated symmetry of the composition stressing the other-worldly artifice of the imagery.

This painting contains the antithesis of the landscape traditions

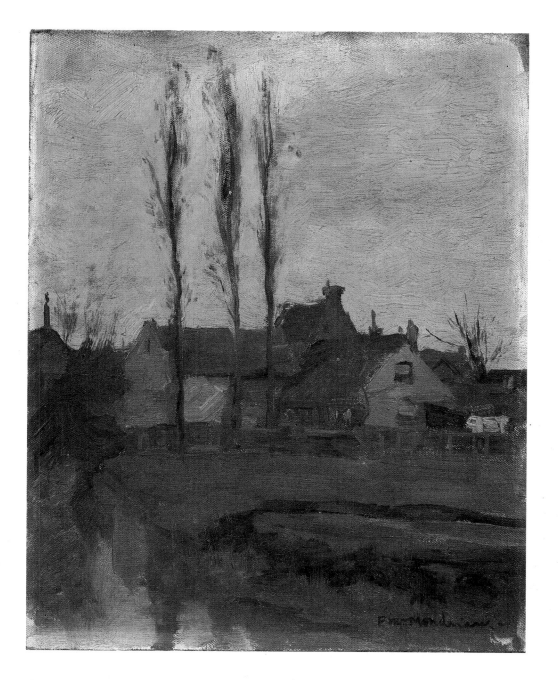

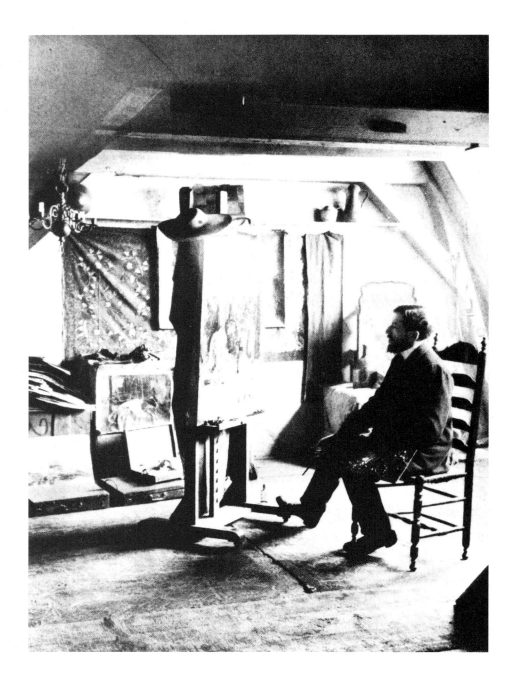

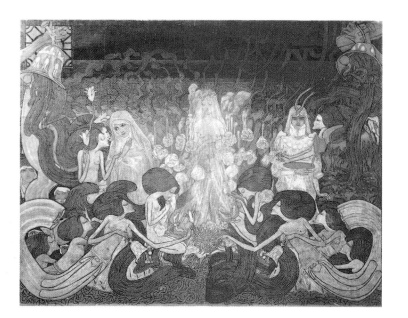

3 Mondrian in his studio, 1905
The Hague, Gemeentemuseum

4 Jan Toorop: **The Three Brides** 1893
Black chalk, pencil and colour on brown paper, 78 x 98 cm
Kröller-Müller Museum, Otterlo

of The Hague School which were among Mondrian's earliest experiences of painting. Furthermore, the other-worldly and spiritual aspect of symbolist painting was complemented by a growing interest in magic and non-Christian religions. Interest in mysticism was integral to symbolist developments. Péladan proclaimed himself a magus, for example, and in the Theosophical Society, founded by the Russian mystic Madame Helena Petrovna Blavatsky, there emerged a search for a new religion arising from a synthesis of Christianity and of the great established religions of ancient India, Egypt, Israel and Greece. Blavatsky sought the prehistoric origins of Indo-European religion by studying the common features of religious knowledge from Pythagoras to spritualism. Her book, *The Secret Doctrine*, explained in detail a world view, a cosmology, that in a few years was to influence thinkers and artists across Europe.[2] In Russia these included Kandinsky; in Holland they included Mondrian.

After three years' full-time study at the Amsterdam Royal Academy, Mondrian continued to attend evening classes while trying to relieve his financial needs by copying paintings. It is possible that he may have learnt about Theosophy in the period 1894-7. It is certain that during the period of his training he became aware of Dutch symbolist art.

In a **Self-Portrait** of 1900 **1** Mondrian depicted himself staring

as directly from the canvas as had Toorop's figures of the brides. While this is a directly observed study by the young Mondrian and contains no symbolic images, it achieves an icon-like intensity by its central and symmetrical placing of the head. The sharpness of focus this achieves and the forceful rigidity of the composition make it impossible to see the painting as a casual or incidental glimpse of the artist caught up in the activities of daily life. His gaze rivets the viewer's attention; the forehead is lit as if to stress the mind and brain behind it. All that is unnecessary or superfluous is edited out, and the artist has presented an image of himself that is intense, alert, intellectual and, in the power of the eyes reflected in his mirror, hypnotic. His head is strictly vertical and the eyes with their dark brows form a firm horizontal line which Mondrian was careful to reiterate in the line of his shirt-collar. Here is a painter of profound introspection and self-scrutiny. Just as The Hague School techniques found a contrast in Toorop's symbolist painting and the strong expressive colour of Van Gogh, so Mondrian, of strict Calvinist upbringing, became aware of the other, stranger forms of mysticism. In this powerful early work the intensity of his quest is apparent. There is ample evidence here of both his technical ability as a painter and his tendency to mystical introspection.

Yet drawing and painting the Dutch landscape remained

5 Still Life with Plaster Bust c.1900
Oil on canvas, 73.5 x 61.5 cm
Groninger Museum, Groningen

seminal experiences for Mondrian in his early years as an indepen-
dent artist. The fact that certain drawings by his uncle Fritz are almost
indistinguishable from his own testifies to the closeness of their
relationship and Mondrian's avid interest in the techniques and sub-
jects of The Hague School landscape painters. But in painting
human habitations, windmills, farms and even factories Mondrian
was also examining the theme of the relationship of man-made
dwellings to the landscape. Man within nature was to be a recurrent
preoccupation of his thinking throughout his life. In Holland, where
the forces of nature had to be controlled to preserve the landscape,
this theme was evident all around him.

But in the teachings of the Academy, working in the life-room,
copying from old masters and studying composition, Mondrian was
learning methods of painting which were independent of the land-
scape so familiar to him. His early **Still Life with Plaster Bust** of c.1900
5, for example, is an intricate and studied composition in which he
took care to fix precisely the positions of the objects and planes
within the painting. The background wall, parallel to the picture
plane, is dominated by the concentric circles of the reflective bowl,
fixing the precise focal point of its centre level with the head of the
plaster bust which provides the firm vertical emphasis at the left. The
level surface of the table top which supports the bust is embellished
with a sprig of flowers that also indicates the shallow recession of the

picture space. Mathematical in the precision of its arrangement, this
still life positions every surface and object in space by a strict control
of shapes and lines across the flat canvas. Nothing is left to chance.
This is a *tour de force* of controlled technique, manipulating the
shape and texture of objects into in a composition of monumental
rigidity.

During the years around 1900 Mondrian disciplined his
observed studies into paintings of remarkable originality. Whilst he
observed familiar farms and mills, his vision was increasingly edited
and organized in his paintings. Aware of the world around him and
carefully recording what he saw, he was aware also that in making
a painting he needed structure and organization. Composition was
the means to reconcile these two activities and by 1900 he was
already, at the age of 28, an inventive and an original composer of
paintings. Even his small studies, most probably from direct observa-
tion, show this preoccupation with the contradictory requirements of
painting to organize a spatial image on a flat canvas. Mondrian
emphasized the tension between depth and flatness.

In **Farm with Line of Washing 7** a sharply receding perspective
gives depth and volume to the farm buildings. By contrast, the line of
washing, placed across the canvas, creates a compositional theme
with variations, which rhythmically articulates the surface of the paint-
ing like a flat screen across the illusion of depth.

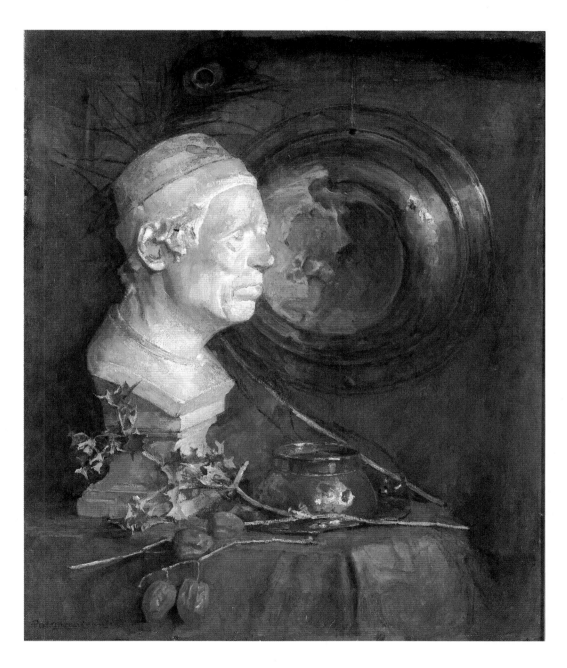

6 View of a Farmhouse c.1898-1900
Oil on canvas, 26.7 x 36.5 cm
Private Collection

7 **Farm with Line of Washing** c.1900
Oil on canvas, 31.5 x 37.5 cm
Gemeentemuseum, The Hague

18

8 **House on the River Gein** 1900
Oil on canvas, 23.5 x 31 cm
Mrs W van Eck, Niewenhuizen Segaar, The Hague

From 1900 Mondrian frequently returned to the same farms, trees and mills, reworking his compositional devices in the process. If this indicated a dedication to familiar landscapes, it also meant that Mondrian was refining the structure of his paintings. He sought out particular places that permitted this, and engaged in an interplay of subject and composition that was seminal to his development as a painter. These studies are full of light and atmosphere. They are painted vigorously and do not appear to be the calculated or cold exercises of an academic mind. Observation and the recording of his native landscape were important to Mondrian, and he frequently repeated the same subjects: they were significant to him. In these original compositions he was learning from experience apparently without a predetermined theory. His ideas evolved steadily from 1900 in the light of this experience, as he studied man within nature

among the windmills, farms and canals of Holland, and became increasingly aware of the earlier achievements of his own painting.

Mondrian made three studies of a house on the river Gein in 1900 **8**. The house, inscribed 1741 in large figures across its wide, low gable-end, is viewed across the river so that its reflection is clearly visible in the water which fills the lower half of the canvas. By viewing the house frontally the artist ensured that the broad triangle of its end wall is complemented by its inverted reflection to establish a square shape balanced upon its point. This device, which Mondrian was to use periodically throughout his career, forces a contrast between the flat geometry of his composition and the air and light which evoke the space of recession in his painting. Standing upon the earth of the river-bank, the house sits firmly within the air and light of the countryside; in its reflection its triangular shape shimmers in the

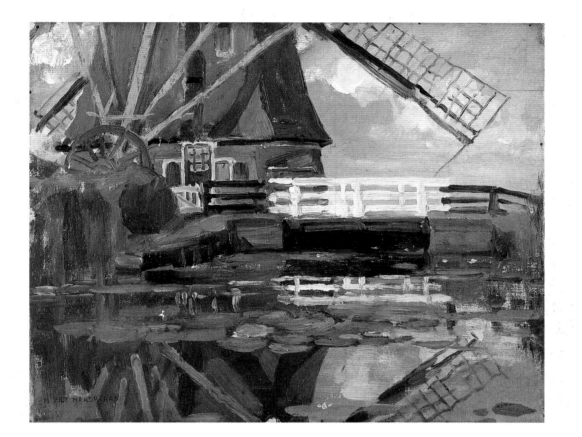

9 **Windmill by the Water** 1900-4
Oil on canvas mounted on cardboard, 30.2 x 38.1 cm
The Museum of Modern Art, New York (Purchase)

water. The river-bank which divides the air from the water also divides the canvas. In the Dutch landscape the human dwelling was established precariously between air and water. The farm needed both elements, and the human dwelling, starkly geometric among the rounded forms of trees, was the means to control and use the forces of nature.

The image of the windmill more overtly signified man's precarious control of natural forces. Mondrian, painting **Windmill by the Water 9**, repeated the device of the triangular shape reflected in water, although here it is empty space defined by the edge of the windmill's sail and the struts attached to the mill. Again the square shape, which Mondrian later inaccurately called the lozenge, dominates the composition, linking in its upper half the air which turns the windmill's sails to the watery reflection below. The massive mill raises its bulk upon a slender surface of earth that divides the painting horizontally. The fence and its reflection emphasize this. While Mondrian is looking analytically, observing the weather, its reflection and the intricate structure of the windmill, he is also composing his painting with elaborate care, and finding in the geometry of his composition a means to show the poise with which the mill articulates those natural forces of air and water that define its shape and purpose. In painting this man-made machine, the artist revealed the precarious and ingenious relationship of man and nature. Man is part of nature, and Mondrian identified his own background with this landscape of mills and waterways. Yet man is also separate from nature, for he uses its forces to his own, different, ends, bringing the intelligence and planning of geometry into his machinery as the artist brings it into his painting. Composition in this way allowed Mondrian to give

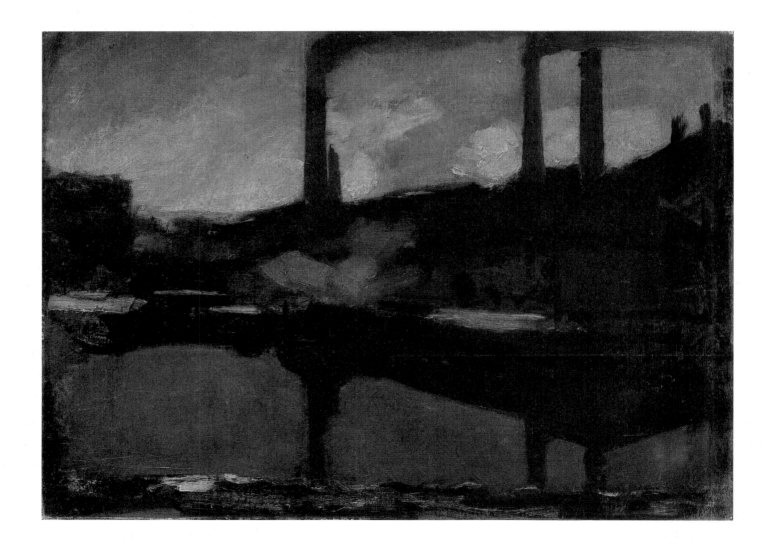

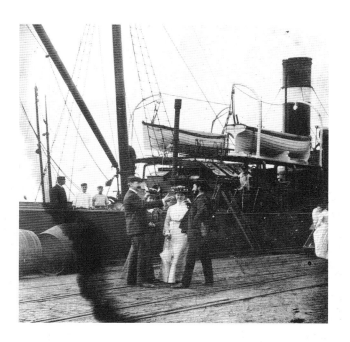

10 **The Factory** 1900
Oil on card, 35 x 48 cm
Gemeentemuseum, The Hague

11 Mondrian and Simon Maris at the harbour
at Bordeaux en route for Spain, c. 1901
Photograph
Gemeentemuseum, The Hague

meaning to the structure of his painting and significance to the images which he so closely observed and recorded.

The reflection was an invaluable resource in this respect and Mondrian repeated it in numerous studies. It gave geometric structure to the composition without diminishing the atmospheric or descriptive aspects of the painting. In **The Factory 10** he built his composition upon similar lines, contrasting the tall factory chimneys, which continue down through their reflections to the bottom edge of the painting, against the dominant horizontal of his canvas. Within this simple, flat division of the canvas the rising mass of the factory is reflected in the water to form a compressed lozenge shape. What inhabits the air above, inhabits the water below. Between air and water the bulk of the factory exemplifies human activity perched upon a shallow plateau of earth.

In this series of small studies painted at the turn of the century Mondrian was no longer content to rehearse the acceptable and attractive formulas of the Academy or The Hague School. Emerging as an individual artist, he used his experience of the Dutch landscape to reveal the relationship of man to nature. Despite the familiarity of the landscape, Mondrian was approaching his theme with originality and intelligence: he was developing paintings that commented upon what he saw. By these unconventional means he gave his images an unsentimental import and created new forms in the organization of his paintings.

Mondrian remained close to the Maris family, and he travelled to Spain with Simon Maris, the son of the painter Willem, in 1901, although he was disappointed by the visit, **11,12**. He also visited Cornwall in England. This expansion of his geographical horizons had no discernible effect upon his painting, yet it marked a growing rejection of his provincial background. He had begun his career as a distinctly Dutch artist but, made aware of the wider world of painting at the Amsterdam Royal Academy, he was now revealing an

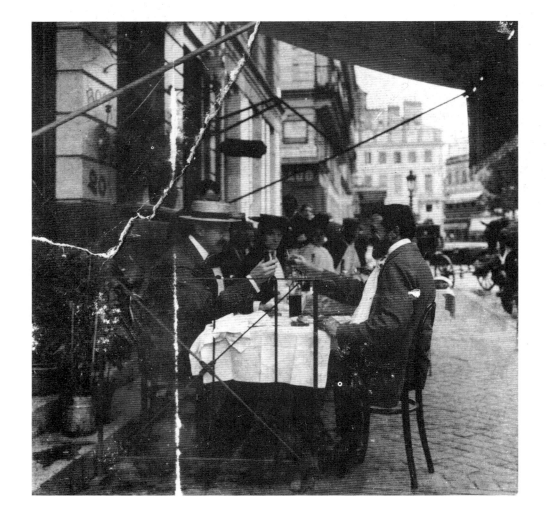

12 Mondrian and Simon Maris dining at
Bordeaux en route for Spain, c. 1901
Photograph
Gemeentemuseum, The Hague

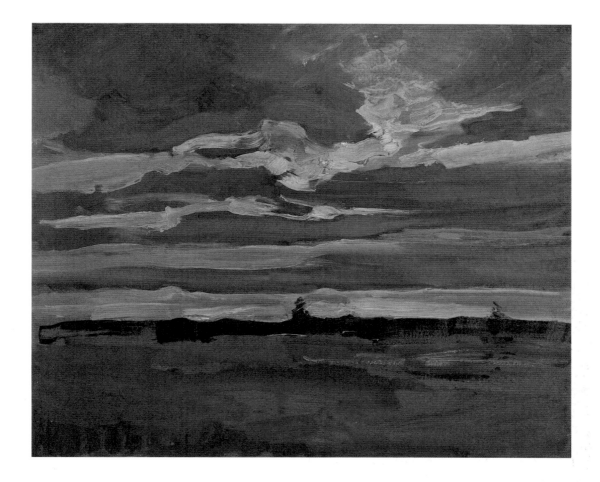

13 **Landscape** 1902-3
Oil on card, 63.5 x 76 cm
Gemeentemuseum, L. Homan Collection, The Hague

14 Landscape by Moonlight c.1902-3
Oil on card, 63 x 74 cm
Gemeentemuseum, Slijper Collection, The Hague

independent and unique talent. Conversely, the traditions and achievements of past and present Dutch painting provided a background which he could neither ignore nor avoid. In examining his own aims as a painter Mondrian necessarily adopted an attitude to the conventions and traditions to which he was heir.

It is a feature of the extensively flat landscape that dominates much of Holland that land appears to recede rapidly to a distant horizon above which the sky may appear enormous and expansive. Hobbema, among numerous earlier Dutch painters, depicted this immense space, and the seventeenth-century Dutch preoccupation with aerial perspective in the landscape complemented an equivalent concern for linear perspective in domestic and urban scenes. In two paintings of c.1902-3 Mondrian appeared to address directly these inherited conventions of landscape painting. A vigorously worked landscape **13** dominated by an immense and luminous sky reduces interruptions on the horizon to a few small marks, while the features of the flat land recede rapidly towards it, so that the broad foreground handling falls away to little more than a line at the horizon. In the sky the swirling clouds reduce with equal rapidity to narrow bands of light and shade. Mondrian, clearly at ease with the atmospheric effects of aerial perspective, produced a dramatic illustration of the immensity of a sky filled with energy and light spreading with uninterrupted expansion off the sides of his painting. The swirl of clouds provides a focus of attention in a limitless space which radiates upwards, outwards and forwards. In this painting it is the sky which is the source of energy: it is the source of light, and the swirling

forms of clouds, themselves a confusion of air and water, dwarf the features of the landscape below.

A possible pair to this painting, **Landscape by Moonlight 14**, is similarly dominated by the light and movement of clouds and air, now lit by a pale and evocative moon above a landscape of trees and flat fields. Movement is suggested by the handling of paint in both works, while the colour and tonality define the light. These paintings contrast the light of the sun and the reflected light of the moon. The air and earth are dominated by the sun and moon; mankind has no place in this except as observer. Mondrian, in his astute observation of nature, showed its forces at work within the expansive space that earlier Dutch painters evolved to depict this landscape. In contrasting these effects of light, he extended the image beyond observation to glimpse nature subject to the forces of sun and moon.

If the landscape is seen as the dynamic interaction of natural forces, where air, sunlight, clouds and earth intermingle and affect each other, then living forms, including man, evolve in response to this, and the windmill is designed by man to make use of this changing balance of forces. In a similar way a tree, like any other living matter, has also evolved a response to elemental forces, using light, air, earth and water to construct its branches and leaves. Between 1900 and 1906 Mondrian made many studies of trees; indeed, the theme was to recur as an important focus of his thinking at least until 1913, surviving many transformations of technique and approach, as the subject of prolonged deliberation and study.

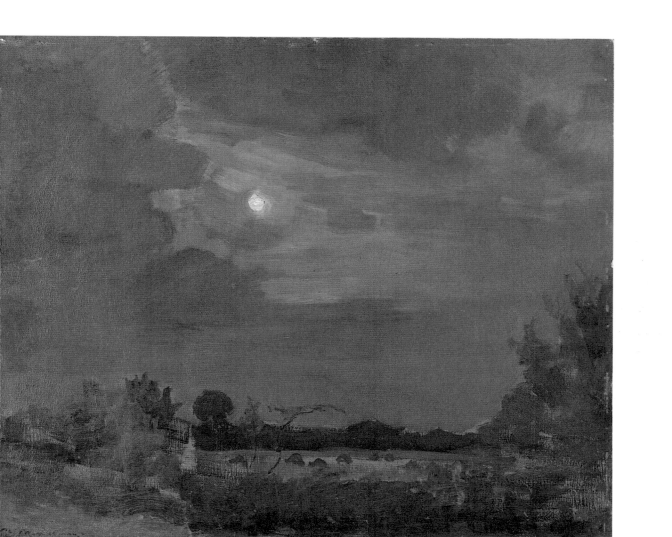

15 Tree on the Kalfje 1901-2
Oil on canvas, 23.5 x 37.5 cm
Gemeentemuseum, The Hague

16 Tree on the Kalfje 1901-2
Oil on canvas, 23.5 x 28.5 cm
Gemeentemuseum, The Hague

In **Tree on the Kalfje 15** the river recedes languidly to a vanishing point above the centre of the painting. The horizon is high and in the foreground a single stark and leafless tree links the lower and upper edges of the canvas. Mondrian's viewpoint is central and he chose his position with care so that the river seems to expand across the bottom of his painting. In a related squarer painting of 1901-2 **16** two trees dominate the foreground and the river curves away to the right. Both paintings flatten the picture space by giving distinct shape and clear edges to the trees, river-banks and water. The middle distance is defined by a small foot-bridge in one and by the curving river-bank in the other. There are in effect two subjects – trees and river. Mondrian, in keeping the edges of his forms clear, has rejected a painterly approach in favour of a decorative assemblage of flat areas of luminous colour tuned one against the other.

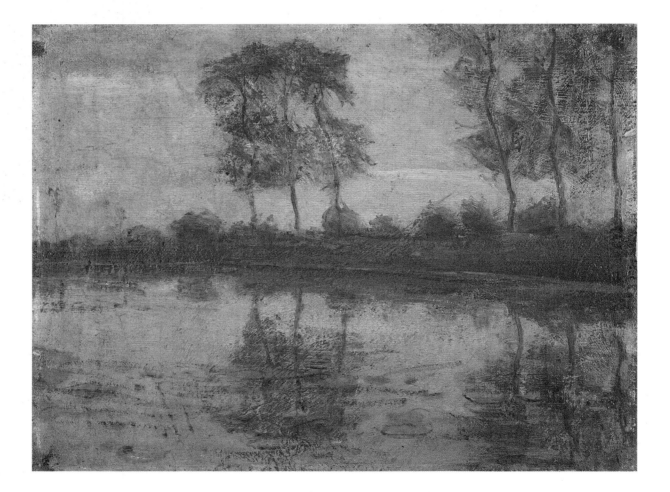

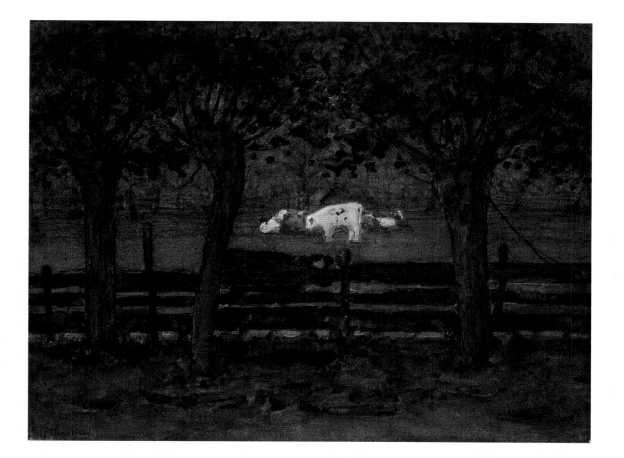

17 **Trees by the River Gein** c.1898
Oil on canvas, 25 x 32 cm
Gemeentemuseum, The Hague

18 **The White Cow** c.1903
Watercolour on card, 44.5 x 58.5 cm
Gemeentemuseum, The Hague

The device of a screen of trees was being used by Mondrian perhaps as early as 1898 while painting on the river Gein **17**. As in the painting of the factory the uprights are extended in reflections dividing the horizon into a series of rhythmic intervals. There is no loss of atmosphere or description yet the forceful pattern of trees and their echoed reflections emphatically divide the canvas. Linear perspective is minimized and surface pattern predominates.

The White Cow, c.1903 **18**, uses the same screening device without reflections and the horizon is now replaced by a fence to stress the horizontal. The trees and fence frame a painting within a painting, focusing attention upon the cows as a view through the screen. The only residual hint of perspective here is provided by imaginary lines from the lower corners of the canvas through to the central motif of animals - in this way Mondrian reconciled depth and flatness. The trees are in leaf, spraying across the upper canvas to form a dark band corresponding to the dark foreground below. By composing in bands in this way, the artist does not undermine the freshness of his vision but in fact enhances its complexity and rhythmic structure. Here the trees are individuals, alive and growing, yet the composition is clearly related to other compositions of factories and mills.

The Amstel, c.1903 **21**, for example, closely resembles **The

19 **Canal Scene** c.1902.
Pencil, 17 x 27 cm
Private Collection

20 **Farm behind Willows** c.1905-6
Charcoal and grey wash, 73 x 95.5 cm

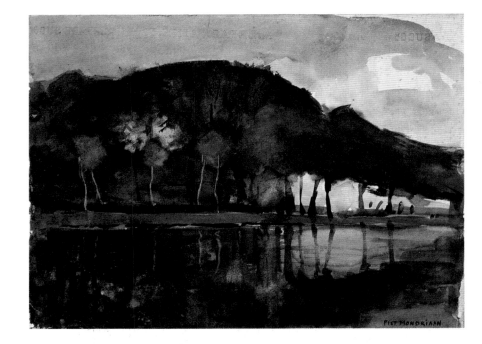

21 **The Amstel** c.1903
Watercolour on card, 31 x 41 cm
Gemeentemuseum, The Hague

22 **Trees along the Gein** 1902-5
Oil on board, 31 x 35 cm
Gemeentemuseum, The Hague

Factory in the swelling shape of its main forms and their reflection. The mass of trees spreads up from the horizontal river-bank. This is not incidental detail, but the dominant shape within the painting to which everything is related. It fixes the focus of the painting at the left of centre while the light seen through the trees further right provides an empty counterpoint to this solid mass. This spatial arrangement together with the overall shape of the trees causes an interplay of both positive and negative across the canvas and into its picture space. Mondrian's monumental simplicity is also dynamic, since it relates all the parts to the whole. The simplification involved in this, and particularly the stress that he places upon the reflection, makes his painting almost symmetrical around the axis of the river-bank.

This rhythmic division of the canvas horizontally and vertically was significantly repeated in other paintings in this series. **Trees along the Gein**, c.1902-5 **22**, for example, reverts to the device of c.1898. The thin tree-trunks, before reaching a feathery band of leaves, mark out clear intervals across the canvas like a musical notation. Three close trees and then four trees more widely spaced, terminating in an eighth tree at the margin of the canvas, establish first a tight, then a spacious and then a broad division of the picture space. The tentative irregularity of the tree-trunks prevents too systematic an

appearance - they still read as living individual trees observed and recorded by the painter and not as simple repetitions, but they mark out space across the canvas and suggest extension of the landscape beyond the painting's edge. By contrast, the horizontal divisions perform a different role. The limpid water of the foreground is cut across by alternating bands of grass and water and these culminate in a firm horizon. There is a suggestion of distance receding into the painting, evoking a view through the screen of trees. Mondrian has flatness expressed in his vertical lines, and recession in his horizontals. Restricting his colour to greens and grey-greens, the painter stresses the atmospheric effect of damp green landscape in which earth and water constantly succeed each other before and behind the trees. The interchanges of trees and their reflections, of air, water and earth suggest a mutual interdependence and relationship in which the living trees play an intermediary role, cutting across and linking the bands of air, earth and water; their trunks are rooted into earth and water while their branches fan out into the air and light. Mondrian avoided conventional aerial perspective here. Instead, these level bands denote a division of the elements in receding space, whereas his screen of trees does not recede at all but merely marks off progress across the canvas. He has effectively given hori-

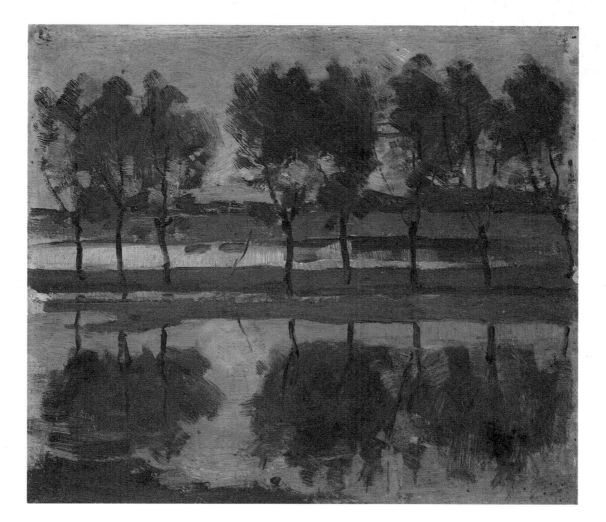

23 **Farmstead** 1905
Watercolour on paper, 51 x 65.5 cm
Gemeentemuseum, The Hague

zontal and vertical bands distinct roles and has identified their different functions.

Aspects of this theme continue in **Farmstead**, c. 1905 **23**. Using a spacious screen of four tall, thin trees and a low horizon, Mondrian suggests a view through the screen to an expansive distant space. The farm is dwarfed by the scale of its surroundings and even by the scale of brushmarks used both at the base of the painting and in the rhythmic repetitive movement of the leafy branches spread out against the sky. The trees which link earth and sky appear immense and vibrant with vitality. Placed almost symmetrically, they enclose three sections of the distant landscape, and because of their symmetry the central section dominates, implying the vanishing point of single-point perspective. This is emphasized further by the trees at the edges of the painting which veer outwards as if the central expanse of light and space were pushing them apart.

The sequence of early landscapes, formulated on the quiet and almost deserted river-banks where Mondrian could work undisturbed, embody an increasingly complex development of his contemplation of nature and of the demands of painting. The undiminished vigour of his handling of both the material and colour of his pigments still evoked the light, air and atmosphere of familiar and long-studied landscapes. In painting them he reassessed his Dutch heritage as a painter, devising original means of perspective appropriate to his understanding of what he saw in these lines of trees

24 Simon Maris: **Mondrian painting on the River Gein**, June 1906
Pencil, 18 x 11.5 cm
Gemeentemuseum, The Hague

along the water's edge. What he began to isolate in these fields was a realization of the landscape as a dynamic interplay of forces. His eye organized what it saw in order to understand it, and his paintings revealed an underlying structure beneath the detail of particular forms. He looked out upon a landscape where nature was precariously controlled by human ingenuity and where farms, canals and reclaimed land were maintained by human effort. This too was a dynamic balance of forces which could easily decay through neglect and change. Lines of trees made order out of wildness, yet the farm was still exposed to an immense sky on a wide plane of fields; it was tenuous in its control and open to the elements. Mondrian in fact organized his landscapes with the same care for con-

struction that the owners of these Dutch fields and farms employed in organizing theirs.

In August 1903 Mondrian spent a few weeks at Brabant with his friend Albert van den Briel whom he had known since 1899. As a landscape painter he was impressed by the rural life of Brabant and in January 1904 he decided to return there, settling at 29 Sint Janstraat, Uden, until February 1905. He was already reading mystical texts by this time, including Edouard Schuré's *Les Grands Initiés*, first published in 1889, but his response to Brabant was first and foremost to its fields, mills and farms. In this period he painted studies of facades; these were observed not from a distance but from a close viewpoint, thus giving his paintings a rare hint of the intimacy

25 **At the Lappenbrink, Winterswijk** c.1904
Canvas laid down on board, 33.5 x 45 cm
Private Collection

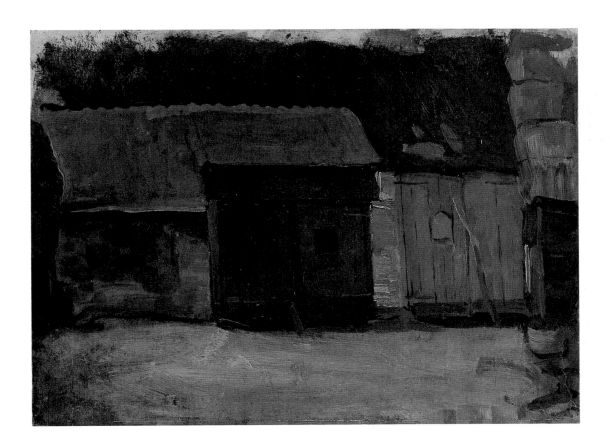

26 **Farm at Nistelrode** c.1904
Oil on card, 33 x 43 cm
Gemeentemuseum, The Hague

27 Jan Vermeer: **The Little Street** c.1661
Oil on canvas, 54.3 x 44 cm
Rijksmuseum, Amsterdam

characteristic of the Dutch seventeenth-century paintings of De Hooch, Vermeer and their circle. In Vermeer's *Little Street* (Rijksmuseum, Amsterdam; **27**) of c.1661 the facade of a house dominates the right half of the painting, and the whole facade remains parallel to the picture plane: all of its architectural features - window-ledges, door frames, steps - are parallel to the edges of the canvas and this arrangement continues along a low wall with doors in it to the lower left of the painting. The facade is punctuated by openings. These form an elaborate pattern of rectangles and brick arches, all seen frontally so that the pattern also divides up the picture surface.[3] This is precisely what Mondrian was doing in the **House on the River Gein 8** in 1900, and continued to do in the small studies of facades of farm buildings in the period 1903-5 (**26, 28, 30**). These rectangles provide visual incidents, sometimes enclosing figures in action within the facade so closely identified with the picture surface. As a result the picture surface itself resembles a kind of facade.

Farm at Nistelrode 26 maintains precisely this approach. Seen frontally and at close quarters, the doors and walls of the barns form loose rectangles across the painting subdivided by small openings and boards parallel to the picture plane, making small containers of visual incidents and variations much as Vermeer employed them. The perspective system used by Vermeer was geometrical, yet its aim was to re-create an illusion of space that was explicit and convincing. Geometry underpinned a wealth of detailed description in which every brick found its place. Geometric composition and detailed description were not in the least incompatible: indeed, the geometry upon which perspective relied, by using both a viewpoint and a vanishing point, was a means of fixing the positions of both the viewer and the objects examined. It was, in a word, a means of conveying a relationship between the viewer and what was observed. Vermeer's system required one plane to be strictly parallel to the picture surface (the facade), while lines in the third dimension, into the picture space, all pointed to a single point (the vanishing point). In *Little Street* Vermeer reduced this last effect to a minimum but it is clearly visible in the converging, and therefore receding, lines of the foreground cobbles, especially in the diagonal at centre left, which pierces the door frame in the wall to pass the small figure, clad in red, blue and white, that is busy in the yard behind the wall. Vermeer's vanishing point is located near the upper hinge of the shutter below the centre of the painting: the cobbles and benches at left converge upon this precise yet discreet focal point.

By contrast, Mondrian, in his **Farm at Nistelrode**, employs diagonals for gable-ends (as Vermeer does too) but no clear vanishing point. This is achieved by avoiding any three-quarter views of objects requiring their side elevations to recede from the viewer, and by keeping the foreground free of perspective lines. A flatter articulation of the picture plane results. In **Farm on a Canal 28** this is developed further by using the familiar motif of a reflection of farm wall, door and window in the lower part of the painting. This visual repetition stresses further the flat surface of the painting by causing the eye to move across the canvas to recognize the repeated shapes. In this way the dominant horizontal lines of the water's edge and the line of the roof guttering are crossed by the vertical lines which carry through visually from both window and door to the reflections below them. Mondrian has minimized any suggestion of recession or vanishing point without losing his atmospheric description of light and colour. His attitude to the conventions of a particularly celebrated achievement in Dutch painting is revealed. He has modified the convention by reducing the third dimension of depth, but in other ways he has shown his respect for its possibilities.

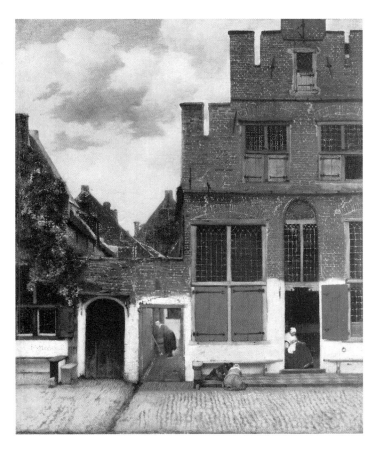

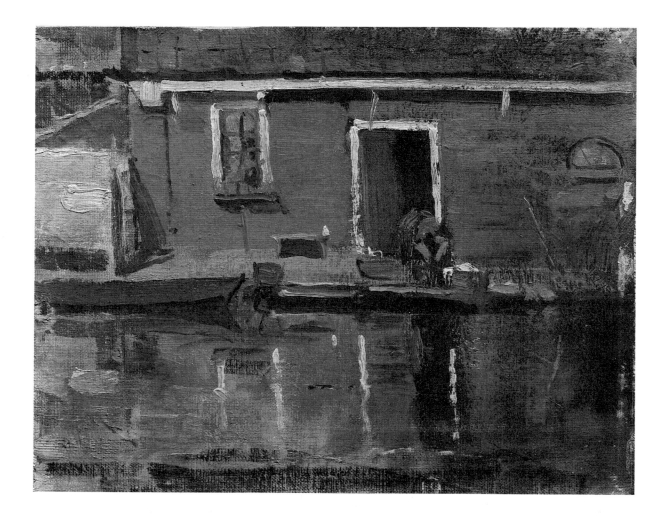

28 **Farm on a Canal** 1903-6
Oil on canvas, 22.5 x 27.5 cm
Gemeentemuseum, The Hague

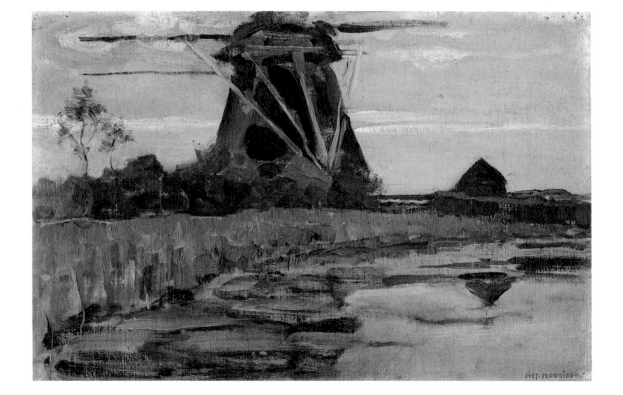

29 **The French Mill on the River Gein** c.1905-7
Oil on canvas laid down on board, 35 x 51 cm
Private Collection

Evolution

2

30 **Woman with a Child in front of a Farm** 1904-5
Oil on canvas, 33 x 22 cm
Gemeentemuseum, Slijper Collection, The Hague

Conventions characteristically persist and develop. In this way a painter establishes an individual attitude to a convention under changing circumstances. Almost two and a half centuries after Vermeer painted *The Little Street*, for example, Mondrian appears to be doing just this. It is a sign of a serious and thoughtful response to his artistic inheritance. Mondrian was not, in this sense, alone amongst these small farms, but aware of precedents and the means employed by painters before him when they depicted comparable themes.

Woman with a Child in front of a Farm 30 resembles an incidental detail from a painting by Vermeer or De Hooch. A simple human subject is placed against a facade such as Vermeer provided in his glimpse of the woman in the yard in *The Little Street*. In each case the figure is fixed against the line of a building, the wall of which is firmly parallel to the picture plane and is itself presented as a rectangle with smaller rectangles of doors and windows within it. The chief difference is that once again Mondrian resisted the diagonal which recedes to the vanishing point in Vermeer's painting. While Mondrian appears to address conventions of seventeenth-century Dutch painting he also adjusts them by minimizing recession to produce a shallower picture space in which only the overlapping of figures against a background implies depth in the painting.

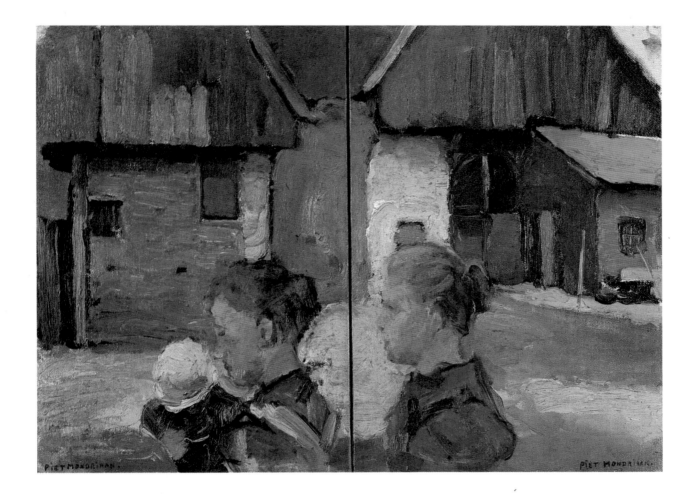

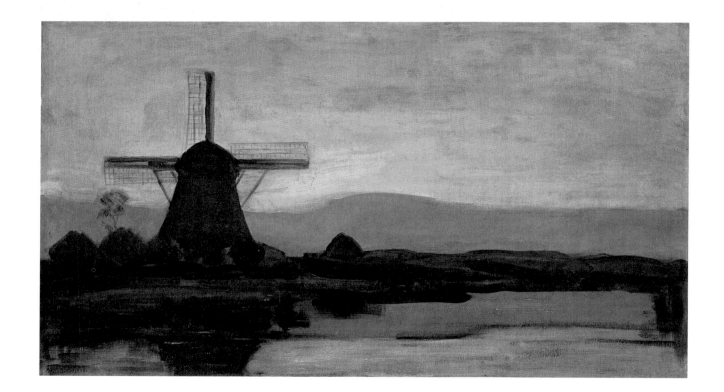

31 **Mill at Evening** c.1905
Oil on canvas, 67.5 x 117.5 cm
Gemeentemuseum, Slijper Collection, The Hague

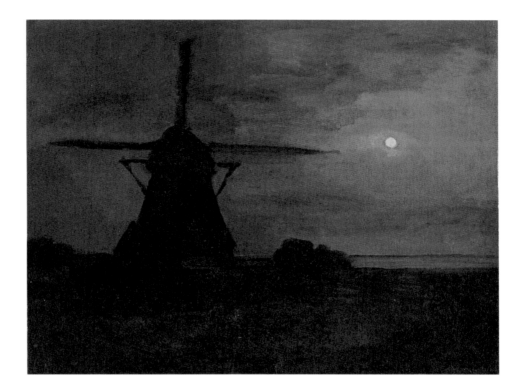

32 **Mill on the Gein by Moonlight** 1906-7
Oil on canvas, 99.5 x 125.5 cm
Gemeentemuseum, The Hague

33 **The Mill** 1905-6
Oil on canvas, 74.6 x 96.5 cm
Private Collection

The man-made structures of barns and buildings were easily compatible with this system: the facade itself organized the flattened painting. This resembles Mondrian's screen of trees in a spacious countryside or reflections that continue and repeat his forms, though it was an effect difficult to accomplish in open landscape. Two paintings of the period 1905-7 achieve a subtle solution which reintroduced the theme of the place of man within nature. Both **Mill at Evening 31** and **Mill on the Gein by Moonlight 32** were executed on a more ambitious scale. They are closely related in subject and approach. The reduced light of evening and night was not a new theme for Mondrian but here it is used to silhouette the shape of the windmill against the sky.

In **Mill at Evening** the watery foreground reflects the mill, and the strip of land is suspended across the broad canvas between the light of the sky and its reflection in the water. As it expands laterally off the canvas, it evokes the calm stillness of evening over the wide fields, an emphasis interrupted only by the stark bulk of the mill's silhouette which Mondrian has painted in strict symmetry, the strut of its sails in line with the axis of the mill so that its other sails are balanced and level. The cross format of the mill breaking the horizon is repeated in the lines of these wooden beams against the sky; only the swastika-like progression of the sails themselves suggests their potential for movement. These crossing struts, which describe a circle when the mill is operating, are now fixed perpendicular in the repose of evening. They reflect both the horizon itself and the edges of the canvas in a succinct and harmonious contrast of flat landscape and the upright construction of man within it. Horizontal is identified with the expanse of nature and vertical with human construction. In silhouetting this sail against the sky, and repeating the effect in **Mill on the Gein by Moonlight 32** Mondrian gives it dramatic force: it is the

visual focus of the whole composition. In this painting the horizon is sharp and clear, and in separating out the lower struts of the mill's mechanism the artist has suggested a downward pointing triangle like a smaller reflection of the large triangle defined by the limits of the windmill's sails. As both are symmetrical around the axis of the mill, the emergent lozenge shape suggests both descent and ascent. Mondrian was still as preoccupied with geometry as he was when painting the house on the Gein and its reflection several years earlier **8**, or the more recent lines of trees **17-18**, **22-23** and facades **26, 28, 30**.

In 1908 Mondrian travelled to Domburg on the island of Walcheren in Zeeland where the symbolist painter Jan Toorop was currently working. There the house of the painter Marie Tak van Poortvliet provided a focal point for artistic discussions and encounters. Domburg rapidly became an important centre for Mondrian's activities and he returned in 1909-11, giving drawing lessons to Jacoba van Heemskerck, the only Dutch member of the Berlin-based group Der Sturm. It was here, probably during 1908, that Mondrian made close contact with Jan Toorop and the Dutch painter Sluyters. Although Toorop had gained fame and notoriety as a leading Dutch symbolist, he was now exploring pointillist techniques derived ultimately from Seurat's painting in France. Toorop, a prime mover in the Dutch recognition of Van Gogh and the international activities of the Brussels-based group *Les XX* during the 1890s in Holland, was well connected and widely informed. Far from being the remote place that its geography suggested, Domburg provided Mondrian with the opportunity to learn of the most diverse and recent international developments in art. His painting evolved rapidly away from direct observation.

Religious mysticism played a catalytic role in this. Mondrian's colleagues at Domburg were interested in Theosophy which the

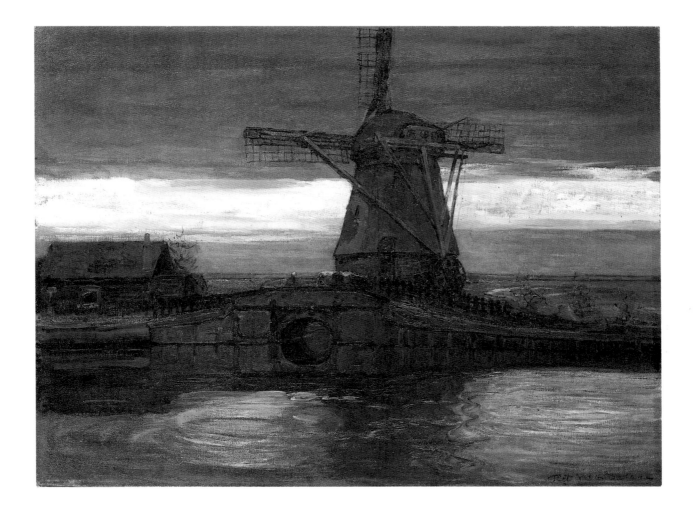

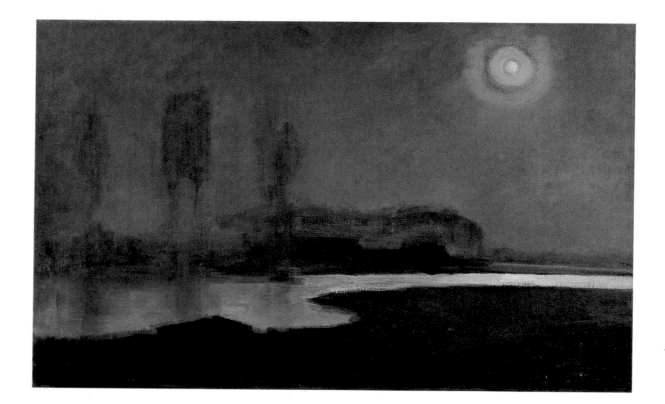

34 **Summer Night** 1906-7
Oil on canvas, 71 x 110.5 cm
Gemeentemuseum, The Hague

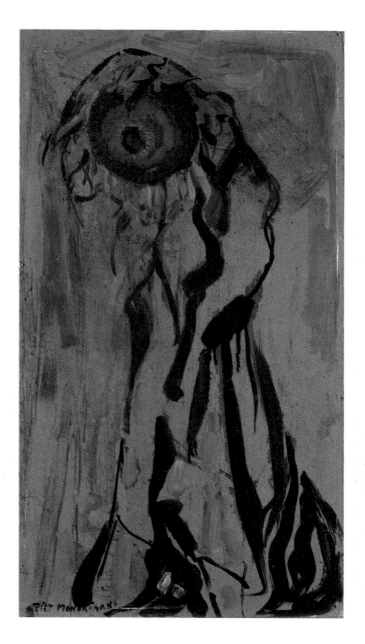

35 **Dying Sunflower** 1907-8
Oil on card, 65 x 34 cm
Gemeentemuseum, Slijper Collection, The Hague

36 Roland Holst: **Catalogue cover for the Van Gogh exhibition, Amsterdam 1892**
Lithograph, 16 x 18 cm
Print Room, Rijksmuseum, Amsterdam

mystic Helena Petrovna Blavatsky originated in 1875, and which had recently been complemented by the former theosophist Rudolf Steiner in his own Anthroposophical Society.[4] According to theosophical beliefs matter has arisen from the interaction of universal forces engaged in an evolutionary progression in which humanity plays a central role acted out through multiple reincarnations. Among other aspects of the movement, the concept of reincarnation led to an interest in the activities of mediums and extra-sensory perception. Mondrian was to take a serious interest in Theosophy and the mystical systems it embraced, and it is possible that he was already interested in clairvoyant experience by 1908. Domburg provided the opportunity to discuss Theosophy as well as art. By a study of major world religions, theosophists sought a new synthesis in which the concepts of karma and reincarnation were of prime importance.[5] They envisaged a divine motivating force pervading the entire universe, including therefore all space and matter. By means of consciousness and will, humanity had the potential for increased spiritual awareness and development. Through consecutive cycles of reincarnation human life could realize its divine potential, and this process theosophists called evolution. In this way theosophists considered all matter not as isolated objects scattered in empty space but as phenomena produced by the interaction of universal forces. Humanity was exceptional only in its position within the evolution of the cosmos, its attendant self-awareness, consciousness and apparent free will.

One sign of this spiritual evolution was the concept of the aura, a glowing envelope of colour encapsulating people and other forms of life and reflecting their emotional and spiritual state, a phenomenon accepted as real by both Blavatsky's theosophists and Steiner's anthroposophists, although only certain sensitive or clairvoyant individuals could detect these visual manifestations of living energy.

Theosophy, which sought understanding of the world through a synthetic study of religions, did not hesitate to draw upon related philosophical as well as religious ideas of the nature of the universe and the place of mankind within it. In order to construct her view of the universe, her cosmology, Blavatsky, for example, went to great lengths in her books to examine the mystical significance of numbers, and the philosophical systems of alchemy and astrology, as well as Greek philosophy and legend, and much of this was to interest and influence Mondrian in his own understanding of man's place in the scheme of things.[6]

Allusions to theosophical thought can be discerned in Mondrian's **Dying Sunflower 35**, which is in many ways a symbolist painting even though symbolism as such had been substantially superseded by 1907-8. It is a generalized image of no particular time or place but isolating a stage of existence or experience. Remarkably, the decay and death which artists have so frequently depicted in a human setting is here displayed as a stage in the life of a flower. The dramatically emotive lines of the painting are inappropriate to still life. As an image of the material decay and collapse of a living plant it has the expressive power of a portrait. The spectacular dissolution of a sunflower, from a brilliant yellow radiant form to a deep ochre and sienna mass of seeds, links decay with regeneration. The sunflower's particular association with the sun, evoking comparison with the sun's own setting and rising, was an image already explored by Van Gogh and Gauguin. The Dutch symbolist Roland Holst, in his cover for the catalogue of Toorop's Van Gogh exhibition in Holland in 1892 **36**, had personified Van Gogh as a dying sunflower acquiring a martyr's halo in its collapse, completing his image with the sun setting in the distance. Mondrian's **Dying Sunflower** shares some of these characteristics. Van Gogh's adoption of the sunflower motif is an obvious precedent, and Mondrian might have discussed Van Gogh with Toorop at Domburg, but this painting is a less specific reference to Van Gogh than Roland Holst's. Mondrian's sunflower is living matter in the process of decay and

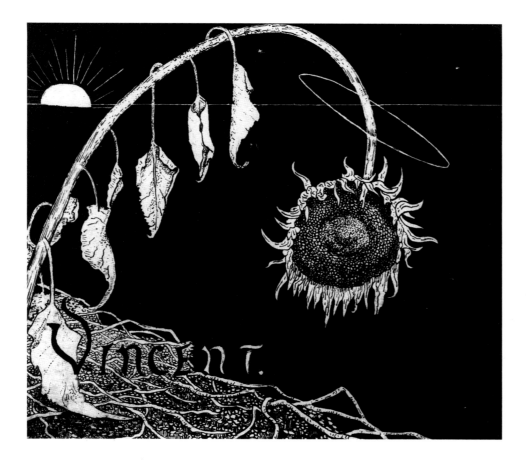

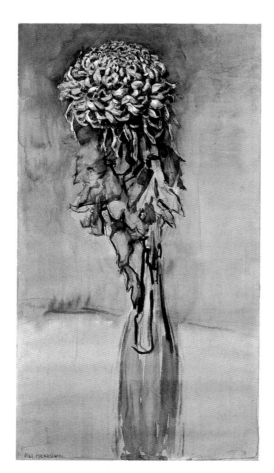

37　**Chrysanthemum** c.1909
Watercolour on paper, 72.5 x 38.5 cm
Gemeentemuseum, The Hague

38　**Dying Chrysanthemum** 1908
Oil on canvas, 84.5 x 54 cm
Gemeentemuseum, The Hague

rebirth, a theme compatible with the theosophists' ideas of reincarnation. Its drama is, as it was for the theosophists, closely related to that of human life.

The slightly larger painting, **Dying Chrysanthemum 38**, probably exhibited in 1909 by Mondrian under the title **Metamorphosis**, signals a further examination of the decay of a radiant flower. As these living creatures succumb to dissolution, they collapse from vigorous upward growth towards the earth and rebirth. If the sunflower recalls the sun, the chrysanthemum recalls the moon. Birth, growth and decay form a cycle. According to Steiner, whose writings Mondrian studied, and the theosophist Annie Besant whose book *Thought Forms* was published in Dutch in 1905, flowers as well as young girls emit vibrant auras of colour which are manifestations of higher spheres of existence. The particular significance of certain hues of red was associated with deeply felt affection, while blue signified devotion, according to Rudolf Steiner.

Devotion 39 was the title given by Mondrian to a contemporary profile portrait of a young girl. With her head raised she stares upwards beyond the hovering image of a chrysanthemum in full bloom. Red and blue dominate the painting. Mondrian explained carefully that this painting represented not prayer but devotion. Mondrian's colours precisely coincided with the signficance Steiner attributed to red and blue. When Mondrian approached mystical beliefs and concepts between 1908 and 1911 it was the work of Blavatsky, Steiner and Theosophy which provided guidance in his self-confessed search for 'knowledge of the occult spheres'.[7]

In these paintings, and in **Passion-flower 40**, Mondrian used symbolic imagery to express mystical ideas. His figures **39-40** look upward or have the closed eyes of meditation. They are associated with flowers that float in a mysterious and heraldic

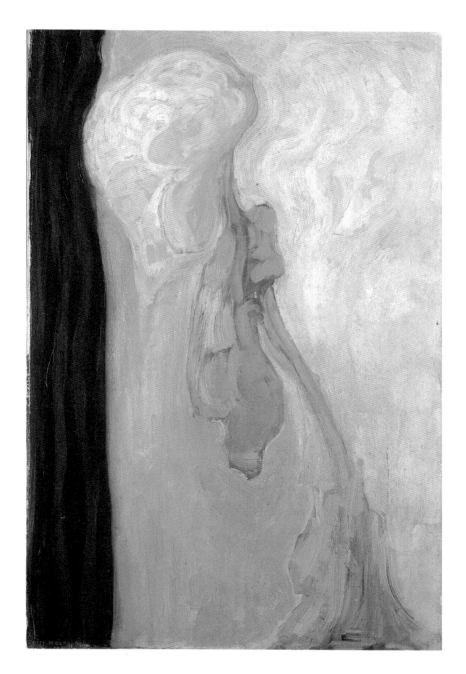

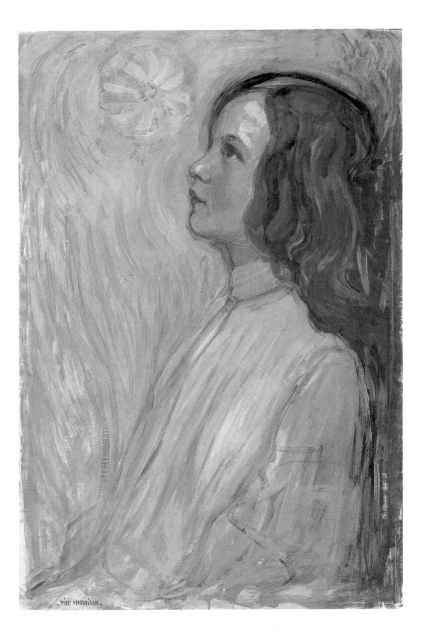

39 Devotion 1908
Oil on canvas, 94 x 61 cm
Gemeentemuseum, The Hague

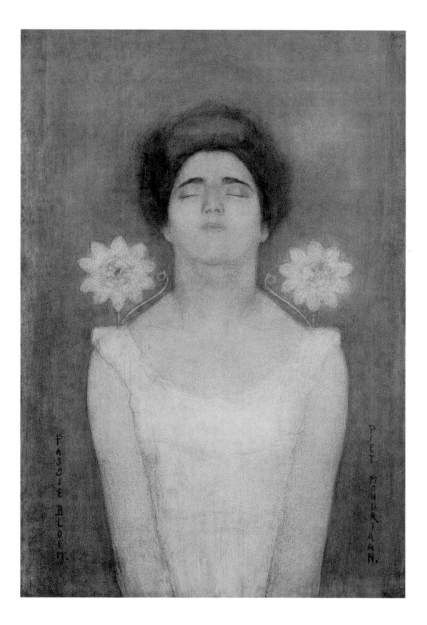

40 **Passion-flower** 1908
Watercolour on card, 72.5 x 47.5 cm
Gemeentemuseum, The Hague

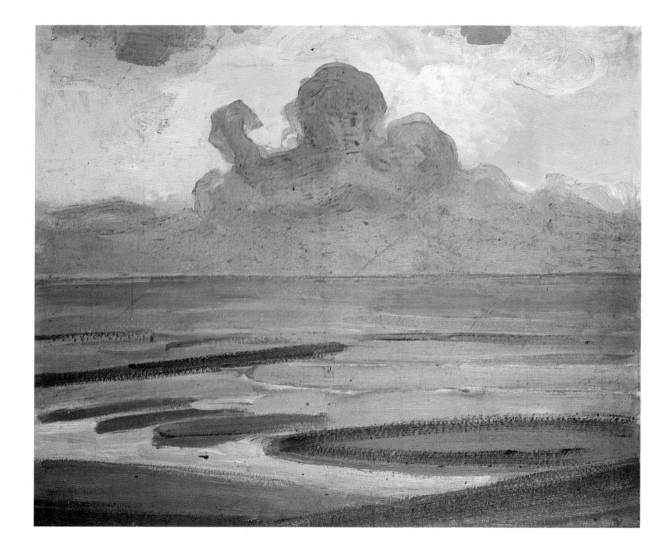

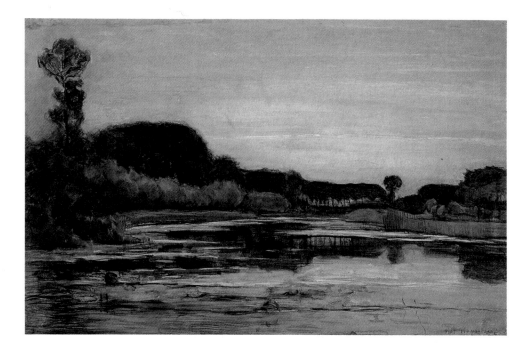

41 **On the Shore** 1907-9
 Oil on card, 40 x 45.5 cm
 Dayton Collection, Minneapolis

42 **A house along the River Gein** 1895-1900
 Oil on panel, 41.5 x 41 cm
 Private Collection

accompaniment in an other-worldly space.

In the **Dying Chrysanthemum**, **Devotion** and **Passion-flower** he used a technique employed in numerous earlier paintings. A strictly frontal view or a profile avoided any suggestion of incidental or arbitrary effects. **Passion-flower** takes this further by means of a strictly edited and symmetrical composition. As a result any variety and change in the painting occurs only up and down the central axis in a rhythmic sequence which emphazises the upward movement of the raised and introspective face. This compositional theme of rising and falling movements was previously evident in the landscapes. In the new sequence of paintings descending rhythms are associated with decay, while rising rhythms are related to spiritual meditation. In this way compositional techniques first evolved by Mondrian in landscape painting took on a specifically mystical meaning. What at first

appears an abrupt change in his work reveals continuity and development in composition.

The centrally placed clouds rising above the sea in **On the Shore 41** repeat the motif of an ascending triangular mass but transferred to the shifting atmosphere of expansive seascape. In subsequent years Mondrian exhaustively reassessed seascape and landscape painting in the light of his growing mystical interests. He evolved an independent personal philosophy in which mystical concepts coalesced with his intense experience of the landscape itself. On the sea-shore depicted here, the forces of nature are engaged in a constantly shifting balance of land against sea, of water in the landscape and water in the dramatic cloudscapes of the air, by daylight, at evening and by moonlight **42**.

Mondrian now sought an underlying principle in appearances

43 **The Old Watermill at Oele with Moon** c.1907
Oil on board, 59 x 73 cm
Private Collection

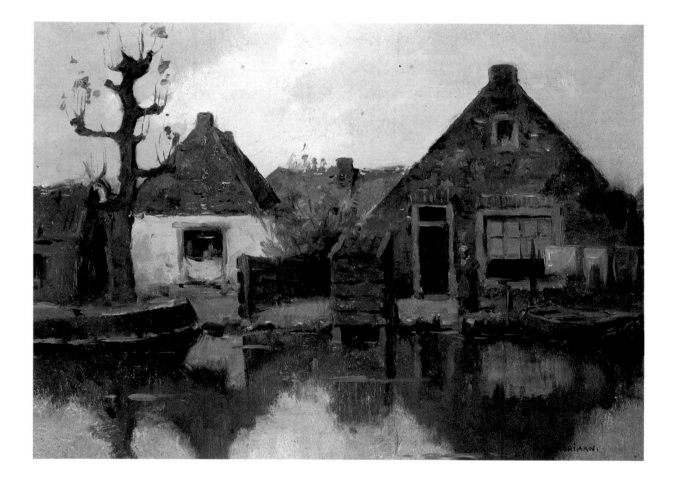

44 **The isolated tree on the River Gein** c.1906-7
Watercolour, charcoal and pastel on paper, 43 x 64 cm
Private Collection

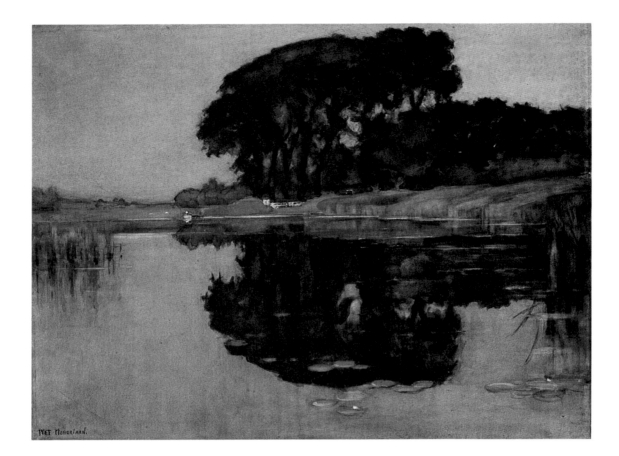

45 **Trees Reflected in the River Gein** c.1905
Watercolour on paper, 50 x 63.5 cm
Private Collection

and the permanent structure that encompassed change. He rehearsed themes from his own earlier paintings, and made of composition, in the process, the means of editing what he saw to reveal the balance and order of his own cosmology. The tree, for example **47**, was a living creature balancing the energies of air, light, water and earth in the midst of which it grew, flourished and declined. Here the grey-green trees are seen against the light of the red sky and yellow moon. The handling of their foliage retains the movement of gestures which made these marks, adding an intense vitality to the

image. In repeating this theme, again perhaps from direct observation on the banks of the river Gein, Mondrian has simplified the earlier theme and enriched it (see **22**). Red replaces the dominant green of the earlier treatment, and the focal point seen through the screen of trees is now the moon set in a red sky.

Throughout the years of Mondrian's closest encounter with the mysticism of Theosophy he continued to paint the Dutch landscape of farms, mills, flat fields, waterways and trees. Observation did not diminish in importance: in the close scrutiny of nature he found his

46 **Sheepfold in the Evening** 1906
Charcoal, crayon and watercolour on paper, 73.7 x 98.1 cm
Gemeentemuseum, The Hague

most significant themes, but his handling of those themes continuously evolved with each new painting. Two closely related views of a farm at Duivendrecht make this clear. Low buildings stand amongst trees on a curve of the river. Again, reality and its reflection combine to form the dominant shapes of the composition, but in the second version the screen of trees is handled in an entirely new and important way **50**. The gaunt, irregular and leafless branches silhouetted against the sky in the first version become rhythmic curving forms in the second. Although the overall composition scarcely changed,

Mondrian's later handling of the same branches was no longer awkwardly irregular and the effect of this on the composition is dramatic. In his second depiction of the trees he found a new structure in which the twisting branches form small curves, a cellular screen through which the sky is seen. The luminosity of the sky between the dark branches makes these small cells glow, and although they depict empty space, they now appear as globules of light and colour between the bounding contours of dark branches. Two remarkable achievements are evident: empty space is given positive shape, and

47 **Trees by the Gein in the Moonlight** 1907-8
Oil on canvas, 79 x 92.5 cm
Gemeentemuseum, The Hague

48 **Farm with Cattle and Willows** 1904
Pencil on paper, 46.9 x 58 cm
Gemeentemuseum, The Hague

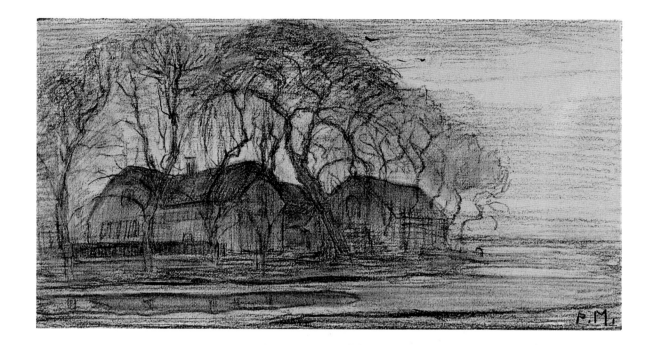

49 **Farm at Duivendrecht** 1906
Pen and ink
Gemeentemuseum, The Hague

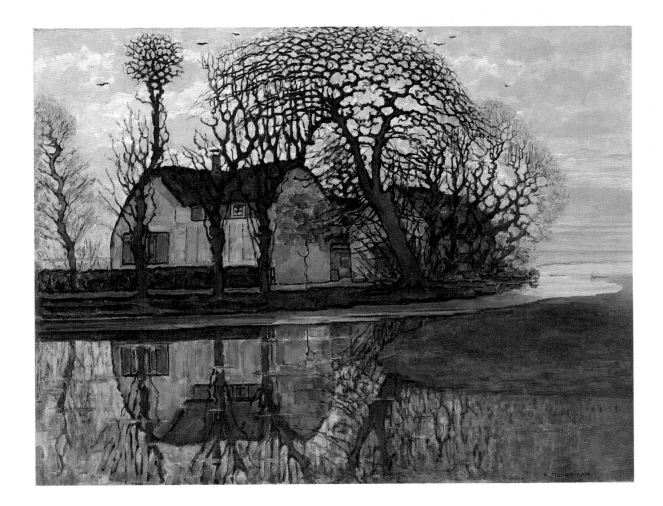

50 Farm at Duivendrecht c.1907
Oil on canvas, 87 x 109 cm
Gemeentemuseum, Slijper Collection, The Hague

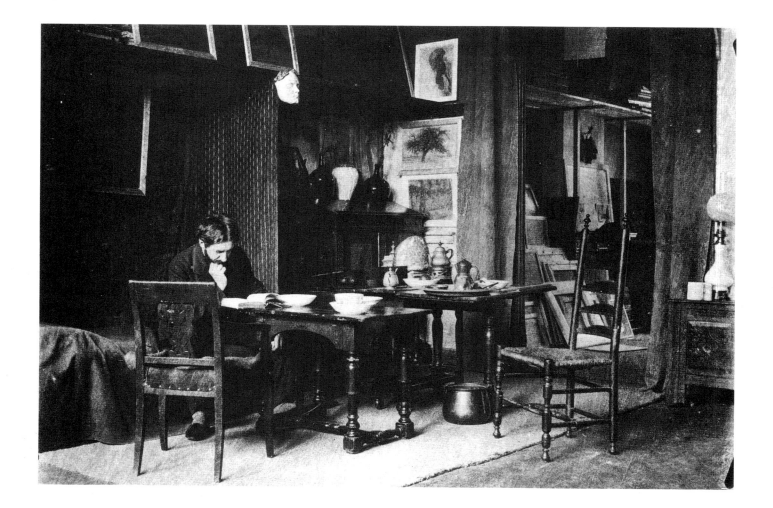

51 Mondrian in his studio at 42 Sarphatipark,
Amsterdam 1908-10
Photograph
Rijksbureau voor Kunsthistorische Dokumentatie,
Gemeentemuseum, The Hague

the branches themselves engage in an interplay with space that describes the pattern of their growth and their overall shape.

With the advent of this cellular technique Mondrian linked positive and negative forms together. The trees and sky intertwine into a pattern which can close, open, grow dense or sparse, suggest the umbrella-like surface of the outermost branches, or the thickening of the many branches into the trees' main stems. These are no longer simply trees silhouetted against the sky, as in the first version, but trees with branches dispersing upwards and outwards to encapsulate the air, as the air penetrates down and inwards in return. These trees interact with the air and light into which their gnarled branches reach. The interchange of image and reflection, of land and water, is enriched by a new device in which the tree and its surrounding space interpenetrate and fuse into a dynamic balance of forces, precisely descriptive of the trees' dependence upon light and air as much as upon earth and water. The pattern this forms across the canvas instigates a new development in Mondrian's approach to composition in which the image of the tree as a living creature is locked into its surrounding space: foreground and background fuse together.

Images of trees provided a recurrent preoccupation for Mondrian in the period between 1900 and the outbreak of war in 1914. A photograph of the artist taken in his studio at 42 Sarphartipark, Amsterdam, between 1908 and 1910, shows him reading at a table **51**. Curtains and a screen divide off his picture store. Among the paintings covering his walls are the **Dying Chrysanthemum** and two studies of single trees. He reworked the theme repeatedly, reducing his composition from complex landscapes to a single tree, refining the elaborate interplay of foreground and background by which the solid trunk of the tree was seen to disperse itself through branches and twigs into the empty space around it. In **The Red Tree 52** this

resolution of opposites is edited and refined to powerful effect.

Reducing his subject to a single tree permitted Mondrian to intensify his examination of its form, scrutinizing its gnarled and curving branches in detail. Van Gogh had adopted a similar tactic, as French Barbizon painters had before him. Like Van Gogh, Mondrian chose a tree that was twisted in its growth, its branches subdividing into the air from the solid, arched and forking trunk. From a single thick trunk the branches split and twist into a multiplicity of ever smaller branches. What was single and solid expands outwards into a multitude of thin curving lines. Among those branches the empty space of the surrounding air is resolved into a cellular structure, as in the **Farm at Duivendrecht 50**, and this has the effect of making these pockets of space appear more substantial than the curved lines of branches which enclose them. Both space and tree are painted firmly and solidly, so that foreground (the tree) and background (space) interlock into a firm and vigorous structure across the flat canvas. The lack of any distant background enhances this. As a result the branches spread out across the painting with little suggestion of depth. Their multiple lines arch upwards and sideways towards the edge of the canvas, rising from the trunk and then bowing to the pull of gravity at either side. Other branches lift upwards in a cluster at the top. In this way Mondrian created an organic cross-like composition, which embodied expansion, growth, decay and dispersal in a single image. His tree is locked into a play of forces in which air and light pull upwards and outwards, while gravity pulls downwards towards the earth from which the wide trunk first emerged.

Mondrian reworked and simplified the image through repeated studies until it efficiently depicted growth and decay without any part distracting from the rhythms of his theme. Tones were simplified to a basic three for the trunk, the darker thin branches and the surrounding

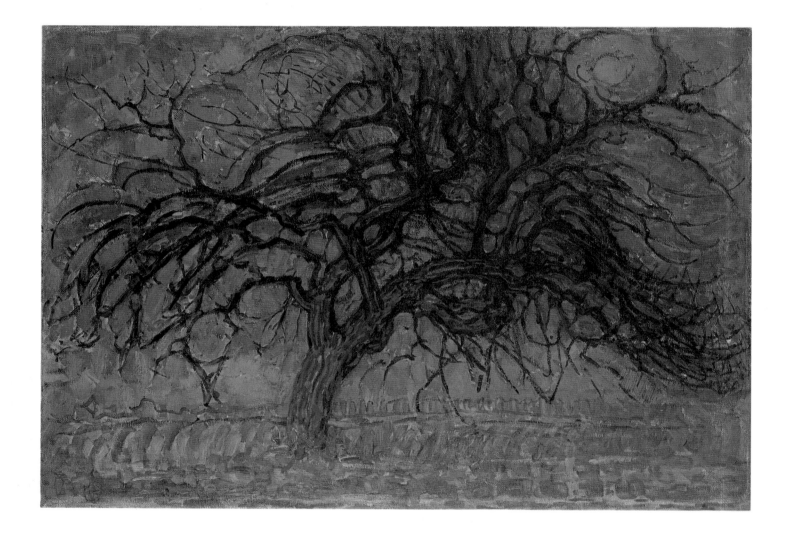

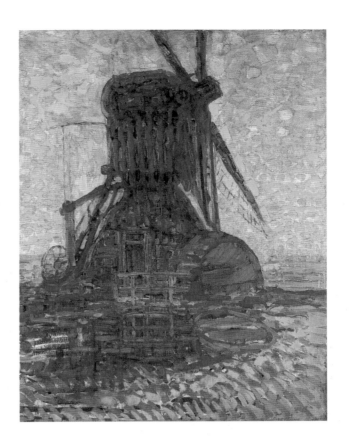

52 **The Red Tree** 1908-10
 Oil on canvas, 70 x 99 cm
 Gemeentemuseum, The Hague

53 **Mill in Sunlight** 1908
 Oil on canvas, 43.8 x 34.3 cm
 Gemeentemuseum, The Hague

space. Colour was simplified to a contrast of red and blue. The opaque and rhythmically applied paint suggested substance equally in surrounding space and in the tree. This intensely resolved image of a living tree recorded the stages of its growth: it contains vitality and decadence, balancing the outward and upward growth from its central core against the gravity and decay which pull it down. Concentrating upon the one tree, Mondrian increased the power of his image as a single focus of conflicting and interconnected forces.

In its partly broken brushwork and strong colour, **The Red Tree** is comparable with pointillist painting which as late as 1905-6 was still pursued in modified form by Signac, Matisse and other French painters. In Holland Toorop became an active and accomplished pointillist painter, and Dutch artists were beginning to respond also to Fauve painting. Yet **The Red Tree** is dominated by only two colours, red and blue, and although the blue suggests space and the red stands firmly and forcefully forward of the blue, the brushmarks do not blend in the eye to suggest daylight. Instead, Mondrian relied upon the contrast of two primary colours counterposed in larger

areas rather than the small adjacent dabs devised by pointillists. In this work his colour is perhaps more suggestive of mystical significance than optical effect.

The pointillist techniques of evoking light by dividing it into its constituent colours were developed by Mondrian to new ends. Through pointillist colour he began to employ dabs of strong red, yellow and blue, extending the pointillist dot into lines and skeins which, far from mingling in the eye, actually stressed the conflict of contrasting primaries. **Mill in Sunlight 53** exemplifies this: a smaller study than **The Red Tree**, it adopts the broken brushwork of pointillism but the mill itself remains the single, massive dominant image. There is little attempt to evoke a single coherent light. Mondrian has again isolated a potent image from his earlier work, presenting forcefully and blatantly the now familiar windmill which, like the natural form of the tree, relies upon and uses the earth, air and water of the Dutch landscape. But now his colour has been transformed. The primary colours, each with its unique qualities and associations, are revealed as the elements which create all the diversity of

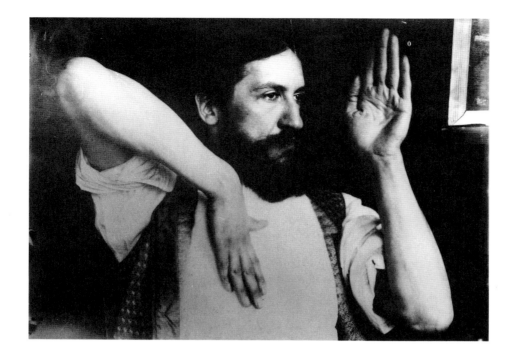

54 Mondrian in a meditational pose. 1909
Photograph
Gemeentemuseum, The Hague

55 **Seascape at Sunset** 1909
Oil on card, 34.5 x 50.5 cm
Gemeentemuseum, Slijper Collection, The Hague

observed colour. Their clear, powerful and optical interplay gave a new dimension to his imagery.

Although Mondrian's adoption of pointillist technique was short-lived and was substantially over by 1909, it had its importance in his development. He was continually aware of diverse techniques and his experience was rapidly expanding. Indeed, throughout his life he maintained close contact with other artists, and his connections in both Domburg and Amsterdam were important for the development of his ideas and innovations. He exhibited, for example, with the Dutch painters Sluyters and Cornelis Spoor at the Stedelijk Museum in Amsterdam in January 1909; and if his painting responded vigorously to the visual potential of pointillism at that time, his ideas continued to respond to mystical thought and theory, for in May 1909 he joined the Theosophical Society of Holland **54**.

Mondrian executed numerous small studies of the sea using pointillist techniques, but the subject itself had theosophical signifi-

cance. The sea, which threatens so much of Holland, was immediately accessible at Domburg. Mondrian now avoided man-made structures, isolating as his theme the action of the ocean upon the shore with the same intense concentration that had characterized his **Red Tree**. But the theme of the sea provided no upright form to break the horizon, and the waves flowing against the shore formed uninterrupted bands across the view **55**. Both shore and sea extended off the sides of the canvas. The only movement lay in the encroaching water and resisting shore. In these conflicting forces of sea and land, the foreground receded away to the seemingly infinite expanse of the ocean. Nothing human is visible to make this conjunction of land, sea and sky specific in time and space. In this sense the theme is eternal.

Mondrian's brushwork corresponded to the movement and light observed. In **Beach at Domburg 56** the smooth expanse of sea is contrasted against the scattered brush-strokes of the beach whilst the

56 **Beach at Domburg** 1909
Oil on card, 41 x 76 cm
Gemeentemuseum, Slijper Collection, The Hague

sky is a mass of regular marks forming a wall of colour. Mondrian was aware of the need to evolve and define his technique by experiment and experience, as a letter written in 1909 to the critic Israel Querido made clear: 'I believe it definitely necessary in our period that the paint be applied as far as possible in pure colours set next to each other in a pointillist or diffuse manner.'[8] The small beach paintings of 1909, which do precisely this, show Mondrian consciously developing his technique to express his ideas, for 'it seems to me', he

wrote in the same letter, 'that clarity of thought should be accompanied by clarity of technique'.[9]

The frontal view that is characteristic of so much of Mondrian's early work was at its simplest in these seascapes, several of which depict vast expanses of space and light on very small canvases. The lack of interrupting motifs stresses the near symmetry of the paintings, and in one of them **57** the downward expansion of reflected light from the sun implies a high central focus which acts like a vanishing

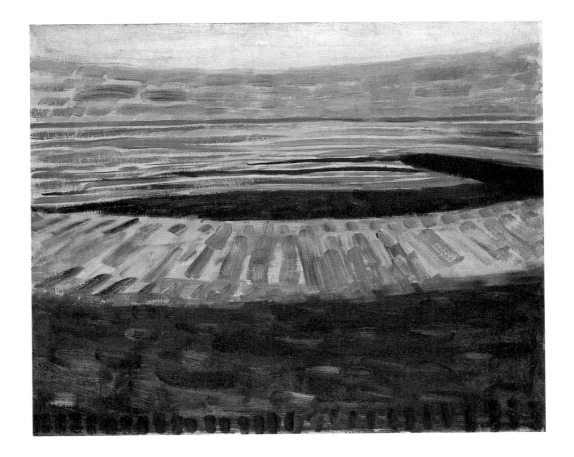

57 **Sea at Sunset** 1909
Oil on card, 62.5 x 74.5 cm
Gemeentemuseum, A P van den Briel Collection, The Hague

point to evoke the enormous space of the sky and sea. By contrast, others of the sequence assert the mass of land which confronts the sea, rising like a barrier against its influx. **Dune I 58** is an example of this. The sand-dune, shaped by wind and sea, rises up gently while in other **Dune** paintings **59-61** its bulk is more prominent but with water intruding in a curve in front of its mass. The dunes, barriers to the ocean's encroachment, act like foreground mountains in a shifting landscape, ceaselessly adjusted by opposing natural forces.

Mondrian's pointillist brushwork, as well as describing light and colour, also emphasizes the slowly rising curve of the dunes echoed by the curve of water that encircles and undermines them.

The sequence of sea paintings concluded with two of Mondrian's largest paintings to date, in both of which he abandoned pointillism for flatter forms, grander scale and radically simplified colour. The ascending triangle of **Dune VI 61** finds its counterpart in the descending slow curve of the foreground. The shore erects its

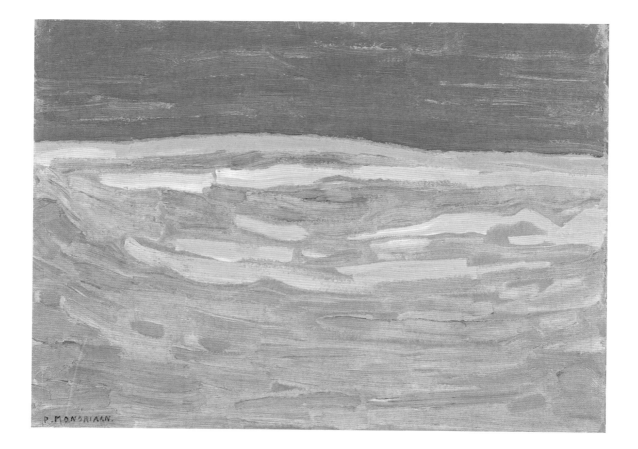

58 **Dune I** c.1909
Oil on canvas, 30 x 40 cm
Gemeentemuseum, The Hague

59 **Dune II** c.1909
Oil on canvas, 37.5 x 46.5 cm
Gemeentemuseum, Slijper Collection, The Hague

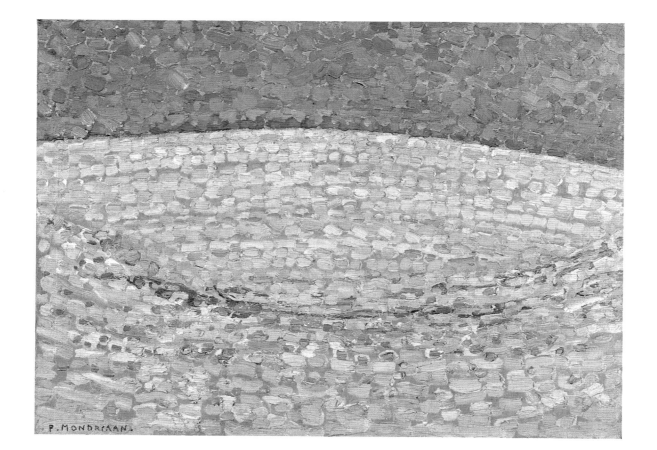

60 Dune III 1909
Oil on canvas, 29.5 x 35 cm
Gemeentemuseum, The Hague

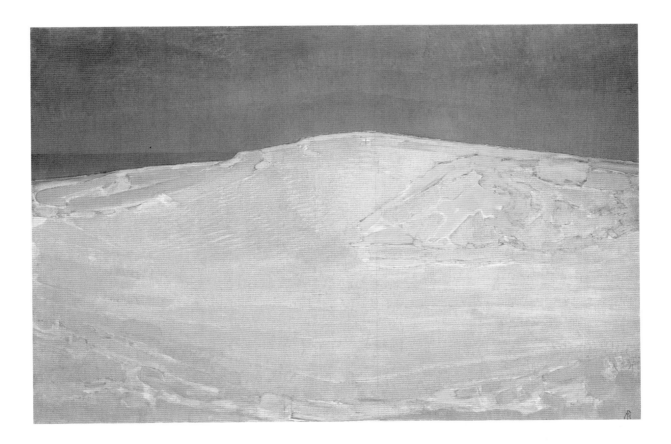

61 **Dune VI** c.1910
Oil on canvas, 134 x 195 cm
Gemeentemuseum, Slijper Collection, The Hague

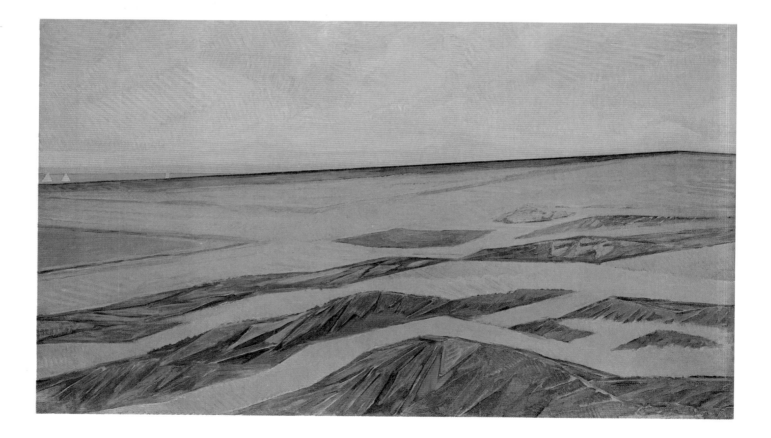

62 **Landscape with Dunes** 1910
Oil on canvas, 141 x 239 cm
Gemeentemuseum, Slijper Collection, The Hague

63 Piet Mondrian, 1909-10
Photograph
Gemeentemuseum, The Hague

monumental mass against the sea. The artist has again isolated and repeated a single theme which, through a series of studies, he has edited, refined and simplified until it dominates his painting and permits no distraction. Mondrian was not a doctrinaire pointillist in any sense; for him, pointillism was a useful means and an extension of his powers as a painter, but it could be readily abandoned. Observing the sea and shore, he sought its rhythms, which in the large **Landscape with Dunes 62** are the water's movements recorded in the sand. Light and air were not his sole concern. The rhythm was more important in its record of the conflicting natural forces which confronted him. He was ready to set aside pointillist technique in order to present this theme with force and simplicity.

Although Mondrian's pointillist works gained approval at the exhibition of the Guild of St Luke in Amsterdam where he exhibited with Toorop and Dutch Luminarists in 1910, he rapidly abandoned the technique to pursue two new developments with vigour. Late in 1910, together with Toorop and the painters Kikkert and Jan Sluyters, he formed a new exhibition society, the *Moderne Kunstkring* (Modern Art Circle), with internationalist ambitions of linking Dutch painting with new developments in France, Germany and elsewhere. In Mondrian's own painting, 1910 saw the fullest expression of his interest in the mystical cosmology of the theosophists. While Theosophy was not a movement in painting, it proposed a view of the world which painting, based upon observation, could attempt to reveal. In this way Mondrian emerged as a kind of philosopher in paint who did more than illustrate ideas. He observed the processes

64 **The Lighthouse at Westkapelle** 1909-10
Oil on canvas, 135 x 75 cm
Gemeentemuseum, Slijper Collection, The Hague

which Theosophy brought to his attention and revealed their rhythmic interplay in action. In this mixture of theory and practical experience it was the latter which ultimately provided the basis of his achievements. With the passing of time he moved beyond Theosophy but the philosophical tenor of his thought did not diminish, for it was inextricably bound up with his experience and practice as a painter. It was Theosophy which first clarified this commitment in Mondrian's development. The single forceful image, first developed in 1909-10, took on added significance during his closest involvement with the Theosophical Society. Three large vertical paintings, depicting a lighthouse **64**, a windmill **66** and a church **65**, exemplify this involvement which became finally explicit in the triptych **Evolution 68**.

These three canvases and each of the three panels of **Evolution** are dominated by a single image placed almost symmetrically around the vertical axis of the painting. The familiar theme of the windmill is presented with new force, while the lighthouse and church break new ground. Each of these distinctive buildings contains a series of openings which provide a rhythmic subdivision of the facade. All three are monumental man-made structures but each has a distinct purpose, **The Lighthouse at West Kapelle 64** is related in theme to the seascapes; projecting to enormous height from the low horizon, it is part of the battle of sea and land, of nature and man, its light providing guidance and protection for the seafarer.

The Mill at Domburg 66 looms up against the sky with an equal energy, its base fixed in the earth and its sails articulating the movements of air, a man-made link between sky and earth. **The Church at Domburg 65** also links heaven and earth but in a different sense, for its purpose is not practical but spiritual. It glows with the red light of the setting sun through a mosaic of leaves and branches.

All of these low-horizoned canvases suggest upward movement by compositional means. The low viewpoint contributes to this, but just as significant is the sequence of lines and shapes which rise either side of the central vertical axis. In the lighthouse the sequence

of window openings on two sides rise like the hieroglyphics on an obelisk to the pointed roof-line dictated by Mondrian's steep perspective. This roof-line, which makes the lantern almost invisible, recalls his earlier use of the upward pointing triangle. The mill, painted with uncompromising frontality and symmetry, is pierced by a pointed window, acting as an arrow to the chevron shape dramatically reinforced by the lower sails that dominate the upper canvas. Conversely, a lesser, downward, thrust is signalled by the other sails and smaller struts behind the mill, a conflict of rhythms resolved in the diamond shape used by Mondrian at the centre-point of the sails' construction. Finally, the shape of the body of the mill itself thrusts up into the sky. This composition, despite its symmetry, is full of movement. Because of its symmetry and frontality this is not movement in depth but movement up and down the canvas.

The Church at Domburg 65 likewise rises up against the sky from a low base, the upward lines of its roof echoed in each pointed arch of its facade, while the angular stylization of leafage through which it is seen indicates a variety of diversely placed angular shapes. The church alone terminates in a flat surface culminating the sequence of lines which divide the tower into reducing bands as it rises. The visual intensity of these images precludes incidental observation. Their monumentality is won from long study and preliminary drawings and sketches. In resolving these three paintings, Mondrian has focused attention upon the theme of ascent and aspiration. They are the counterpart of his studies of landscape and the sea; they depict human construction against the low horizon, and human aspiration within nature.

Evolution 68 painted in 1910-11, is a triptych painting of singular importance in Mondrian's early career. Painted when the artist was 39 years old, it explicitly reflects theosophical thinking and Mondrian's membership of the Theosophical Society of Holland. It is substantially unique in his work, although it is related to **The Passionflower** of 1908 **40**. The **Evolution** of the title is the theosphical

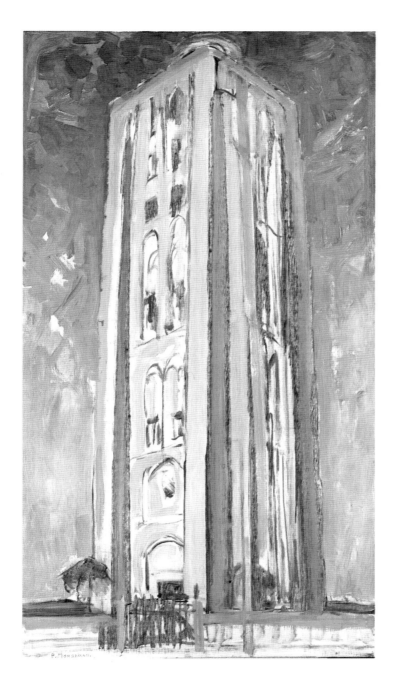

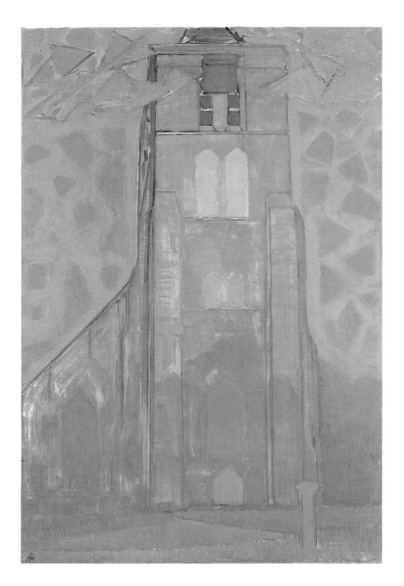

65 **The Church at Domburg** 1910
Oil on canvas, 114 x 75 cm
Gemeentemuseum, Slijper Collection, The Hague

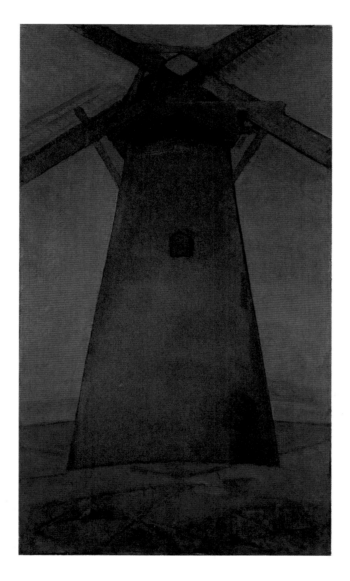

66 **The Mill at Domburg (The Red Mill)** 1910
Oil on canvas, 150 x 86 cm
Gemeentemuseum, Slijper Collection, The Hague

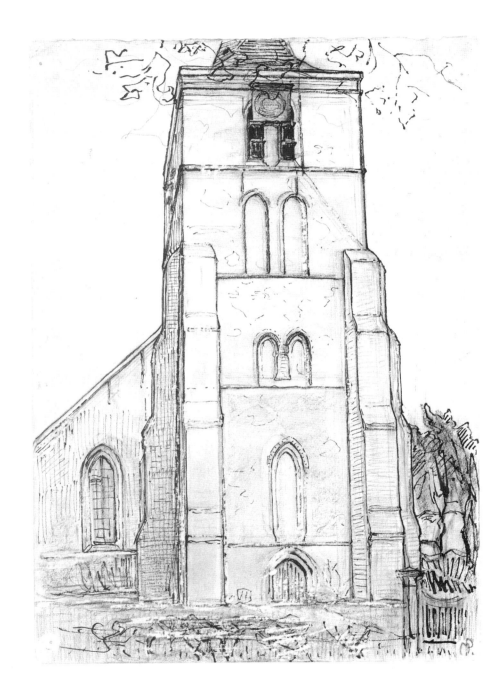

67 **The Church at Domburg** 1909
Ink on paper, 41.5 x 29 cm
Gemeentemuseum, The Hague

evolution of spiritual enlightenment. At left a woman raises her face in meditation, at right her inner experience is indicated by geometric, coloured forms appearing, like an aura, beside her. In the larger, central panel she is transformed into a spiritual being as her enormous eyes open upon mystical enlightenment. The symmetry of the figure in each panel recalls that used by Mondrian in the lighthouse, mill and church paintings **64-6** but now spiritual aspiration is associated with a simplified human form which in the side panels incorporates the rising triangular chevron-shape in shoulders, chin, mouth and slant of eyes. In the centre panel there is another movement also as the head levels and the wide circular eyes open directly forward.

Details of these paintings permit a specifically theosophical interpretation. The very theme of evolution was itself basic to Blavatsky's view of the structure of the world, the cosmological system that she discussed in detail in her writings. In Theosophy the upward-pointing triangle (the sign of Siva) represented fire, as it did in alchemy, while the downward-pointing triangle represented its opposing element, water (the sign of Vishnu).[10] Odd numbers were associated with divinity,[11] and the triangle, as the simplest perfect geometric figure, illustrated the trinity, the unity of three forces in one form.[12] Again the interlacing of upward and downward triangles into the six-pointed star illustrated the interaction and balance of oppos-

ing elements, and signified the generative force of the world.[13]

All of these forms are used by Mondrian in the triptych **Evolution**. The figures' nipples, for example, begin at left as triangles pointing earthwards; at right they are square; in the centre they form triangles pointing heavenwards. For theosophists, the world comprised matter, intellect or consciousness, and spirit or divinity, all interconnected in a dynamic evolving fusion. In the first (left) panel the effusions resembling the six-petalled amaryllis by the figure's shoulders are red and black with downward-pointing triangles. In Theosophy red was earthbound and sensual in its significance. In the second (right) panel the six-pointed star emerges, signifying understanding of the world as the generative conflict of opposing forces. It symbolizes unity in diversity and the blue associated with divinity emerges, while in the centre white reveals insight, an emptiness that is full of all potential.

Evolution abandons observation for an explicit image of mystical enlightenment, where spirit and matter interreact in a timeless and placeless space. The upward-pointing triangle and the downward-pointing triangle were more than mere visual forms to Mondrian by 1910, however; his recurrent use of these motifs in his early paintings had made him so familiar with their effects of movement in composition that he was perfectly placed to extend the philosophy to

68 **Evolution** 1910-11
Oil on canvas, triptych: side panels 178 x 85 cm,
centre panel 183 x 87.5 cm
Gemeentemuseum, Slijper Collection, The Hague

which he was attracted not only into the subjects of his painting but to reveal their actual visual interaction. This may explain in part the compositional similarities of, for example, **The Mill 66** and **Evolution**, as well as his shift of strategy from depicting a particular time and place to a monumental representation of the sea, lighthouse, mill, church and figure.

Evolution personified mystical theosophical enlightenment. Its other-worldly timelessness illustrated the process of Blavatsky's cosmology which also sought a structure of the world beyond time. The intersecting triangles could also, according to Blavatsky, signify male and female, or spirit and matter, opposing forces which interact to form the world.[14] She identified the vertical as male and the horizontal as female, so that the upright cross also indicated their interaction and union.[15] All of this could be related by Mondrian to his painting, even retrospectively to works executed before he joined the Theosophical Society in 1909. The horizontal surface of sea meeting sky was intelligible, in theosphical terms, as a female image, whilst the tower and mill against the sky were vertical and male. Within the central panel of **Evolution**, descending triangles meeting rising tri-

angles indicated, in Theosophy, the interaction of matter and spirit, the understanding and awareness of which led to spiritual evolution. Ostensibly abstruse, obscure and mystical, these theories and beliefs laid the basis of Mondrian's own philosophy which, uniquely, he developed through the practice of painting. He simplified and edited his means to maximize the clarity and force of his image, not to illustrate or refer to theory. His aim was to provide visual examples of the opposing forces with which (like the ancient philosophers, alchemists and theosophists he studied) he sought to discern an underlying structure in the world; he offered a vision of the cosmos which had ancient as well as contemporary roots, and which in its sense of harmony and rhythm could also be taken as a framework for the construction of Utopia.

In **Evolution** Mondrian no longer provided an illusion of a window upon the visual world. Observation, however, was to remain vitally important to him. Yet in returning to observation, he sought first of all new means to express his understanding of pictorial structure. Turning his back upon the flat fields of Holland, he departed for Paris on 20 December 1911.

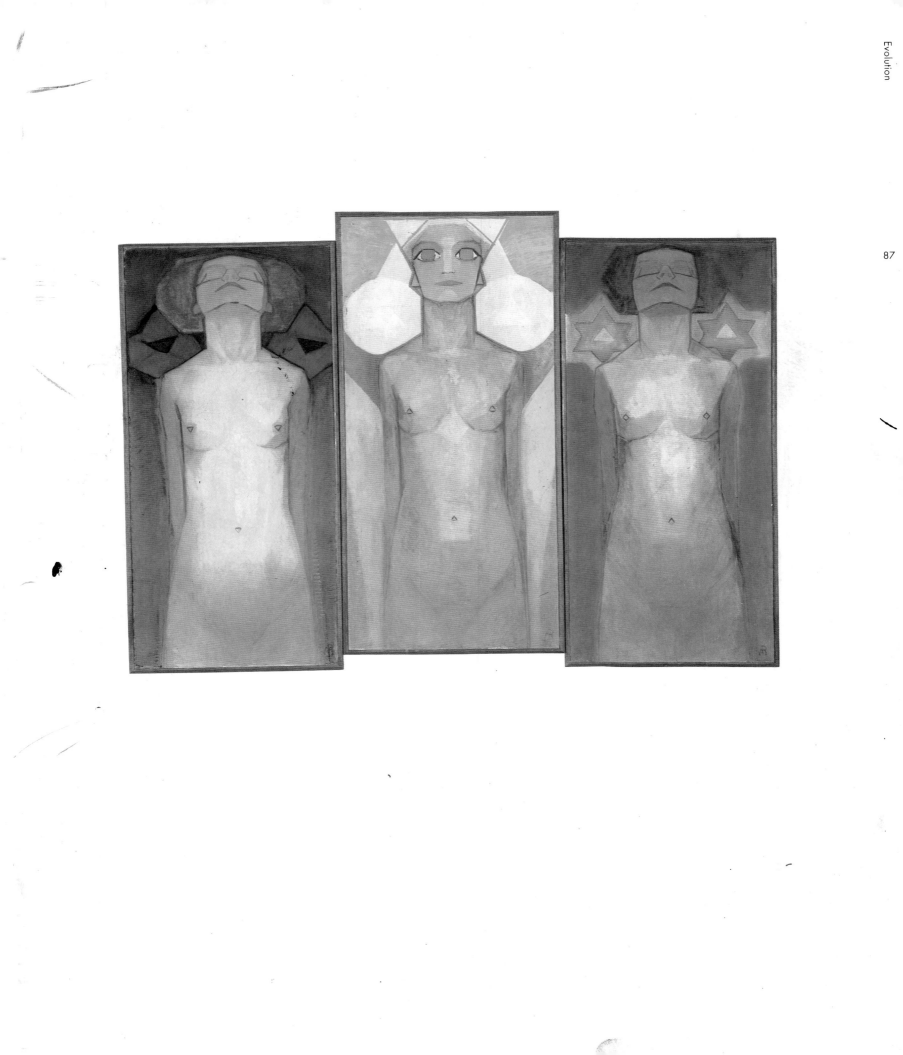

A Cubist in Montparnasse

3

69 Mondrian and Lodewijk Schelfhout at
26 rue du Départ, Paris, c.1912
Photograph
Gemeentemuseum, The Hague

On arriving in Paris, Mondrian moved into a studio at 26 rue du
Départ near the Montparnasse railway station. The studio had been
lent to him by his friend the painter Conrad Kikkert, and another
Dutch painter, Lodewijk Schelfhout, who frequented the cafés of
Montparnasse where painters and writers gathered together, also
lived at this address; at this time, too, Mondrian met the painter Van
Dongen. However, he did not limit his study of painting to that of
Dutch compatriots. Paris in 1911 was in the throes of artistic revolu-
tion, and the duration of Mondrian's visit, 1911-14, witnessed the
most diverse and international maelstrom of artistic talent and theory
that the city had ever seen. Central to all of this was Cubist painting.

Before going to live in Paris, Mondrian had already submitted a
painting, **Sun**, to the Salon des Indépendants, and while he was still
in Holland his painting revealed a knowledge of pointillist and Fauve
techniques; furthermore, the *Moderne Kunstkring*, of which he was a
founder-member, itself had international aims. Its first exhibition, from
6 October to 10 November 1911, gives an insight into Mondrian's
potentially extensive knowledge of recent French painting before his
arrival in Paris. The exhibition included works by Picasso and Braque
(up to 1908-9) and Le Fauconnier, as well as Herbin, Dufy and

70 **Still Life with Ginger Jar I** 1911-12
Oil on canvas, 65.5 x 75 cm
Gemeentemuseum, Slijper Collection, The Hague

71 **Still Life with Ginger Jar II** 1912
Oil on canvas, 91.5 x 120 cm
Gemeentemuseum, Slijper Collection, The Hague

Derain. Cubist works by Schelfhout were also shown. Mondrian exhibited pointillist paintings and **Evolution**, but the core of the exhibition was devoted to twenty-eight paintings by Cézanne; Toorop discussed Cézanne at the opening. It is scarcely surprising that Mondrian's new Parisian paintings responded precisely to Cubist practice approached first and foremost via a study of Cézanne.

Still Life with Ginger Jar I 70 was a new start in a new context, and the first painting that he signed 'Mondrian' instead of 'Mondriaan'. A total contrast to the mystical world of **Evolution** in favour of an intellectual study of pictorial structure, it referred perhaps in its very objects to Cézanne's still lifes with ginger jars. Having abandoned the overtly mystical imagery of **Evolution**, Mondrian was content with domestic objects in a studio interior. His subject-matter was no longer original, and apart from the central focus of the almost circular jar, his composition owed more to French precedent than to his Dutch background. Even the spatial device of the diagonal line on the foregound table edge has its origins in the knife used in this way by Chardin, Manet and Cézanne. On the other hand, Mondrian wrested a firm structure from a seemingly casual assemblage of objects, and the contours of objects are emphasized throughout the painting to provide this structure. In a sense they are the heirs to Cézanne's technique of linking foreground and background through conjunctions of lines. Mondrian, in responding to Paris, appears to have jettisoned his recent achievements completely in order to reassess the conventions of French pictorial construction. His newly adopted techniques reveal him tuning in to current Parisian theory and practice, with nothing ostensibly symbolic in his subject.

This sudden change of priorities led to wholly new developments. Already in **Ginger Jar I** the planes are simplified so that they interlock in a structure which effectively unifies the heterogeneous mass of detail. While there are indications that Mondrian was reassessing conventions employed by Chardin, Manet and Cézanne, he was also simplifying his painting into broad planes of colour demarcated by a network of firm lines. In this the Parisian Cubists' own development of these conventions is visible. Mondrian was becoming less and less isolated as a painter; working in Paris he rapidly responded to the current debate on the nature of painting and representation.

Still Life with Ginger Jar II 71, which is larger than its forerunner, reveals both Mondrian's debt to Cubism and his independence. The subject is substantially repeated, but the artist's method of depicting it has radically changed. The round jar remains central and the foregound fold is preserved. Now, however, the surfaces and planes of objects abut side by side across the painting. Only the clear blue of the jar and the white of the cloth are easily recognized as objects. Around them in subdued, greyed colours of similar tones different objects become indistinguishable and are reduced to a series of simplified interconnecting contours. The triangular forms at right of centre and the structure at left are now unidentifiable. These are not quite the broken faceting of paintings by Picasso or Braque, and this is not pastiche. Mondrian's concern for the frontal view and the flattened picture space is much in evidence, and his colour emerges from grey into areas of blue, red and yellow. The lines which in the previous painting clearly defined the edges of separate objects now lock into a mosaic of closed flat shapes dominated, except in the central jar, by the vertical and horizontal.

In 1912 Mondrian's study of Cubism intensified and he was now exhibiting internationally - at the Sonderbund exhibition in

72 Piet Mondrian, c.1912
Photograph, Robert Welsh
Gemeentemuseum, The Hague

Cologne and the second *Moderne Kunstkring* exhibition in Amsterdam. In Paris he met Fernand Léger, and also became friendly with the pianist and composer Jacob van Domselaer. The meeting with Léger was important: Mondrian later expressed particular admiration for this artist who, among all the Parisian Cubists, most clearly conceived forms strengthened by contrast and was learning to treat colour as a material factor in painting, frequently reducing his range to red, yellow and blue, plus black, white and grey. Léger was also committed to a rhythmic evocation of the fast tempo of contemporary urban life. On the other hand, he seems to have remained aloof from close personal involvement with the many and diverse Cubist artists in Paris, despite exhibiting among them at the Salon des Indépendants from 1912 to 1914.

The novel influences and highly-charged ambience of the French capital may well have contributed to the changes that Mondrian wrought in his personal appearance around this time **72**. He shaved off his beard and wore his hair shorter. A certain simple elegance began to emerge. He now appeared as an urban, well-groomed figure of distinction, an image he continued to cultivate throughout his career.

By way of complement to this significant change in his personal style, two paintings of women **73-4** reveal the enormous change which Parisian art had brought about in Mondrian's painting. They are scarcely recognizable as having been executed by the same hand that had painted the **Evolution** triptych so recently in Holland. In each of them a figure constructed of flat planes emerges from dark surroundings. The flattening of forms recalls the Cubism of Gleizes, Metzinger and Le Fauconnier, as if Mondrian had, for experiment's sake, adopted the technique consciously to explore its effects. As in

the **Ginger Jar** paintings he seems to have studied the new means by manipulating techniques and devices borrowed from other painters, even suppressing colour, as several Parisian Cubists were doing at the time.

The **Nude 74**, a subject rarely attempted by Mondrian, is a whitish figure emerging from surrounding planes of dull grey-green. The structure of lines resolutely adheres to the picture plane; only tone suggests emergence and depth. Similarly, the artist's favoured frontal view is evident again in the figure and in the planes which surround her. Even the breasts and shoulders are defined by straight lines. There is little comparison possible with the female figures of **Evolution** until the face is considered. Although Mondrian has ruthlessly divided the face vertically into the lit and shaded halves, the deep, wide eye which stares out from the shadow is recognizable as the eye of the central figure in **Evolution**.

Mondrian embraced Cubism to develop new techniques. The image which he had recently presented with such force and directness was now less accessible, less easily recognized. Painting as a window upon the world seems to have been abandoned in favour of painting which stressed technique at the expense of image, asserting that painting was an object in itself. But the image in **Nude** still has considerable force through the figure's gaze and through the dark, framing planes which present the glowing pale torso.

The tension between the powerful images of the period 1908-10 and the new period of Cubist experiment in 1911 was resolved by Mondrian the following year. The strategy he employed was to return to the potent images of his earlier work, to the motifs of the single tree and the facades of buildings – images of nature and also of man-made structures, which in Paris meant the high blocks of

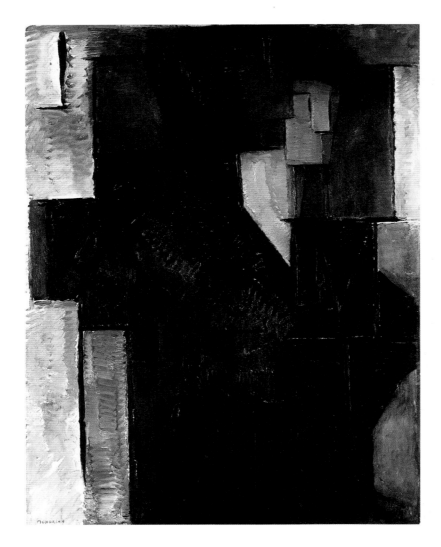

73 **Female Figure** c.1912
Oil on canvas, 115 x 88 cm
Gemeentemuseum, Slijper Collection, The Hague

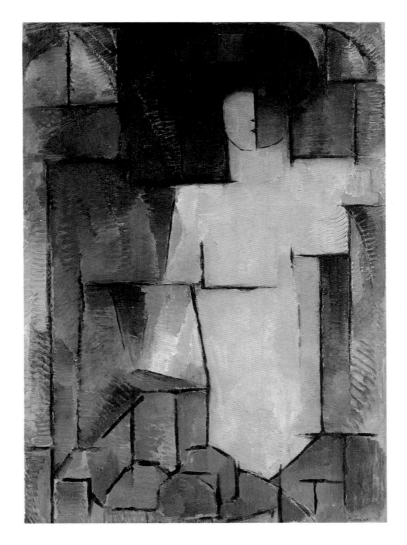

74 **Nude** 1911-12
Oil on canvas, 140 x 98 cm
Gemeentemuseum, Slijper Collection, The Hague

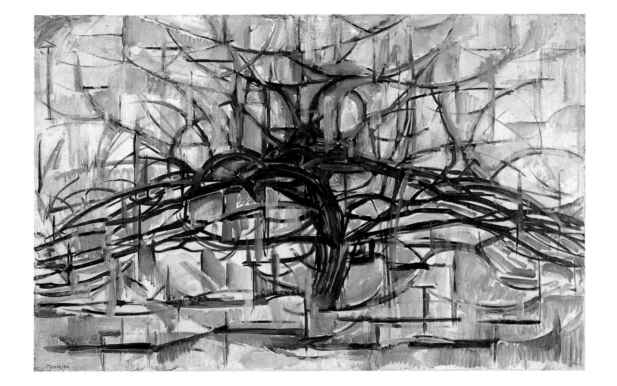

75 **Tree** 1911-12
Oil on canvas, 65 x 81 cm
Munson-Williams-Proctor Institute, Museum of Art,
Utica, New York

apartments near his studio in Montparnasse.

The result of this synthesis was to realign Mondrian's new work with his earlier long development. Continuity was re-established. He no longer turned his back wholly upon his earlier achievements. His evolution embraced both change and continuity. It also made him a Cubist of real originality, reasserting a meticulous independence amongst the deluge of innovations that characterized Cubist Paris at the height of its activity.

The **Trees 75-81** of 1912-13 relate directly to the earlier painting **The Red Tree 52**. The new impact of Cubism is evident but so, too, is Mondrian's originality. These trees have a trunk which now arches to the left but essentially Mondrian is addressing the same image. **Tree** of 1911-12 **75** makes a revealing comparison with **The Red Tree**. The faceting of the background is not dissimilar to that of **Ginger Jar II**, while the tree itself is handled differently, retaining the curvilinear branches evident earlier - though now the individual detail, described branch by branch in **Red Tree**, has given way to lines which provide, above all, the tree's rhythmic extension into surrounding space, curving in a taut arc across the painting. Mondrian also retained the upward thrust at top centre. Compositionally there are

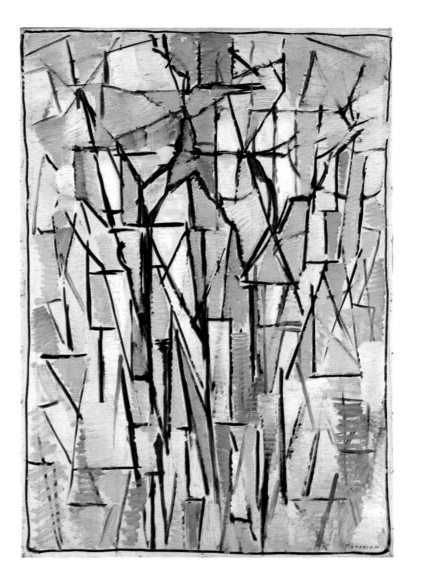

76 **Composition with Trees II** 1912
Oil on canvas, 98 x 65 cm
Gemeentemuseum, The Hague

close similarities, but Cubism has led him to relinquish detail and to isolate rhythm. The curved, organic cross motif is clearer as a result, and reveals an implied circle of lines around the centre of the painting and the core of its image. This hints at a cross within a circle central to the canvas, a form with theosophical significance: divinity divided into the four elements of earth, air, fire and water, produced by the complementary duality of male (vertical, spirit) and female (horizontal, matter).

Although Mondrian's composition and imagery are no longer explicitly theosophical in inspiration, his continued fascination with growth and interacting forces remains apparent. It is not, however, simply a question of illustrating an idea diagrammatically. The rhythms of Mondrian's painting resolve the actual visual tensions of the painting. A close study of Cubism permitted him to step away from depiction in detail to manipulate more freely the mechanics of his painting. In this process of generalizing and simplifying, he found a way to depict rhythm as an underlying structure in what he saw. Paradoxically, observation remained centrally important to achieve this. But it was the rhythms of the painting viewed as an independent object that allowed him to isolate his chief concern. In other words,

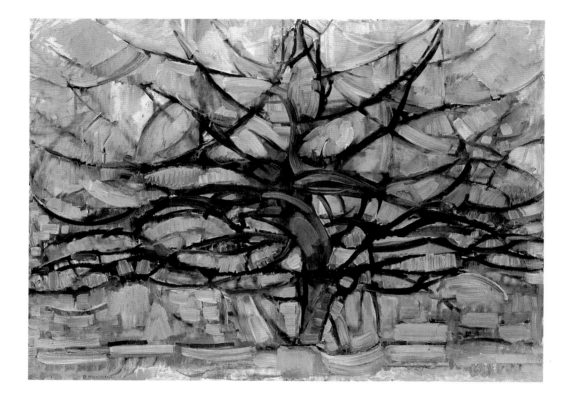

77 **Grey Tree** 1912
Oil on canvas, 78.5 x 107.5 cm
Gemeentemuseum, Slijper Collection, The Hague

he used Cubism to his own ends and what linked his tree to the real tree, which perhaps grew in the Luxembourg Gardens, was rhythm, a familiar priority for Mondrian and compatible with his mystical studies.

This process of refinement made the image more difficult for the viewer to recognize. **Grey Tree 77** rehearses the **Red Tree**'s entanglement of foreground and background, and its reduced colour range, a topical device amongst other Cubists, further emphasizes its linear rhythms. The examination of the role of the image, characteristic of much Cubist debate and experiment, here centred upon a

living object which, expanding upwards and sideways, began to establish an oval form, leaving the corners of the canvas less busy and less worked. In this, too, Mondrian was following Cubist practice in a format employed by Picasso, Braque and others.

As Mondrian's own Cubist techniques evolved, the image of the tree provided a kind of armature within the painting, organizing the relationships of the rhythmic arcs and almond-shaped spaces which they encompassed. **Apple Tree in Flower 78** has no recognizable flowers and the tree is not easy to discern, yet its image remains central and plays an important role in co-ordinating the rhythmic

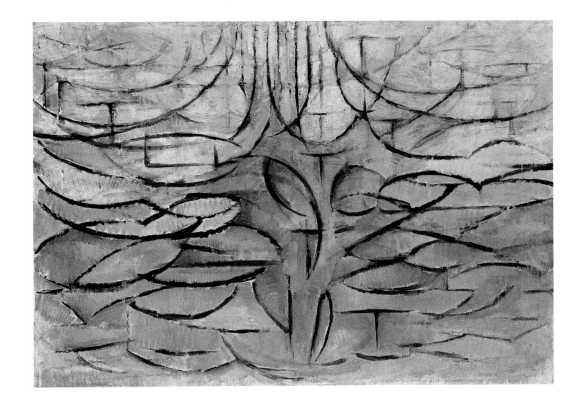

78 **Apple Tree in Flower** 1912
Oil on canvas, 78 x 106 cm
Gemeentemuseum, The Hague

structure, even if it is less accessible to recognition. Background and foreground fully interlock, and Mondrian has employed only the straight line and elliptical curve to construct the intersecting planes of his painting, even to the extent of opening up the previously solid tree-trunk. This is a painting of balance which suggests symmetry through a multitude of planes. It is unified by the use of repeated shapes and the presiding, underlying image of the tree. The near symmetry, the central emphasis, and the frontal viewpoint are all characteristic of Mondrian. To them, through his study of Cubism, he has added the theme of expansion and a new relationship between

depiction and painting. He has struck a new balance between an illusionistic representation of the observed tree and the isolation of its rhythms through lines and planes of paint. His new achievements appeared at the second exhibition of the *Moderne Kunstkring*, Amsterdam, in October and November 1912, when he exhibited both **Still Life with Ginger Jar II** and **Apple Tree in Flower**.

These paintings are complemented by a series of upright canvases of trees in which the image becomes progressively less easy to identify. The upright format has a compositional effect too, for the arching, drooping branches which formerly reached out laterally to

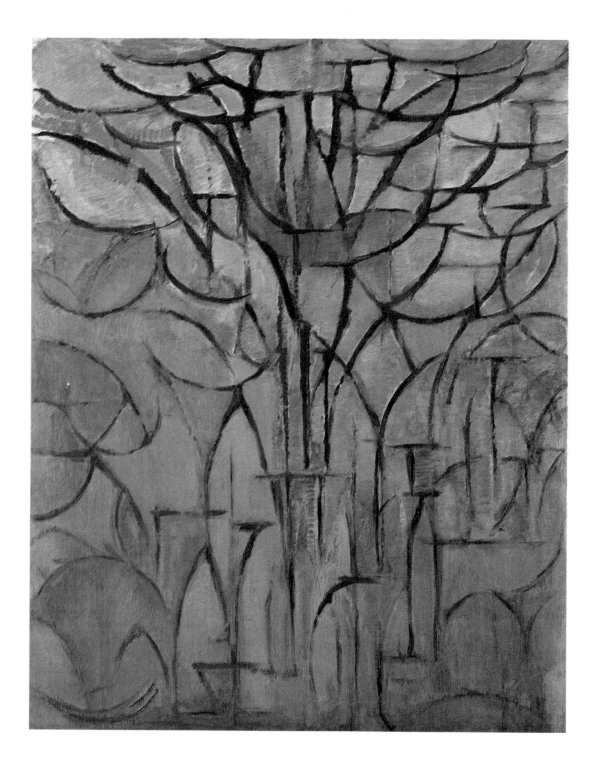

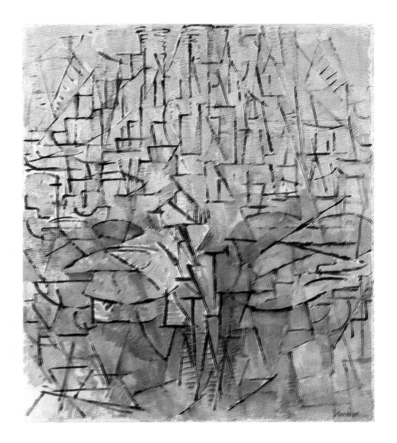

the painting's edge can no longer be accommodated. Instead, the upward surge of the tree is paramount. **Tree** of 1912 **79** again places almond-shaped planes against a background of rectangles (compare **75**), but the rush of growth is predominantly upwards, levelling out only at the crown of the tree and the top of the painting. Rotating the direction of the canvas completely changes the relation of the tree image to the format. There are few, if any, lines suggesting downward movement and the rising effect in a near symmetrical painting recalls pre-Parisian works such as **The Mill** and **Church at Domburg 65-6**.

In subsequent paintings the image of the tree is so diffused among a multitude of small planes and lines that it is almost invisible.

Indeed, a painting closely related to these canvases is entitled simply **Composition No. 3 80**. Only knowledge of related works makes the tree-trunk identifiable (lower centre). The branching lines move up and outwards with a discernible rhythm but it is doubtful whether this painting, seen in isolation, recognizably depicts a tree. Mondrian learnt from Cubism how to facet his forms but he also flattened these planes on to the picture surface, as he had begun to do in **Ginger Jar II**. These planes also diminish in size and increase in number, while the lines so dominant, for example, in **Apple Tree in Flower 78** become short and staccato, terminating frequently in a crossing perpendicular. Only their general disposition gives the broader rhythms of trunk, branches and background. The fusion of

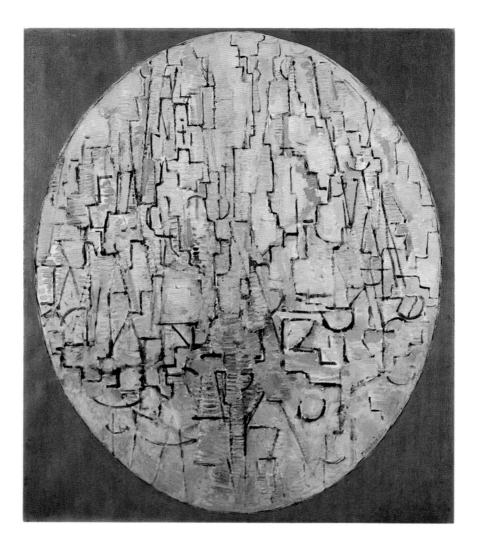

81 **Oval Composition with Trees** 1913
Oil on canvas, 94 x 78 cm
Stedelijk Museum, Amsterdam

foreground and background was almost complete.

This development culminates in **Oval Composition with Trees** of 1913 **81**. It is possible that Mondrian adopted the oval format from Picasso or Braque who used it frequently, but it was also emerging as a compositional feature of his own paintings, as **Grey Tree** revealed. The oval also had a theosophical purport signifying the original cosmic energy, according to Madame Blavatsky.[16] Here the oval is upright and contains a myriad of muted, yellow ochre lines and planes which constantly interrupt each other forming, uniquely, a

kind of zigzag passage across the canvas. There is little trace of the trees. The image has wholly succumbed to rhythm, and depiction has become secondary to construction in the painting. Undoubtedly the image was important – it is preserved in the title – but where it is embedded in the painting is difficult to indicate with certainty. If this painting began with the observation of trees in Paris, then by the time that it was resolved and completed, Mondrian was observing the interaction of the lines and planes of his painting more intensively than the particular branches of a living tree.

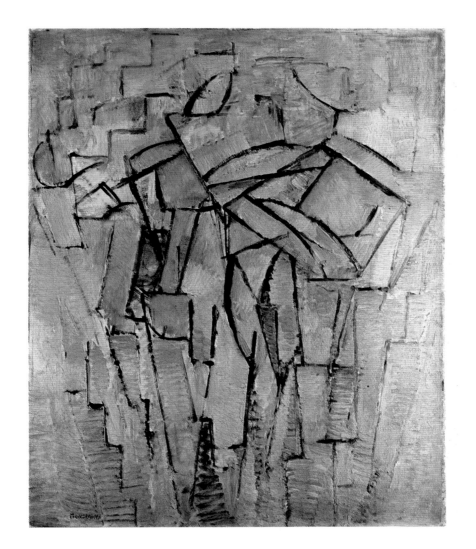

82 **Composition in Grey-Blue** 1912-13
Oil on canvas, 79.5 x 63.5 cm
Thyssen-Bornemisza Collection, Lugano

It should be admitted that in suppressing his image to this degree Mondrian was not alone. During the previous year Braque and Picasso had reached a point of comparable illegibility, but their adoption of lettering and collage had effectively recalled the image from near oblivion by referring directly to its presence and identity. Mondrian did not pursue this path. Apollinaire, poet and apologist of Cubism, seeing work by Mondrian in the 29th Salon des Indépendants noted:

'the highly abstract Cubism of Mondrian – he is a Dutchman and one should not be surprised that Cubism is already represented in the Amsterdam Museum; here people mock the young painters, but there the works of Georges Braque, Picasso, etc. are shown alongside Rembrandt. Although Mondrian takes his inspiration from Cubism, he does not imitate the Cubists. It seems to me that he is influenced by Picasso, and yet his personality remains entirely his own. His trees and his portrait of a woman display a very sensitive intellectualism. That form of Cubism appears to me to take a different direction from that of Picasso and Braque'.[17]

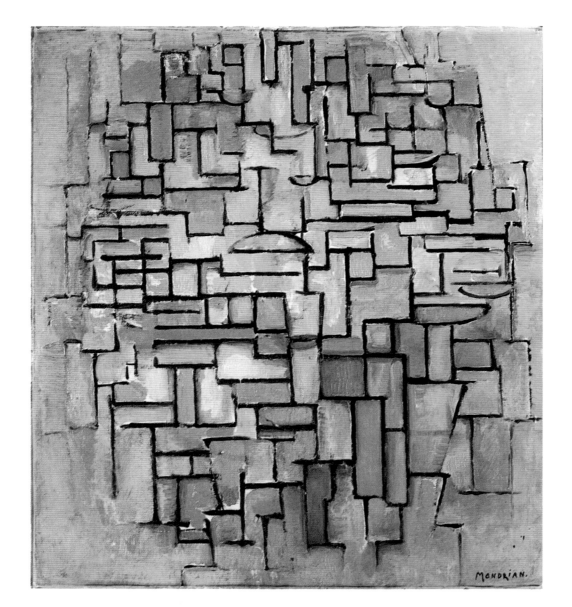

83 **Facade in Tan and Grey** 1913-14
Oil on canvas, 85.7 x 75.6 cm
The Museum of Modern Art, New York (Purchase)

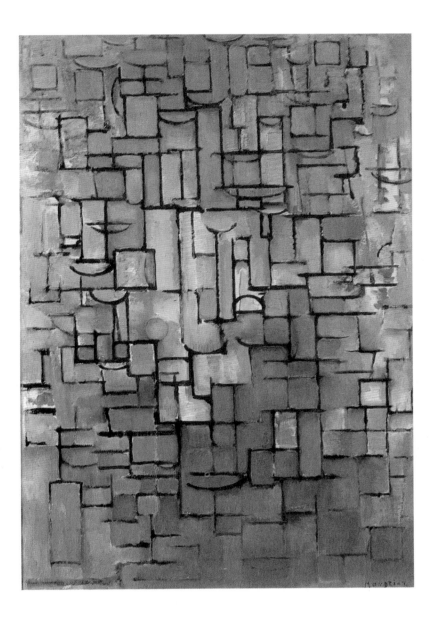

84 **Composition No. 14** 1913
Oil on canvas, 94 x 65 cm
Stedelijk van Abbe Museum, Eindhoven

85 **Paris Buildings (rue du Départ)** 1912-13
Pencil, 23 x 25 cm

Mondrian also exhibited in the First German Autumn Salon *Erste Deutsche Herbstsalon* in Berlin and at the *Moderne Kunstkring* in Holland, where the Dutch critic H. P. Bremner bought two paintings, thereby instigating a valuable financial liaison for Mondrian.

In the long sequence of paintings of facades which preoccupied Mondrian in 1913 and 1914, the issue of how to reconcile observed image and pictorial structure remained of paramount importance and the oval format continued implicit or actual in almost all of them. In **Facade in Tan and Grey**, for example **83**, a cellular structure is constructed almost entirely of horizontal and vertical lines, so that the planes which the lines enclose remain parallel to the picture plane: they are assembled across the canvas. Within this otherwise homogeneous framework two diagonals (lower right) and a few horizontal elliptical curves appear. Larger planes dominate the lower half of the painting while horizontal lines flank the centre, and smaller planes occupy the upper space. Mondrian's structure is quite

clear to the eye and has little about it that is vague. The multitude of small planes is assembled in such a way that a more general vertical or horizontal emphasis predominates in different sections of the canvas. This arrangement approaches but avoids symmetry and assumes an overall oval format.

The facade of the title is not easily recognized. It could scarcely be identified in the street from the information Mondrian has provided in the painting. It might be assumed from this that direct observation was no longer important to him and that he concentrated entirely upon organizing the painting in his studio. Drawings of the period disprove this **85**.

It is likely that a painting such as **Composition No. 14 84**, with a cellular structure assembling small flat planes into a gently oval format, was the result of direct observation followed by a period in which pictorial structure became Mondrian's prime concern. Just as the tree motif, a natural form, was reduced to an essential rhythmic

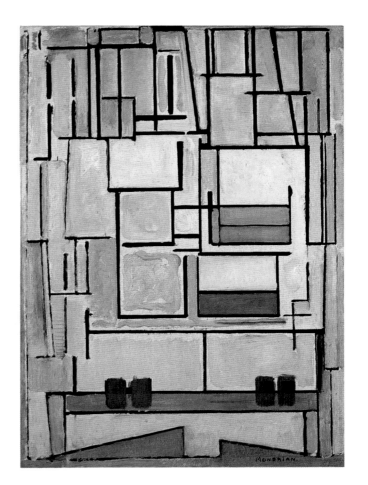

86 **Composition No. 9 (Blue Facade)** 1913-14
Oil on canvas, 95.2 x 67.5 cm
Private Collection

structure from which all specific detailed description had vanished, so these facades appear to have been edited and refined by his theme. Beginning with descriptive drawings of buildings near his studio in Paris, he flattened and adjusted their planes until only their rhythm was preserved. In this way he identified for the first time the urban rhythm of the street or boulevard as his subject. The piled-up, overlapping and largely rectangular planes were a response to what he saw, but stripped of detail to indicate the underlying rhythm of the city's construction with its multitude of apartments, facades, gable-ends, advertisements and traffic.

In his study of buildings **85** Mondrian found a counterpoint to his contemplation of nature. Both grew and decayed. The tree was a single image composed of many parts, and so, too, in its different way was the city. Both revealed an evolving life cycle: neither was static. The rhythms refined by Mondrian reveal their differences and similarities. He was still concerned with man's dual identity: a part of

nature and yet separate from it, making his own constructions of buildings and cities, to produce an environment that is artificial and not natural. Observing the mill in the landscape, the artist had counterposed man against nature, locked in confrontation. But in the metropolis, the tree was exceptional and the boulevard was the norm. In the city human construction was dominant.

To observe the vitality of urban life was to isolate rhythms distinctly human, the result of conscious planning and construction. This was the city, after all, of Haussmann's wide boulevards and Eiffel's immense iron tower, itself a monument to human ingenuity and the engineer's control of natural forces.

Composition No. 9 (Blue Facade) 86 most clearly reveals Mondrian's working procedure in which observation, first of his motif and then of the structure of his painting, strikes a remarkable balance. This painting has no curved lines, but a drawing related to it shows a softer, more tentative beginning. The subject of the

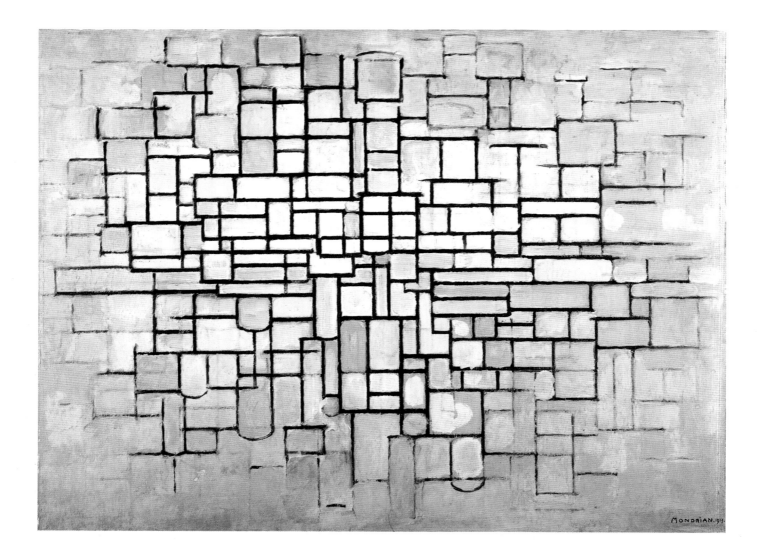

**87 Composition in Blue, Grey and Pink
(Composition in Line and Colour)** 1913
Oil on canvas, 88 x 115 cm
State Museum Kröller-Müller, Otterlo

drawing is directly observed and easily identified. It shows part of a block of apartments in Paris, on the side of which demolition has exposed interior walls decorated in various colours. All that remains of these human habitations are panels of paint and wallpaper around doorways and fireplaces. Mondrian indicated their colours by small letters (B for blue, for example) written in the rectangles. But if the subject of the drawings is readily recognizable, the resultant painting is less easy to interpret. Perhaps attracted to this facade by its resemblance to his recent paintings, or even as an image of the cyclic decay and regeneration of the city, Mondrian has edited and developed the planes of his drawing. By reference to this, the tall sloping lines can be identified as roof-lines and the two pairs of small dark rectangles near the lower edge are evidently chimney-pots. Between them hang the planes of the former rooms' walls, planes which here Mondrian sometimes leaves open with their lines intersecting, yet within them he has placed areas of colour which appear to expand tentatively towards these peripheral boundaries. The planes are large and retain the monumentality of the buildings which the artist observed through his studio window or in the streets of Montparnasse. Clearly these buildings provided the framework of his painting, and observing them was essential source-work.

When Mondrian turned to concentrate upon the structure of his painting he had further drawings to guide him. Observation and composition were inextricably linked, as he moved from the specific and detailed to the underlying structure of his subject. Since rhythmic structure determined the final phase of his painting, his reliance upon observation was obscured. His process of working, however, makes the importance of observation undeniable.

The horizontal canvases of 1913 share a similar rhythmic struc-

ture. In isolating the rhythms of the city and its dynamic restlessness, Mondrian evolved several formats for his paintings which he adopted and reworked in response to different aspects of the city.

Composition in Blue, Grey and Pink 87 organizes its rectangular planes into a cross motif. This is achieved by assembling a preponderance of horizontal planes in one direction and of vertical planes in the other, with almost square planes elsewhere. Without painting in these axes as single continuous lines, Mondrian has revealed a tendency towards them and as a result they act as visual focal rhythms in the painting. It is not the flat planes themselves but their proportions, positions and therefore their relationships which provide a rhythm that clearly exhibits both an overall organizing structure and a multiplicity of variations in every part. This cross-form has been seen in his windmills **31-2** but it also had meaning for theosophists who identified its elements as male and female, conflicting forces making up the diversity of life by their shifting relationships.

Mondrian admired Picasso's Cubism, and evidently Cubist techniques helped him to establish a painting as an object with a visual structure of its own which could refer to recognizable imagery without illustrating it. But although, as mentioned above, Mondrian's restricted colours and oval format find precedents in the Cubist works of Picasso and Braque, there are nevertheless important differences: he did not pursue lettering or collage; his frontally presented planes rely increasingly upon the vertical and horizontal; and he excluded all suggestions of depth in the cellular structure of his painting, which was unified by the similarity of its parts and its underlying rhythm. In the facades the rhythms are urban but they are still compatible with a continuing interest in Theosophy. The theme of man's place in nature is quite distinct from many Cubists' concerns, but its converse, the

110

88 **Composition in Grey and Yellow** 1913
Oil on canvas, 61.5 x 76.5 cm
Stedelijk Museum, Amsterdam

celebration of the dynamic city, was enthusiastically embraced by many contemporaries (from Italian futurists to Léger and Delaunay) among adherents of Parisian Cubist painting.

Composition in Grey and Yellow 88 is a wide cityscape. Its rhythms resolve into a T-shape, rather than a cross. The letter T indicates termination, according to the theosophist Blavatsky,[18] and it is likely that this painting is based upon the railway terminus of Montparnasse, close to Mondrian's studio at 26 rue du Départ.[19] The lines rush up the centre of the painting and are terminated by a level emphasis along the top. Blavatsky evolved a theory, but Mondrian presented a visual phenomenon. The lattice-work motif along the top edge is perhaps a railway bridge or other iron structure, and the almost square shapes left and right of centre suggest buildings. Short lines end in perpendicular stoppages, and so repeat the main compositional theme with a corresponding emphasis upon lines terminated at the top. Finally, a sequence of elliptical curves intersect the irregular grid; these are perhaps derived from overhanging structures. They appear to rise from the lower right up to the central axis before dispersing. Mondrian found in this urban theme an equivalent to the rhythmic structure of the tree paintings (**79**, for example), as if the railway's rushing line up the canvas had a hidden resemblance to the trunk of a tree. As the tree dispersed into branches in the air, so the railway's purpose is dispersed into the surroundings of the city at its terminus.

While the facades adapted the building's elevation to that of the paintings **85**, it may be observed that in certain cases – **Facade in Tan and Grey 83**, for example – an effect similar to aerial perspective is achieved by an apparent recession from larger planes in the lower part to smaller planes in the upper part. In **Composition in Grey and Yellow 88** a comparable effect occurs. Mondrian rejects conventional perspective; the flatness of his planes militates against this illusion, but an element of perspective persists, an effect which the elliptical curves' diagonal progression reinforces. If there is a residual perspective at work here, its nearest equivalent is the single-point perspective of the Dutch seventeenth century exemplified by Vermeer and De Hooch, a system which itself required two dimensions of space to remain parallel to the picture plane, just as Mondrian's rectangles and curves do here.

In letters of 1913-14 Mondrian indicated that he thought of his painting as the consequence of all past art.[20] This implies an active awareness of tradition, and suggests a dialogue leading from the past into an art of the future. In a sense Theosophy had a similar aim, for by the study of diverse mystical systems of the past it sought to find the ancient roots of an ultimately new religion. Mondrian's interest in Theosophy was great enough for the Dutch mystical journal *Theosophia* to ask him for articles in 1913-14.

In the light of Cubist practice Mondrian was rapidly developing new techniques, but what he expressed with them did not necessarily mean the abandonment of theosophical thought. No other Cubist in Paris dealt with the image of the city as Mondrian did. His tendency to philosophize was not a hindrance to paintings that were as slowly resolved and reworked as these were. As the elements at his disposal (straight lines, minimal curves, frontality and so on) were reduced further into a construction of relationships, his paintings appeared to seek a basic language, a set of primary devices with which everything he wished to study could be approached. This reduction, evident in the paring down of detailed drawings, was a search for a fundamental means to describe the rhythms of the world around him. This was how he related observation to composition. He recorded the observations of his eyes in

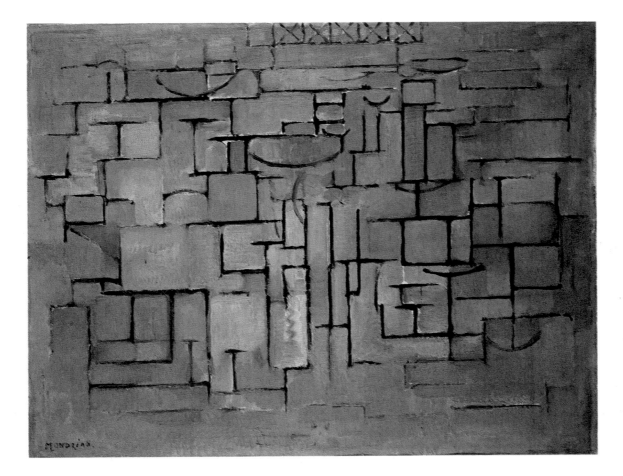

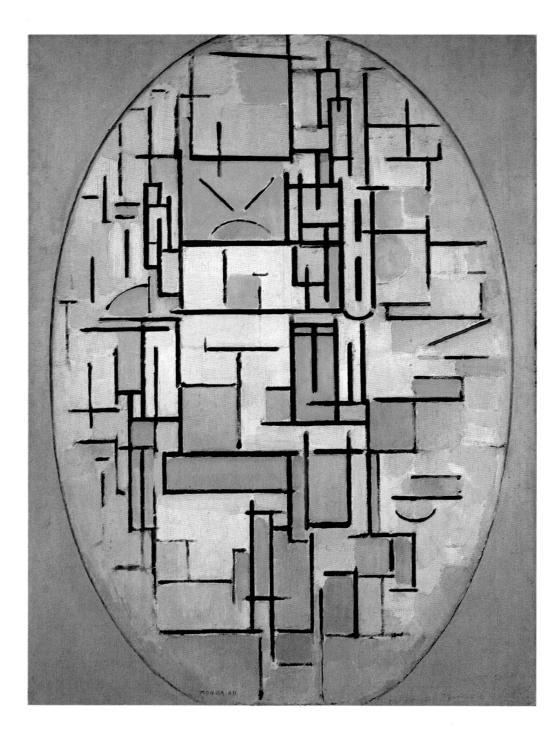

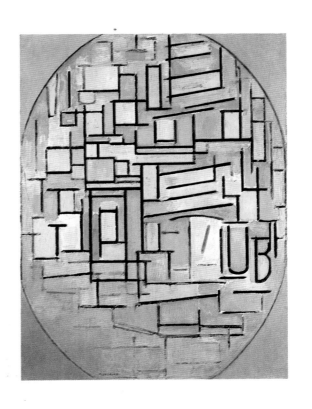

89 **Oval Composition with Light Colours
(Colour Planes in Oval)** 1913-14
Oil on canvas, 107.6 x 78.8 cm
The Museum of Modern Art, New York (Purchase)

90 **Oval Composition** 1914
Oil on canvas, 133 x 84.5 cm
Gemeentemuseum, The Hague

studies and drawings; his contemplative mind sought harmony and rhythmic vitality in composition.

A sequence of closely related oval paintings of 1913-14 **89-91** shows Mondrian's intense study of a single image. A drawing **85** shows a tall gable-end bearing advertisements towering over low, foreground buildings in the streets of Montparnasse. Though the inclusion of lettering (*KUB*) may owe a debt, and even refer, to Cubism, the drawing is clearly taken from observation. '*Cusener*' reads the upper sign, and '*KUB*', descending to the right below this, derives primarily from an advertisement for a stock-cube. The paintings based upon this image mark a departure from the preceding cityscapes.

Oval Composition with Light Colours 89 derives from the broad planes of the gable-end, compressed either side by tighter rhythms. The hoarding inscribed *KUB* is incorporated and the *U* is visible slightly to the right, above the centre of the painting. This imposing tower of rectangles is frontally viewed and, by reference to the drawing, is readily recognizable. In **Oval Composition 90** Mondrian has evidently changed his viewpoint. This painting is closer to the drawing and retains the diagonal lines caused by the oblique

view. *KUB* is more evident below centre at the right. Although *K* is reduced to a vertical line and a single acute diagonal, *U* and *B* are easily legible. The location has been identified as the junction of the rue du Départ and the boulevard Edgar Quinet in Montparnasse.[21] **Oval Composition 91**, also known as **Painting III**, is much more elaborately tesserated, although the broader planes of the gable-end still dominate and *KUB* in fragmented form appears to the right, below centre, as before.

In these three oval paintings the cityscape recovers its monumentality in the rising block of central forms around which all else clusters. Like the **Church Tower at Domburg**, which Mondrian had reconsidered in drawings close in technique to these, the monumentality of construction unifies the painting. Lines progress and are stopped along both axes. The eye, in seeking the image, runs along these lines and jumps from plane to plane. The optical experience is of continuous staccato movement, for although the building acts as an armature to which everything else is related, the eye explores the cellular structure without finding a final point of rest. Instead, it glimpses the whole towering gable and then is drawn in to examine again the intricate rhythms of the painting. **Oval Composition 91**

91 **Oval Composition (Painting III)** 1914
Oil on canvas, 140 x 101 cm
Stedelijk Museum, Amsterdam

also exhibits a new sense of colour dominated by the emergence of red, yellow and blue, though not as primary colours. Darker tones, in the lower parts, progress to lighter tones at the top, suggesting distance and atmosphere in a painting which uses flat shapes only and permits as few diagonals as possible. The smaller elements in effect frame the larger central planes, adding to the forcefulness of the work. This is a painting to explore with the eye: its effect is achieved by the position and proportion of the parts and their relation to the whole; its subtle energy arises from their shifting relationships.

Just as Mondrian's lines retained particular theosophical meaning, so the selection of red, blue and yellow may still signify, respectively, material, intellectual and spiritual forces in interplay as the theosophists envisaged. Having said this, it is also evident that Mondrian places these colours with an expert and experienced painter's eye. Their relationship is intricate and restless, defying the eye to sum up the pattern of their arrangement. There is both balance and ambiguity in this. By 1914 Léger too had made special use of red, yellow and blue together with black, white and grey in his *Contrasts of Form*, a series in which the recognizable image is undermined by the forceful pictorial contrasts that he presents. Both for

Mondrian and for Léger these colours had a special role; as they approached primary colours, so they avoided secondary colours, and traces of green, orange and purple began to disappear. Just as the straight line is an intellectual concept (as in geometry), so too the primary colours appear pure and unalloyed, the ideal state of colours to which all others relate. Mondrian had discovered this in his study of pointillism, and he now returned to the isolation of red, blue and yellow in this urban elevation.

By 1914 Mondrian had made a thorough study of Cubism in Paris, finding his way rapidly and systematically from an immediate response to Cézanne in **Ginger Jar I 70**, via responses to several Cubist techniques, to establish a position that was distinctly his own. His independence and his originality of view, practice, and achievement were not evolved in isolation. He had become a contributor to the Cubist debate. His recognition of the painting as an independent man-made object, with a significant relationship to the city he observed, freed him from depiction of what was specific and detailed, to take up an art of relationships based upon rhythm, and therefore movement, embodied in paint. The life of the city became his particular study.

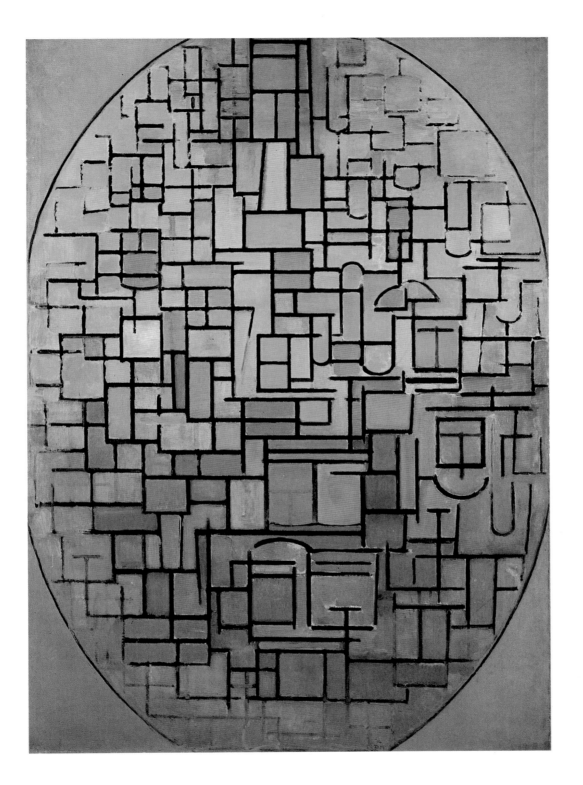

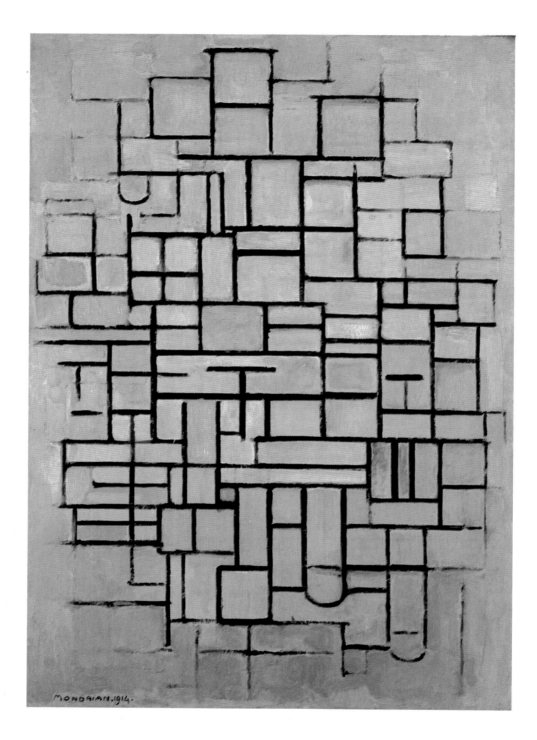

92 **Composition No. 6** 1914
Oil on canvas, 88 x 61 cm
Gemeentemuseum, The Hague

Seeking to refine the rhythms of what he saw, Mondrian began with matter-of-fact drawings of the area in which he lived. From these he evolved compositions by sustained, slow effort and many adjustments. These compositions, at their most complex by 1914, no longer showed objects but rather their rhythmic relationships, the parts within the whole, cheek by jowl across the painting – a flat plane of interlocked rectangles. This entailed reducing his means to the minimum to force relationships rather than objects into the forefront of attention. If the means were simple the relationships were complex. With straight horizontal and vertical lines he gave irregular but balanced vitality to his geometrical planes, adjusting them by intuition and experience into a new kind of image of the active city, an underlying image of its man-made artificial life.

Composition No. 6 92 and the larger **Composition No. 7 (Facade)** show both the elaboration of relationships and the accompanying simplicity of Mondrian's means. Observation and image play their role but the result is paintings of independent coherence, derived from the image but not bound by it. His observed drawings, by comparison, are unremarkable, except in one respect. They had a purpose: they were the start of the process that began with a detail of a street and ended in paintings of the city's own vitality.

This was a new kind of image requiring new means, as Mondrian noted: 'For in nature the surface of things is beautiful but its imitation is lifeless. The objects give us everything, but their depiction gives us nothing.'[22]

Holland : the art of balance

93 **Pier and Ocean** 1914
Charcoal and white watercolour on buff paper,
87.9 x 111.2 cm; oval composition 83.8 x 101.6 cm
The Museum of Modern Art, Mrs Simon Guggenheim Fund, New York

4

In 1914 Mondrian left Paris to visit his sick father in Holland, but it was to be another five years before he saw the French capital again, for the outbreak of the First World War prevented his return; he was therefore obliged to immerse himself once more in the artistic developments of Holland. His painting had altered decisively in the international milieu of Cubist Paris and he was now exhibiting internationally, showing not only in Holland, but also at the Salon des Indépendants in Paris between 1912 and 1914, and at the Cologne Sonderbund exhibition in 1912. He returned to the relative isolation of Holland as a painter excited by the city, yet the paintings and studies which followed his move were inspired neither by Paris nor by Amsterdam. They depicted the sea. Mondrian returned from the dynamic metropolis to the isolation of the beach, the eternal rhythmic balance of nature which he had studied five years earlier. The contrast could not have been greater.

Mondrian was still open to theosophical ideas. He considered that the forest (vertical theme) was male, whereas the sea (horizontal theme) was female.[23] Looking at the sea, a man saw the female aspects of his own being, for in Mondrian's words, 'the unity of positive and negative is pronounced in the artist, in

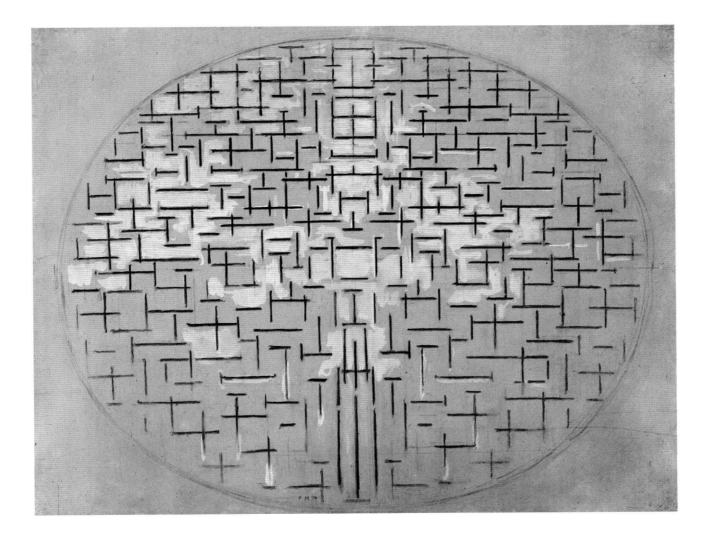

94 Church at Domburg 1914
63 x 50 cm
Gemeentemuseum, The Hague

whom both male and female elements are found'.[24]

The two major paintings, with their associated studies, which eventually resulted from Mondrian's contemplation of the ceaselessly shifting ocean marked an important stage in his development as a painter **93, 97**. Neither employed colour; the paint marks are restricted to black and white. **Pier and Ocean 93**; executed in 1914 in charcoal and white watercolour on paper, is the most resolved of the studies. **Pier and Ocean 97** which is almost the same size, is painted in oil on canvas. Both, together with other related drawings, employ the oval format recently adopted in Paris **89-91**. For Blavatsky the oval was the cosmic egg, while for Mondrian the sea exemplified the female principle. There is a similarity in these views which suggests that the oval meant more to Mondrian than simply a useful Cubist device.

Preparatory drawings of the sea played a role similar to his drawings of buildings in the streets of Paris and were only gradually evolved into the composition finalized on the canvas **97**. Mondrian retrospectively confirmed the importance of observation at this time in an autobiographical account in 1942: 'Observing sea, sky and stars, I sought to indicate their plastic function through a multiplicity of crossing verticals and horizontals.'[25] In terms of this severely reduced range of marks, which in the version painted on canvas consistently avoid making closed forms or planes of any kind, Mondrian asserted that 'Art has to determine space as well as form and to create the equivalence of these two factors'.[26]

Pier and Ocean in charcoal and watercolour **93** has a characteristic unique in Mondrian's work: it is, with the exception of one small line, *symmetrical* around its central vertical axis, a literal example of balance. The axis is marked by a sequence of vertical lines which are the only lines not repeated. There is no symmetry about the other axis of the ellipse. Horizontal lines accumulate above the ellipse's own central axis and remain fairly close above this. This is highly suggestive of perspective, indicating recession and depth even on so markedly flat a surface as this. Alternatively, it can be read as expansion in scale towards the viewer or foreground. The chief vertical focus is, however, precisely central, derived almost certainly from a man-made structure projecting away from the viewer into the sea. The cellular effect of pointillist brushmarks employed in 1909-10 is now formed by black lines, only occasionally approaching to form square enclosures. These occur up the central axis and at the sides. One central box is cut into four by a cross. The square signified immortality to the theosophists; divided into four sections, it represented the four elements of earth, air, fire and water.

How far Mondrian deliberately incorporated these meanings into his work is not known, but as a system of indicating the pulsating balance of forces that comprise the world, it was not incompatible with observation. Indeed, this point illustrates how closely Mondrian in fact clung to observation and visual stimulus, for such an analysis is not at all adequate to describe what he has achieved here. As the eye seeks to sum up the composition and resolve it into the image of an object, its attention is drawn instead to the many small points of conjunction. This creates rhythm literally in the field of vision; it is no longer symbolic imagery but actual visual experience.

Although there are no diagonal lines, diagonal rhythms occur towards the corners of the paper, formed by the crossing of lines. In this way Mondrian suggests not only movement and rhythm but also light effects, as tone adjusts with the concentration of lines and the diagonal rhythms indicate depth. Even the ellipse may be read as a

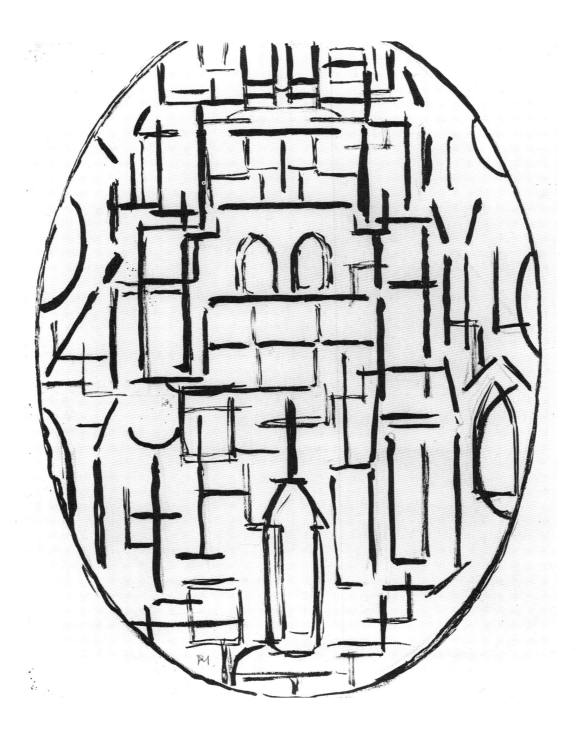

95 **Pier and Ocean** 1914
Pencil on paper, 11.4 x15.9 cm

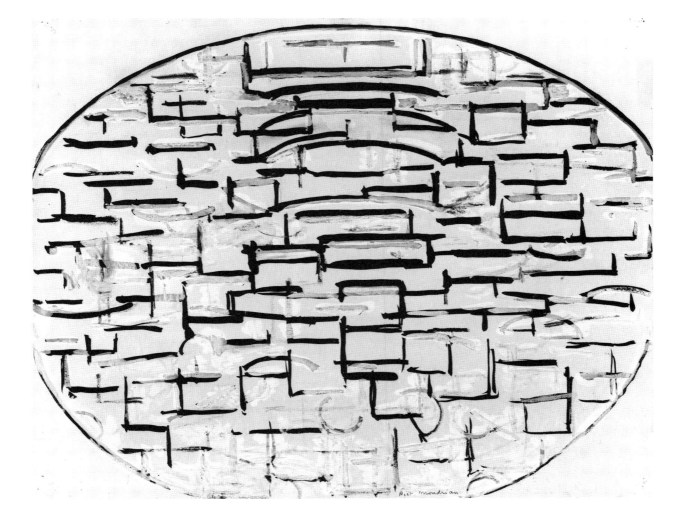

96 **The Sea** 1914
Gouache, ink on paper, 49.5 x 63 cm
Moderna Museet, Stockholm

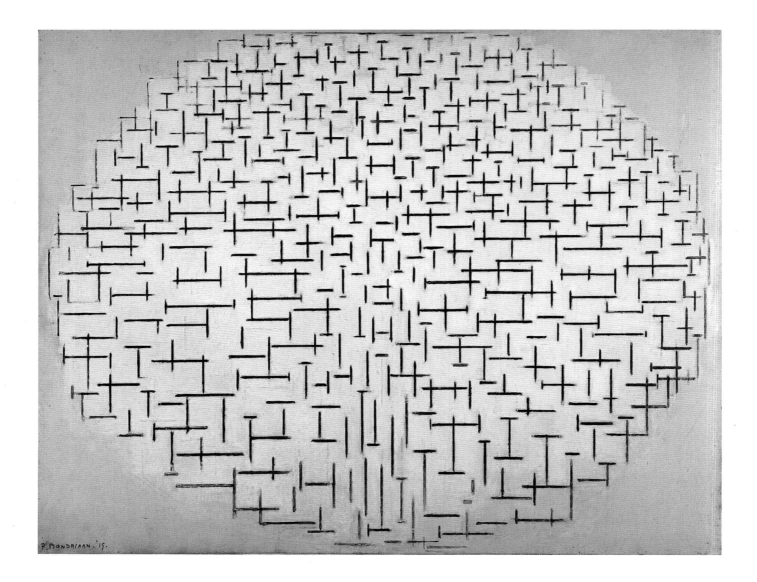

97 **Pier and Ocean (Composition No. 10)** 1915
Oil on canvas, 85 x 110 cm
State Museum Kröller-Müller, Otterlo

circle seen in perspective. With the simplest means of straight black lines and white paint, the artist has devised a surface that is clearly flat in every part and yet full of the space and movement of the shifting, glittering sea. Just as he assessed the rhythms of the city's vitality, so now he embodies the ocean in his painting. The means are strikingly similar; the effect is strikingly different.

The parts are unified by symmetry, by the simple means, and by the overall control which gives horizontal expansion beyond the vertical structure. Opposition is the key. Now one direction dominates, now the other. The drawing is flat and also full of depth. In the balance of these oppositions the rhythm emerges, inhabiting each part and all the parts within the whole. Visually the work shifts and pulsates before the eye like a living organism. It breathes.

Mondrian's final canvas of **Pier and Ocean 97**, also called **Composition No. 10**, is different in two important respects: it is *not* symmetrical and none of the lines form closed rectangles or squares. The white space is continuous throughout the painting. It is a painting without colour, without curves, without diagonal lines, without solid imagery - an insubstantial, restless, glittering record of the ocean's movement. Through the precise placing of each small conjunction of lines, there emerges the larger crossing of the vertical emphasis (up through the centre) and the horizontal emphasis (above the centre). The pier projects; the sea expands. They are locked in continuous opposition, congregating towards substantial form, dispersing into broad surfaces. The painting has, as a result, a tempo, a pulse, a vitality - in a word, rhythm. That rhythm is not solely the ocean's movement, however, for a man-made form projects against it. The pier and the ocean are in interplay and opposition. This is man and nature, just as the windmill was projected against the sky in earlier

paintings. The vertical, said Blavatsky, is action in time; the horizontal is eternity. The pier and the ocean are in the same relation to each other.

The next two years in neutral Holland were important for Mondrian's career. From the summer of 1915 he frequently stayed at Laren, a small village near Amsterdam. At first he lodged with his friend the composer Jacob van Domselaer whom he had known in Paris, but he subsequently rented his own studio there. It was at Laren that he also met Salomon B. Slijper who was to purchase some two hundred paintings and drawings, now in the Slijper Collection at the Gemeentemuseum at The Hague. He was also exhibiting from early 1915, sending works to the Rotterdam Art Circle (*Rotterdamse Kunstkring*) for a show in January and February, and in October exhibiting with Sluyters, Le Fauconnier and two Dutch painters, Gestel and Van Epen, at the Stedelijk Museum in Amsterdam. On the other hand, he severed his links with the *Moderne Kunstkring* from June 1915, but showed four compositions at the Dutch Artists' Circle (Hollandse Kunstenaarskring) in Amsterdam in 1916.

At about this time, too, Mondrian attracted the interest of several critics, including the art historian Dr H. P. Bremner, with whom he made a financial arrangement (lasting until 1919) by which he was paid a regular stipend in exchange for a specific number of paintings. His work was also noticed and reviewed favourably by Charles E. M. Kupper in November 1914. Kupper, who adopted the name Theo van Doesburg, was soon to play a vital role in Mondrian's life; as well as being an active writer and theorist, he was also a painter. Mondrian's first meeting with him occurred in 1916, at a time when Van Doesburg, filled with enthusiasm about Wassily Kandinsky's book, *Concerning the Spiritual in Art*, was fired with

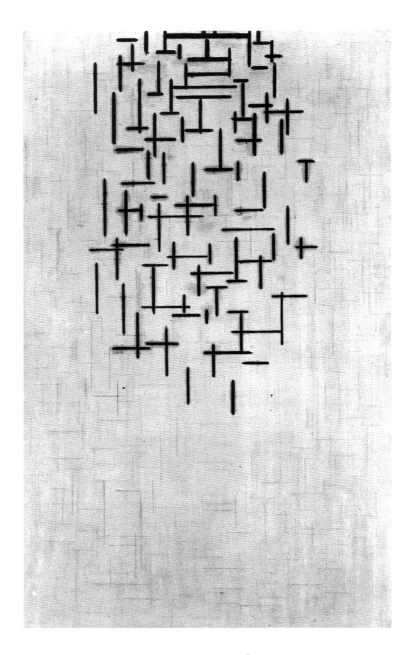

98 **Study for Composition** 1916
Oil and pencil on canvas, 124.5 x 75 cm
National Museum of Modern Art, Kyoto

99 Composition 1916 1916
Oil on canvas with wood strip at bottom edge, 119 x 75.1 cm
Solomon R. Guggenheim Museum, New York

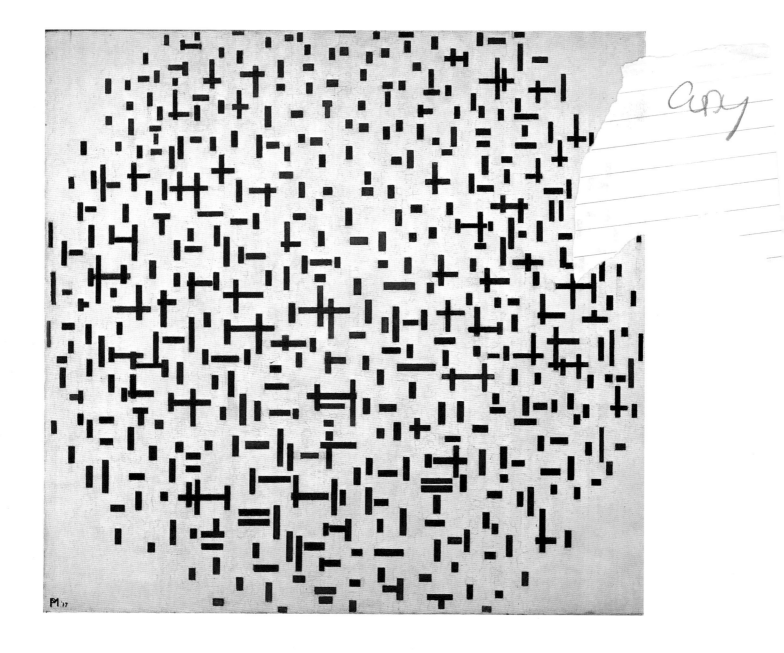

100 **Composition with Lines**
(Composition in Black and White) 1917
Oil on canvas, 108.4 x 108.4 cm
State Museum Kröller-Müller, Otterlo

ambition for the future of Dutch art as a contributor to a new international style. He published a pamphlet, 'The New Movement in Painting', in 1916 and was eager to draw together Dutch artists of sympathetic aims; among these was Bart van der Leck who had moved to Laren in April 1916 and whose work had much in common with Mondrian's, for he too had excluded all modelling and perspective from his painting.

Mondrian made another significant contact in this period. He met the priest and philosopher Dr M. H. J. Schoenmaekers whose theoretical writings extended Theosophy into what he called *Christosophy*, uniting mystical and mathematical concepts into a theory of direct interest and relevance to Mondrian. His recently published books included *Rudiments of Figurative Mathematics* (1916), *The New Image of the World* (1915) and *Plastic Mathematics* (1916).[27] 'We want', wrote Schoenmaekers, 'to penetrate nature in such a way that the inner construction of reality is revealed to us.'[28] Like the theosophists he saw the horizontal line as passive, and the vertical as active. Opposing forces, which they embodied in the cross, signified creation of the universe. In *Plastic Mathematics* he also discussed colour, considering red, yellow and blue to be ultimately the only colours existing, as they were the basis of all the other colours which emerged from their conjunction. Yellow, visually expansive, was, for Schoenmaekers, the movement of rays outward, and blue, which recedes visually, was the firmament. Red lay in between; it stayed put, floating, and in this respect reconciled the opposition of blue and yellow.[29] All of this related to Mondrian's own convictions. It is clear that by 1917 he was in a position to consider Schoenmaekers's theories alongside those of Theosophy, although it is not possible, or even fruitful, to try to disentangle the two when considering his extraordinary progress in that year.

Composition with Lines of 1917 **100** extends the principles of Mondrian's **Pier and Ocean** paintings, but it employs thicker, flat-ended 'lines' with some thin lines incorporated. It abandons the theme of the pier, dispersing its cross-formations asymmetrically in broad areas to left and right and in the lower part of the canvas. Lines that do not form crosses also sparsely populate areas in which the white background is dominant. Closely related to the sea paintings, its effect is of a shifting, glimmering surface of reflected light. Its balance of energies is a visual example of unity in diversity. It has a pointillist shimmer of light, but without either the round brushmark or colour of pointillist painting. The sense of light is nevertheless apparent.

There is another change here from the **Pier and Ocean** works. Their pacific and expansive horizons, stretching sideways to infinity off the sides of the the painting, are here curtailed because the painting is precisely square. It has no upright or sideways expansion. It also abandons the oval. This painting suggests a circle within a square. It was not Mondrian's first use of a square canvas (see **16**, for example), but in this new context it was an important innovation.

The square perfectly balances by its very nature. This is why, for theosophists, it represented the world as a unity, a balance of the forces of creation, of nature and man. Within it Mondrian revealed diversity and a dynamic, irregular, assymetrical play of forces. The circle is eternity. It is possible that in this format of the circle within the square Mondrian attempted more than a mysteriously glittering surface, for in presenting a visual example of the interaction of

opposing forces he resolved them, by their positions, into the unity of the circle. He has removed, to an unprecedented degree, everything that is descriptive in any specific way, even the personal touch of brushwork. The rhythmic surface which results is instead related to the geometry of the circle. However active the parts, the whole is still, changeless and permanent, as eternity contains events in theosophical theory. Simplicity contains diversity, just as silence contains sounds and eternity contains time. Such a cosmological reading of the painting might not be credible without the visual evidence that Mondrian's painting in fact achieves this kind of balance. And images of the world in these terms were precisely the subject both of Theosophy, and of the writings of his new acquaintance Schoenmaekers, who indicated as much in the very title of his *New Image of the World*.

Together with two related paintings of the same year, this work was exhibited in a triptych format in May 1917 at the Dutch Artists' Circle exhibition in Amsterdam. This was the largest of the three paintings, hung higher and centrally between its coloured companions, like an altar-piece **101**.[30] The two pendants were, with great simplicity, entitled **Compositions with Colours A and B**.

These **Compositions 102-3** are not quite square: their format is gently vertical. They have some features in common with **Composition with Lines**. Short black squared-off lines are dispersed across the canvas to describe an irregular ovoid shape, avoiding the corners of the canvas in each case. Mondrian has, however, now included colour in planes of red, blue and yellow also dispersed across the canvas. These interrupt the implied oval of the black lines, but also avoid the corner spaces of the canvas. In each case some of these planes meet the edge of the canvas, particularly at the top. Although the circle within the square is still present as a compositional device, it is now broken by coloured planes. The geometric centre of the canvases is left empty and the planes tend to suggest a visual focus above this point. All of this both canvases have in common, but, within the narrow range of pictorial elements to which Mondrian has reduced his vocabulary, their differences are substantial.[31]

Composition with Colours A 102 features a red square, or near-square, above the middle of the painting. It is the largest rectangle and its central position makes it visually static. Schoenmaekers had also maintained that the colour red is static in that it neither expands nor recedes visually. The two longest black lines are

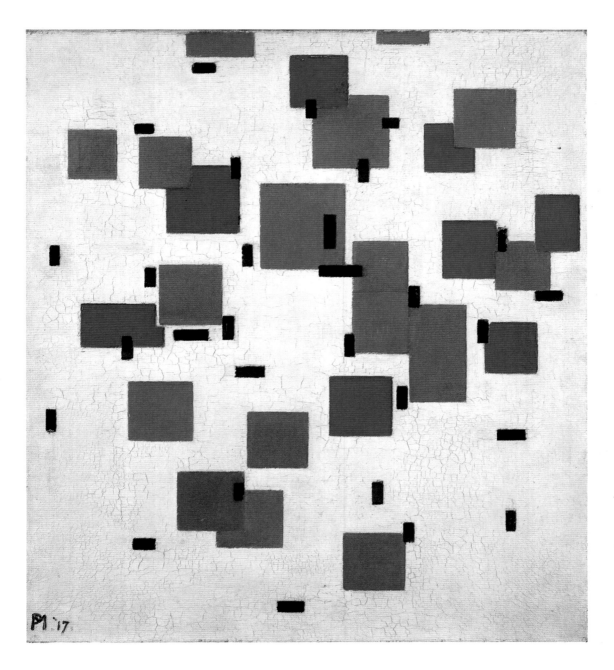

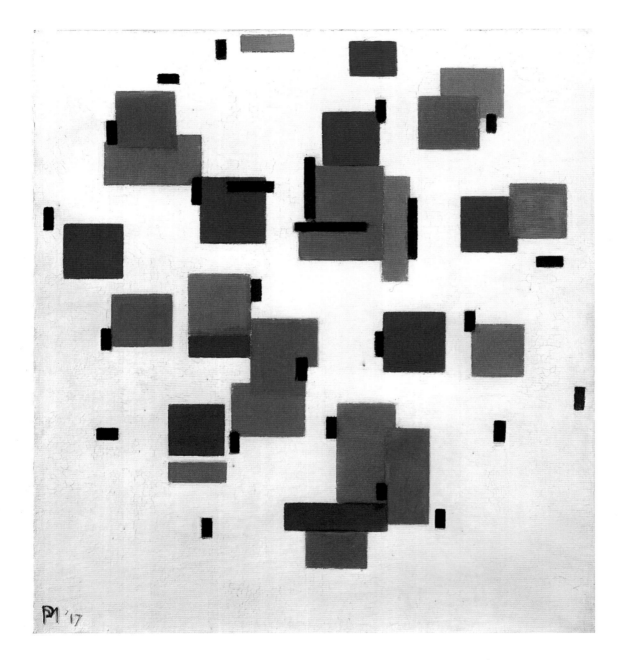

103 **Composition with Colours B** 1917
Oil on canvas, 50 x 44 cm
State Museum Kröller-Müller, Otterlo

associated with this red rectangle. Around it hover other rectangles of red, blue and yellow, appearing to reach out into the surrounding space of white from this focus. The three colours are dispersed in a way which permits no conjunction of rectangles of the same colour, but engages them in elaborately intermingled relationships. For the most part they approximate to squares with four notable exceptions; at the centre left is a wider blue rectangle, while the centre right features a tall yellow rectangle, and adjacent to this red and yellow rectangles are aligned to form a vertical block. Finally, at the top, red and yellow rectangles meet the edge and appear to extend upwards off the canvas.

There are, in addition, conjunctions of colour blocks of two kinds. Two adjacent juxtapositions occur: the red-yellow mentioned above, and the blue-yellow to the right of this. The other kind of conjunction involves apparent overlapping of planes: the top left shows a small yellow overlapping a large blue. But at the centre is a small blue which overlaps a large yellow. Elsewhere a large red overlaps a small blue, and a large yellow overlaps a red of similar dimensions. The same conjunction is never repeated. These are all variations. One last overlap is different again: at centre left a large yellow overlaps a wider blue but a channel of white separates them. Black is always in front when overlapping a plane of colour. This is an art of relationships in which no relationship of two planes ever recurs. Around the focal red unfolds an intricate interplay of relationships defined by colour, proportion and position, expanding visually from the static core outwards into a multitude of different relationships. The eye is proffered two spatial readings, one of which is flat while the other suggests depth of field. The eye links rectangles of the same colour by moving across the canvas to recognize them until it can survey the distribution of either red or blue or yellow or black. There follows an awareness of the distribution of a different colour. This in itself provides a visual pulsation but is a reading of the canvas as flat.

The structure which suggests space into and out of the canvas is achieved by several mutually supportive techniques. First, the overlap effect explicitly suggests that one rectangle hovers behind another; this is an effect of position. Secondly, the comparative size of the rectangles can suggest that a smaller plane is more distant than a larger plane, and planes which share the same diagonal axis, as several do that overlap, imply perspectival recession of the same form (as in red over blue at top right). Where a small plane overlaps a large one, this still creates a sense of colourless intervening space. Thirdly, colour appears to come forward (yellow), recede (blue), or remain static (red). Finally, the overall arrangement describes expansion out from the core to a perimeter off the canvas with an emphasis on movement upward and outwards. This is achieved in part by positioning the large red focal square above the empty centre of the painting. Flatness and depth are engaged in a rhythmic interplay made possible solely because Mondrian has achieved a balance of his opposing visual forces. As a result the painting cannot be assessed in terms of either flatness or depth: it appears instead to pulsate before the eye, both in its overall structure and in the relationship of its parts.

Composition with Lines dispensed with colour but produced an effect of glittering light and movement in space. With the inclusion of colour Mondrian has achieved a comparable rhythm. Red, yellow and blue, in painting, are the constituents of light, for in conjunction they make all the other colours. There is still a link with pointillism in this. These colours the artist has chosen, just as Schoenmaekers

104 **Mill at Evening** c.1916
Oil on canvas, 103 x 86 cm
Gemeentemuseum, The Hague

described, for their elemental quality. They are primary forces from which flow the diversity of all other colours. Against the dualities of black and white, and of the perpendicular, Mondrian has here also inserted the trinity of red, yellow and blue. The relation of parts to each other, and parts to the whole, is intricate but balanced, both single and complex, clear and involved, deep yet flat, literally motionless and yet pervaded by rhythm.

Composition with Colours B 103 shares all of these qualities. The black lines are fewer. **Composition A** had two longer lines associated with the central red. Here several congregate at the core of the painting. Overlapping occurs, but many of the colour planes are far from square. Yellow and blue both adopt elongated rectangular shapes, while red at two points becomes L-shaped, with black lines marking but also obscuring the inner angle of the L. Again the relationships differ and do not repeat. Blue and yellow form three different conjunctions centre left to lower left, each symmetrical in itself. Red joins blue at upper right. But something further occurs at four points where Mondrian assembles red, blue and yellow into a more complex configuration by joining three or four elements together accompanied by black lines. These configurations amount to constructions with varying degrees of stability. Where once the focal red hovered connected only to black lines **102**, here there is a structure reminiscent of Mondrian's analysis of the cityscape. It coincides with the meeting of longer black lines. Clearly the focal point of the painting again, it has an air of building and cohesion. These planes, locked together as they are, do not expand outwards in dynamic flight: they hold together to form a tower of coloured planes. Expansion is held more firmly in check. Rising above the geometric centre, leaving the lower reaches of the canvas white, planes do still escape

at the upper edge. There is still an upward movement, but the black lines at three points hold the edges firmly. Condensation into stability results: it is evident in the symmetrical conjunctions and in the focal area.

The sense of building from elements is not new in Mondrian, but, set in geometric rectilinear planes of red, blue, yellow and black, it is now removed from all specific or detailed depiction and is consequently generalized in its means and its message. The elements, by their varied interaction, lead to construction. What Mondrian presents is an example which is potentially Utopian, for it reveals an underlying harmony and rhythm in construction where each part finds its balance and its place within the whole. Such Utopian views were current among Mondrian's colleagues and friends in 1917. They were inherent in Schoenmaekers's writing and complied with Theosophy's aim of enlightenment and evolution. Theosophy associated body (red), intellect (yellow) and spirit (blue) together in interplay; Mondrian here associates the conjunction of the colours with building. The rhythm is now constructive, as is the actual meeting of the long black lines at the core of the painting.

It is possible that Mondrian's return to Holland precipitated anxieties about the development of his work, particularly now that he was removed from the constant stimulus of Cubist theory and debate and was plunged instead into the Dutch countryside which had once been so fruitful and favourite a theme of his paintings. His writings showed no loss of confidence, but he may have flirted with a return to representational ways of working. He continued to paint flowers, for example, and he may have made paintings of windmills in 1916, although some doubts persist about their date of execution. **Mill at Evening 104** is seen from a low viewpoint so

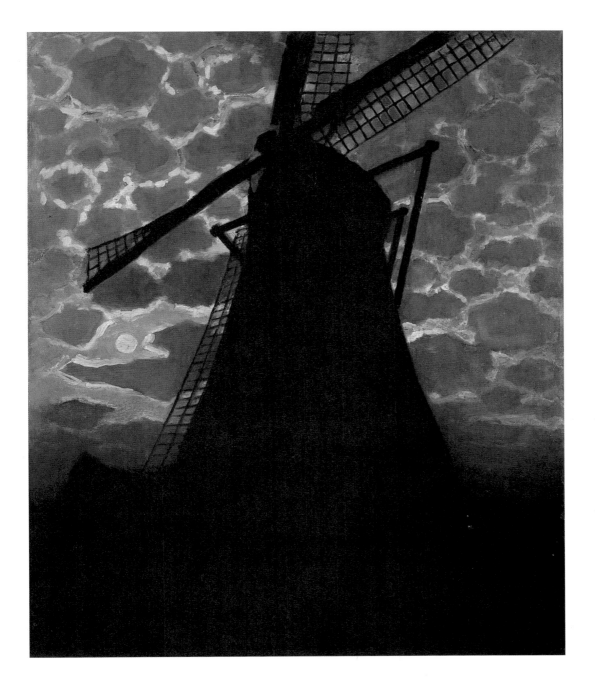

that it rears its bulk against a sky filled with a cellular pattern of moonlit clouds. There is no earlier series which quite corresponds to this motif and Mondrian may have painted this as a special commission.

The rising movement of **Compositions with Colours A and B** was carried up into the central larger **Composition with Lines 100** which they flank. It is an image of aspiration in which the monochrome painting takes precedence. From this point of view the central panel appears more important, and more elemental; it is a globe-like configuration of opposing forces crystallizing specific forms from empty space. It establishes the primacy of rhythm, which creates conjunctions in the duality of black and white, evoking surfaces and light. In **Composition with Colours A** the primary colours expand from a firm core, forming a new tier of diverse and therefore specific relationships, which, in **Composition with Colours B**, grow and consolidate into built structures. To a theosophist this would signify the process of the Creation, the Logos, the living Word from which the world derives its origin. Rhythm, which is the richest aspect of Mondrian's seemingly simple paintings, was in the beginning. The rhythms of proportion and position he embodied in paint because he was a painter; but his friends included philosophers and musicians, as well as painters - rhythm was a concept applicable equally in their activities.

Although Mondrian's paintings in 1917 can still be interpreted from a theosophical point of view, nevertheless the experience of Cubist picture-making, combined with the vigorous upheaval and debate in Paris in 1911-14, where the conventions and means of art were upset, re-examined and recreated, revealed to Mondrian that paintings exist as independent objects. It is evident that his major trip-

tych **Evolution 68**, for example, painted before his Parisian stay, contained a message unintelligible without reference to Theosophy, but **Composition with Lines** and the two **Compositions with Colours A and B**, painted after his return from Paris, revealed their rhythmic coherence independently, because it was inherent in the paintings' own compositional structure. The imagery of **Evolution** was specific to Theosophy whereas the recent work was less an illustration than an example of rhythmic coherence plainly visible to any viewer with the willingness to observe it. Still inspired by observation, these compositions moved towards construction.

The implication is a harmonious relationship, revealed in rhythm via proportion and position, between the forces which created the natural world and the forces operating in human construction. The difference is human intellect and conscious thought, part of the world's envisaged evolution, involving man's place within the natural order, human understanding and manipulation. Geometry could be seen as inherent in nature, in the orbits of planets or the structure of the atom, embedded in the inconceivable complexity of living things. Geometry could also be seen as inherent in human construction, in the straight boulevards of Paris or the canals radiating through Amsterdam, in the printed page or the lines of buildings. Geometry could be conceived as an intellectual construction, its relationships of forms, the circle and square, for example, maintaining their proportions beyond particular size or application in the unobservable, immaterial, but nevertheless real, world of mathematics. Proportion could exist in the void or in the mind, and proportion means rhythm. By adopting geometric elements Mondrian could literally present rhythm; working as a painter, he put it into paint, but the principles, as he repeatedly asserted, are applicable and

observable in any field of activity, as germane to music and architecture as to poetry or city planning.

To a degree the principles were impersonal, and by 1917 Mondrian had reduced to a minimum the evidence of his own brushwork as if to exclude consideration of his personal style, his 'handwriting'. The evolution he envisaged as a painter involved a new attitude to observation, leading to composition and its extension to construction; this too could be impersonal yet it necessitated sympathetic contact with fellow artists. He had never worked in a cultural vacuum and he displayed, to the end of his life, a paradoxical need for contact with other artists in order to acheive the severe refinement that characterized his work. In 1917 his painting, by using geometric means and by playing down the individual in his handling of paint, was open to the closest collaboration.

Theo Van Doesburg was actively organizing a group with precisely these ambitiously impersonal aims. Drawing upon his contacts in Holland, he founded the group De Stijl ('The Style'), aiming to define not personal style, but the concept of style itself beyond the ever-changing manipulation of shape, form and image which art history revealed. He defined the aim as the creation of the purely visual work of art. In order to make the general public susceptible to the beauty of such purely visual art, he launched the periodical, also entitled De Stijl, which survived until 1928.[32] 'As soon as artists in the various branches of plastic art will have realised that they must speak a universal language,' wrote Van Doesburg in his introduction to the first issue of De Stijl in 1917, 'they will no longer cling to their individuality with such anxiety.'[33]

From its inception the De Stijl group also reached beyond painting by including poets and architects among its members. Similarly, it had international aims not immediately realizable in time of war. Initially it included Van Doesburg, Mondrian, Bart van der Leck and Vilmos Huszar, as well as the poet Anthony Kok and the architects J. J. P. Oud, Jan Wils and Robert van t'Hoff. Foreign members were the Belgian sculptor Georges Vantongerloo and the Italian futurist Gino Severini. Significant additions and departures occurred in the coming years, including, in the initial phase, the arrival of the architect Gerrit Rietveld in 1919 and the withdrawal of Bart van der Leck the same year. De Stijl reached out like a Mondrian painting to several spheres of activity and if its centre was not a tightly knit group, its periodical in particular gave it a common forum for theory, debate and promotion. De Stijl was a group with an evangelical purpose. Its impact on art, design and architecture was to prove far-reaching.[34]

It was in the periodical De Stijl that Mondrian first published his theoretical concepts, making explicit the guiding principle which he had pursued so persistently in his painting, and which by 1917 had reduced his painting to a rhythmic art of relationships employing only rectangles of colour and black lines against a white background, where all painted planes conformed to the main axes of his canvas.

'The New Plastic in Painting' ('De Nieuwe Beelding in der Schilderkunst'), Mondrian's first published essay, which he hoped to make into a book, was published in twelve instalments in De Stijl between October 1917 and October 1918, with a supplementary essay, 'The Determinate and the Indeterminate', in the December 1918 issue.[35] Probably written throughout the period between his return to Holland in 1914 and actual publication, it coincided with those researches which culminated in **Compositions with Colours A and B 102-3**. At Laren in this period Mondrian was close to the com-

105 **Self-Portrait** 1918
Oil on canvas, 88 x 71 cm
Gemeentemuseum, The Hague

poser Jacob van Domselaer, the painter Bart van der Leck and the author of *The New Image of the World*, Dr M. H. J. Schoenmaekers.

The word 'plastic' in Mondrian's essay-title is not specific to painting. It implies a wider range of creative activity which could embrace, for example, architecture and music. The artist was discussing the creativity involved in manipulating form and material in any art. In essence he propounded the same theory adjusted to differing circumstances throughout his career. Certain points were clearly made from the very beginning of his text. With the theosophists, he described the human being as a 'unity of body, soul and mind,'[36] and saw the world in a continuing process of evolution where change occurred within an overall, timeless structure. Evolution, for Mondrian, led to an increased awareness of the whole permeating the particular manifestations of the moment: this was revealed through human activity. 'The life of truly modern man is directed neither toward the material for its own sake,' wrote Mondrian, 'nor toward the predominantly emotional: rather it takes the form of the autonomous life of the human spirit becoming conscious.'[37]

In turning away from the description of the outward appearance and detail of natural form, art, according to Mondrian, was revealed as a 'pure creation of the human spirit'.[38] This art dealt with relationships and could be consciously developed, but its roots lay, as for theosophists and Schoenmaekers, in a vision of the cosmos whose rhythms made the world: 'The truly modern artist', he wrote, '*consciously* perceives the abstractions of the emotion of beauty: he *consciously* recognises aesthetic emotions as cosmic, universal.'[39] This involves loss of imitative imagery and loss of an individual handling of materials when related to painting, for 'The new plastic

cannot be cloaked in what is characteristic of the particular, natural form and colour, but must be expressed by the abstraction of form and colour by means of the straight line and determinate primary colour.'[40] All of this Mondrian had achieved in his painting by 1917, revealing rhythm in the balance of relationships. He considered the resulting harmony to be universal, a reflection of the harmony of the cosmos, or, as he succinctly put it, 'extreme opposites in complete harmony, include all other relationships'.[41]

This had practical implications for Mondrian as a painter. It meant that green, orange, purple and brown were not universal but particular conjunctions, or mixtures, of the unique qualities of red, blue and yellow which themselves were unique, distinct, unmixable forces of colour, approximating in pigments to ideal concepts. As this suggests, his theories also had philosophical implications, not least because they linked man and nature by their opposition, their relationship within the whole: 'If we see these two extremes as manifestations of the inward and outward, we find that in the new plastic the bond between spirit and life is unbroken, we see the new plastic not as denying the fullness of life but as the reconciliation of the matter-mind duality.'[42]

Mondrian was not writing for the popular market, for 'ordinary vision', he says, 'is the vision of the individual who cannot rise above the individual'.[43]

Yet far from abandoning natural form Mondrian sought a relationship between the creative force of nature and that of the human mind, an understanding of nature leading to insight and evolution. Nature has one means of creating and mankind has another, yet both have a role within the structure and evolution of the world. This structure, which Mondrian referred to as 'the abstract' permeates all:

106 **Self-Portrait** 1908-9
Charcoal and crayon on paper, 79.3 x 53 cm
Gemeentemuseum, The Hague

'the abstract, like the mathematical, is actually expressed in and through all things…'[44]

Paintings therefore are part of the world consciously tuned by the painter, so that the relationship of these fragments of matter and colour reveal the underlying rhythm which animates the world. They do not simply reflect nature, they exemplify this rhythm: they are examples. Consequently only universal forms will suffice. A square is always a square. It cannot be altered without becoming other than a square. Similarly, red, blue and yellow cannot be altered without growing greener, more purple or more orange, and colour must be composed not by mixing but by the infinite relationships of these three elemental forces.[45] Composition is rhythmic as a result and is identified with Mondrian's concept of the cosmos, but individual paintings have particular rhythms; they are part of the whole to which their form refers. Like the theosophists and Schoenmaekers, Mondrian delineated a concept of the universe which included human awareness of the universe. He explained his ideas in articles but he presented this rhythmic balance as visual fact in his paintings.

It is a curious irony that precisely as these articles were appearing in print Mondrian painted a self-portrait **105** which contradicts his position entirely. Elegantly dressed in urbane suit and bow-tie, clean-shaven with not a hair out of place, the philosopher-painter casts his challenging gaze at the mirror, and thereby at the viewer of his canvas. Behind him hangs, like a manifesto of his views, a painting composed of rectangles, all their sides perpendicular and strictly parallel, a painting similar to **Composition with Colour Planes** of 1917 **107**. There exist some Cubist drawings related to this painting **106**,[46] but the finished canvas unapologetically contrasts two kinds of painting. Mondrian the individual, painted with all the characteristic personal flourish and skill of his early works, is making in fact a last appearance in his painting. It is a touching anachronism, a farewell to what he still can do in his old techniques. Superseded now by the urban intellectual so succinctly described here in city clothes, the painter of highlights and half-tones, of earthy greens in the landscape, never reappeared.

Mondrian's philosophical views were reiterated throughout the remainder of his life. His philosophy was defined by his practice as a painter. He wrote in any case as a painter and this above all distinguished his view, because he spoke from practical experience. He could literally see at work in his paintings the forces, the rhythms

107 **Composition with Colour Planes** 1917
Oil on canvas, 48 x 61.5 cm
Private Collection

and the balance only referred to in his writing and thought. This in itself made Mondrian's achievement unique and explains the permeation of his influence. For the paintings are supremely attuned objects, still emitting the rhythms defined by the painter, and still at work delivering their message wherever they are viewed. Although Mondrian's concept was unchanging, his means of resolving particular canvases never ceased to evolve.

Composition with Colour Planes 107 is one of a series of canvases in which rectangles of colour appear to float against a background of white. There is no overlapping and no black. Only two planes touch and some planes go off the canvas edge. One plane goes off the lower right corner. This is a broad canvas but the touching of two planes makes the importance of the vertical alignments clear. The axis of the painting is located near the centre in the narrow white passageway between the planes, adjacent to the almost square empty space. An imaginary vertical line could be inserted here, but to either side the alignment of blocks is increasingly broken to left and right. The sense of columns of coloured blocks persists but is progressively dispersed by misalignments that grow more pronounced towards the sides of the canvas. This suggests expansion

and dispersal outwards towards the corners, creating an implied perspective effect - an effect which in turn is, as before, strengthened by the depth implied through the relationship of rectangles of different size, and the recession or expansion implicit in the relationships of red, yellow and blue. Expansion and contraction balance. The planes can be read as moving in or out. Rhythm does not lead, in this visual object, to a progression from beginning to end, but to a pulsation of readings, and the awareness of the parts in relation to the whole. The De Stijl manifesto asserted as much in November 1917 in its opening words: 'There is an old and a new consciousness of time. The old is connected with the individual. The new is connected with the universal.'[47] Events, and particular objects, from this point of view, are contained within a changeless universe; they are individual aspects of a universal structure which itself is beyond scale and time and permeates everything.

During 1918 and 1919 Mondrian produced paintings which contrasted a regular, unchanging grid against an irregular subdivision of opposing forces. Regularity was played against irregularity; continuity against change; and universal proportion against specific proportion. In this procedure the square performed a significant role.

108 **Lozenge with Grey Lines** 1918
Oil on canvas, diagonal 121 cm
Gemeentemuseum, Van den Briel Collection, The Hague

'My new paintings', said Mondrian in a dialogue published in *De Stijl* in 1919, 'have the same aim as the previous ones. Both have the same aim, but my latest work brings it out more clearly.'[48]

Lozenge with Grey Lines, dated 1918 **108**, is a square canvas presented in the diagonal format with a point at top and bottom. Like a chessboard it is subdivided into sixty-four smaller squares, eight along each edge. All of the lines composing these squares are diagonal and perpendicular to the canvas edge, but through them runs a second regular grid passing through each crossing point. These lines are vertical and horizontal. All of this is a regular, consistent and symmetrical subdivision of the square canvas.

Within this structure Mondrian introduced irregularity by the simple means of thickening sections of the horizontal and vertical lines. This thickening of lines is not immediately obvious, for the artist has effected a balance between the overall regular structure and the irregular construction almost concealed within it. The effect is dynamic and visually dazzling, since the whole and the parts, the regular and irregular, are in constant interplay, allowing the eye no simple, fixed interpretation. In fact the irregular format of thick lines was to form the basis of a separate painting. Here it may be read in two ways: either as melody within harmony, which Mondrian discussed in the dialogue published in 1919, or as its corollary, that asymmetrical balance is based upon regular rhythm – that the particular relies upon the rhythmic form of the whole structure, that the parts reflect the whole.[49]

The square divided into eight squares along each side like a chessboard is produced by dividing the parent square in half along each axis to produce four squares, which are repeatedly subdivided to produce sixty-four squares. The structure subdivided repeats itself.

It is the simplest progression and can be read as expansion or reduction. The number eight, according to Blavatsky, signified infinity, spiritual action in cycles, the caduceus (the rod of Hermes); its crossing and counter-curving form was for her 'the regular breathing of the Kosmos'.[50] The French painter Robert Delaunay had used the caduceus motif in Paris in works which gave primacy to rhythmic arrangements of colour; these the poet and critic Apollinaire named Orphic Cubism after the mystical, and mythical, poet Orpheus, an adept in the harmonies of the universe. The square, said Blavatsky, was the symbol of immortality, and signified the soul to Pythagoreans. The vitality of Mondrian's painting may yet have a similar significance. Eight is, furthermore, part of the Fibonacci Series and the Golden Section, systems of harmony and proportion related closely to the circle and the square, and extendable to infinity or to zero.

Lozenge with Grey Lines of 1918 is an extraordinary painting. It heralds a long line of lozenge paintings that stretched to the end of Mondrian's career.[51] His final painting in fact used this format. All of the lozenge paintings are square and it is possible that Mondrian reserved this format to initiate new departures.

The square standing upon its corner already had a long history in Mondrian's work, being embedded as a major compositional device in numerous paintings. Portrayals of the old house on the river Gein, executed at the turn of the century **8**, used it in forming both house and reflection. The **Windmill by the Water**, 1900-4 **9**, formed the lozenge, now in empty space, by means of the mill's struts and sail reflected in water, and it appeared, compressed, at the hub of the mill sails in the monumental **Mill at Domburg** of 1910 **66**. Significantly, it was evident in the **Evolution** triptych of 1910-11 **68**, where it marked, in the right-hand panel, the transition from down-

144

ward-pointing triangle (in the nipples and navel, left) to the upward-pointing triangle of enlightenment (centre panel). The six-pointed star of the theosophists was formed of two intersecting triangles. The lozenge can be read in a similar way - as an upward-pointing triangle surmounting a downward-pointing triangle, signifying the mingling of spirit and matter to form the square of the world and its four interactive elements of earth, air, fire and water. The line at which they join forms the horizon of heaven and earth, or, more prosaically, that of earth and sky as Mondrian had used it in his early paintings, emphasizing the division by a river-bank **8** or other firmly horizontal lines **9**. Perpendicular to this, the interaction of upward and downward movements occurs, identifying the vertical axis with change and action. Theosophical study made this explicit to Mondrian, so that by 1918 he must have known, quite consciously, the theosophical significance of the lozenge format, even if it had occurred in his earliest years through the painter's intuitive grasp of a compositional structure latent in the landscape before him.

Mondrian's Cubist paintings also have aspects relevant to the lozenge. For example, the upward, downward and sideways thrust of the **Tree** paintings **77** renders the corner areas of the canvas less important, an effect which the oval format of Cubism resolved in paintings of 1913-14 **81**, **89-91**. Yet this feature was still evident in the **Pier and Ocean 93, 97** and in recent paintings employing the structure of a loosely defined circle within a rectangle. The major painting **Composition with Lines 100** was also square. The lozenge format resolves the issue of empty corner areas by deleting them altogether.

Evidently the lozenge evolved slowly in Mondrian's work. **Lozenge with Grey Lines 108** presents it for the first time with clarity,

force and conviction. The painting may have been conceived with its sides upright, or have been inspired by a stained-glass panel,[52] but the lozenge format had its own significance different from that of the usual format of the square. It also had its own pictorial characteristics. The interplay of upward and downward triangles is evident on the visual level: the lozenge appears more dynamic and expansive than the level square. Appearing to balance upon a point, it is imbued with an upward surge and instability. Its corners reach out like a silent explosion. It defeats, too, the eye's willingness to read a painting like a window, to look through into a more or less convincing imitation of the visual world. It is a conscious recognition of the painting as a flat surface.

Given the importance of orthogonal lines for Mondrian, other qualities which distinguish the lozenge from the level square were important. It provided a longer horizontal and a longer vertical (corner to corner) and located them in the centre of the painting instead of at the periphery. A greater force and range of Mondrian's minimal means ensued.

Lozenge with Grey Lines is comparable with **Composition with Lines 100**, painted the previous year. Neither use colour; both are square. Both produce an effect of intricate, shifting relationships and even a sense of light. But there are important differences. The earlier painting approaches a circular shape in the overall assemblage of lines, whereas everything is straight in the later painting. There are suggestions in the earlier painting of surfaces which recede, evoking light and air in a residual aerial perspective. This has vanished in **Lozenge with Grey Lines**.

Mondrian's colleagues in De Stijl were dedicated to the straight

109 Jan Vermeer: **The Music Lesson** c.1662-5
Oil on canvas, 73.3 x 64.5 cm
The Royal Collection, Buckingham Palace, London

line; Van Doesburg in particular was convinced of its exclusive use. It prevented mere reflection of the visible world; it could be consciously manipulated for construction. It is just this shift from analytical observation to construction that is evident when **Composition with Lines** is compared with **Lozenge with Grey Lines**. The painting is now primarily a constructed object whose own internal structure is more important than whatever observation may have inspired it. Conscious manipulation of the visual balance within the flat painting has extinguished any residual tendency to employ perspective.

What remains is a mathematical subdivision of the square with an irregular emphasis given to some of its lines. Mathematical grids of this kind were used as floor designs by Van Doesburg, who employed black and white square tiles.[53] Regularity embraced irregularity. Floor-tiles had long been important in Dutch interiors, as the paintings of Vermeer, De Hooch and other seventeenth-century painters reveal: they were used by these painters as valuable indicators of perspective, to show a precisely calculable depth of field in the painting. Vermeer's **Music Lesson**, c.1662-5 **109**, provides an example. Although the tiles are laid diagonally across the floor, their corners converge towards a vanishing point which is shared with the window's lines, the roof beam and the table edge. The vanishing point lies behind the woman's left elbow. Single-point perspective of this kind was a thoroughly mathematical construction. It demanded, as we have seen, that one plane (two dimensions) remain parallel to the picture surface, as Vermeer's white wall does here. The third dimension, that receding into the painting, converged upon the vanishing point. What Mondrian has finally done in **Lozenge with Grey Lines** is to remove the vanishing point, thereby identifying with his

own picture surface the two-dimensional surface which results. This does not imply an ignorance of perspective, of which Mondrian undoubtedly had a thorough grasp, but a new and radical revision of it. There is much in Vermeer that is evident in Mondrian: his use of red, yellow, blue, black and white is one example; another is the precise, rhythmic positioning of rectangular forms across the picture plane, an effect illustrated by the back wall of his **Music Lesson**. Vermeer too could play irregularity against order, as the slanted reflection of the floor glimpsed in the mirror makes clear.

This does not mean that Mondrian derived his compositions from Vermeer. It simply means that in firmly establishing a new pictorial structure, as he did in 1918, he was aware that he was evolving as he saw mankind evolving - from a historical heritage towards an increasingly clear goal. The new pictorial structure did not occur as an innovation without precedent of any kind. It bore a relationship to earlier achievements, and sought its future direction in a study of the past.

Relinquishing imagery, Mondrian did not relinquish relationships, any more than Vermeer did in manipulating his own mathematical structure. **Lozenge with Grey Lines** is rich in this respect. The network of heavier lines is asymmetrical; it was repeated precisely in a painting of 1919, **Lozenge with Light Colours and Grey Lines 111**, in which the underlying regular grid just remains visible. The same relationship exists between the smaller variant of **Lozenge with Grey Lines 110** and **Lozenge 112**. Muted greys, blues and yellows fill the planes which the grid establishes. As the lines always continue beyond the limits of the rectangles, they appear to define interlocking planes rather than solid objects, and visual movement follows the

110 **Lozenge with Grey Lines (Composition in Black and Grey)** 1919
Oil on canvas, diagonal 84 cm
Museum of Art, Louise and Walter Arensberg Collection, Philadelphia

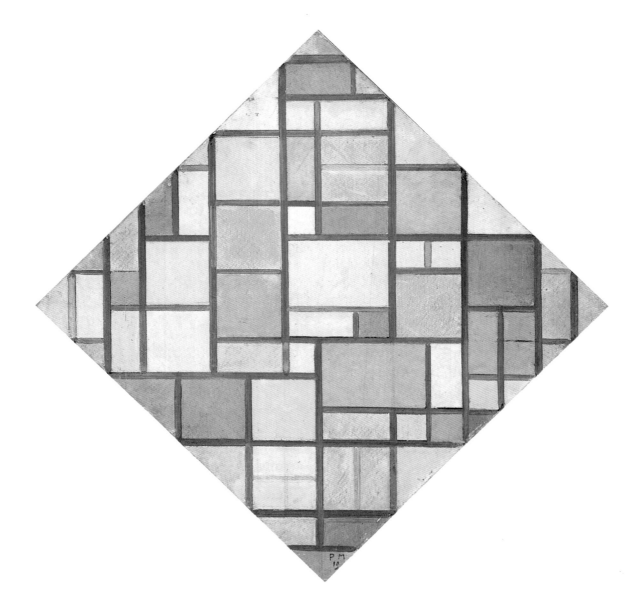

111 **Lozenge with Light Colours and Grey Lines** 1919
Oil on canvas, diagonal 84 cm
State Museum Kröller-Müller, Otterlo

148

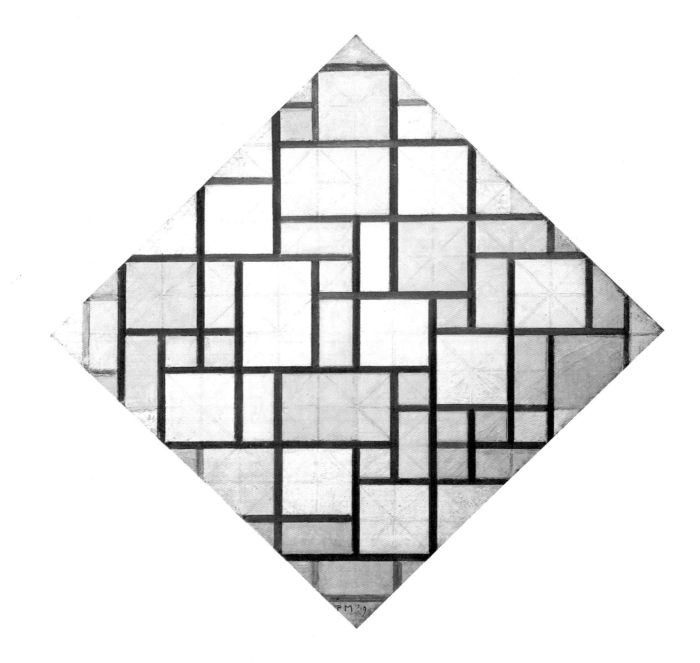

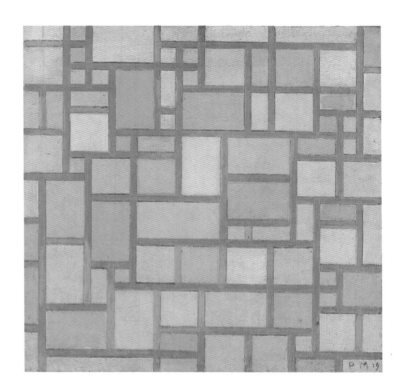

112 **Lozenge** 1919
Oil on canvas, diagonal 34 cm
State Museum Kröller-Müller, Otterlo

113 **Composition with Light Colours and Grey Lines** 1919
Oil on canvas, 49 x 49 cm
Kunstmuseum, Basle

lines deflected by crossings and terminal conjunctions across the whole canvas. The underlying geometric grid means that all of these planes and lines are interrelated proportionally to each other as multiples in length or area of the small square unit. There is no perspective; all lines are perpendicular or parallel. Rectangles at the top of the painting equal rectangles near the bottom. Yet the painting pulsates with movement and the space implied by colour and tone makes the planes emerge and recede in relation to each other. All of this is achieved by position and proportion, inherent but undefined in the regular grid.

Mondrian continued to work with modular compositions until July 1919. A further square painting, for example, **Composition with Light Colours and Grey Lines 113**, shows a canvas reverting to the level position and subdivided four times to produce a grid of 16 x 16 squares, equal to the small squares in the painting.

In this whole series, whether lozenge or square, no rectangle has a dimension more than three units long, so that none of them dominates the painting. None of them contains square planes more than two units wide, so that the larger planes are always clearly either vertical or horizontal. Lines, however, usually surpass three units, so that the sense of a built elevation which characterizes **Lozenge 112** is due substantially to its extended verticals, the longest of which imply towering structures of the planes they enclose. These in turn rest upon the longer horizontals, which suggest a firm structure beneath the stacked rectangles and culminate in a line (eight units long) that cuts right across the canvas, bisecting its two lower edges.

By contrast, the level-square painting is stable throughout, and all of its lines reflect the perpendiculars of the canvas edge. The square in this format inevitably implies perspective lines from its corners to the centre, an effect supported to a degree by the distribu-

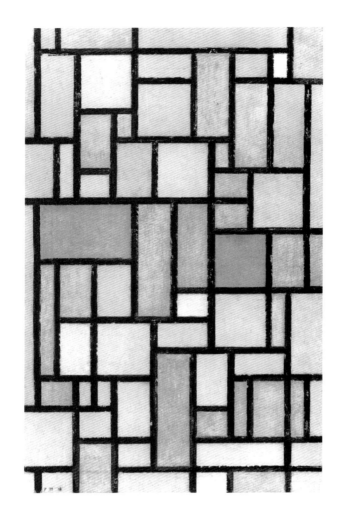

114 **Composition in Grey and Ochre Brown** 1918
Oil on canvas, 78 x 49.5 cm
Museum of Fine Art, Houston

tion of Mondrian's smallest squares. Colour remained muted in these paintings, and the tonal range narrow. The artist approached the resolution of his canvas by testing out solutions, and the many signs of adjustments were tentative and instinctive. One area of colour in **Composition with Light Colours and Grey Lines 113** is not completely filled in (upper right); such colour as had to be inserted was empirically tested for its effect. The grey lines also vary in tone. For all the mathematical precision of the regular grid of squares that Mondrian was using, he proceeded by experience, assessing the visual balance as he worked.

In elaborating on a regular grid, Mondrian literally had to face the fact of a limited range of possible adjustments. As one rectangle grew in size, it diminished the space available to others, which in turn must be adjusted. The parts actually related to each other, and the canvas as a whole was a limited system within which balance had to be found. There is in this both economy and discipline of a kind applicable in fields other than painting. This complied with the aims of De Stijl; it was a necessary concept in architecture too.

The square canvases were accompanied by unit constructions in non-square rectangles in 1918-19 **114-5**, but the sides of these canvases were still subdivided into sixteen units, so that the smallest planes (equal to one unit) were of the same proportions as the whole canvas, and other planes were multiples of these. Every plane therefore had a relation to the whole. The proportion is 2:3, both relation-

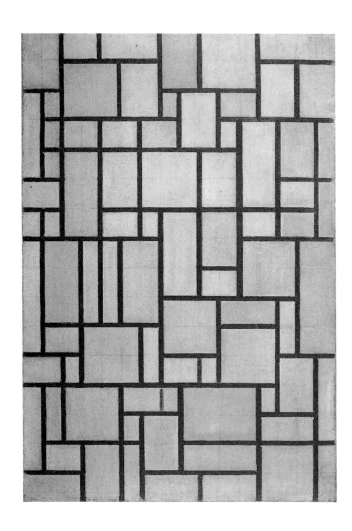

115 **Composition in Grey** 1919
Oil on canvas, 95.5 x 61 cm
Marlborough Gallery, London

ships in the Fibonacci Series and components of the Golden Section. (This ancient system of proportion which related the circle to the square, was expressible in geometric form, and was long considered an expression of the harmony of the universe, with applications in architecture and music as well as painting; hence it has been called the Divine Proportion.) Although Mondrian denied the use of the Golden Section later in life, it is clear that he knew of it. His mystical studies alone would have ensured this. In 1919, when he was most closely concerned with geometrically produced grids and the rectangles that could be assembled within the limited whole that they provided, the Golden Section was an almost inevitable consideration, since it was the perfect expression of the division of a rectangle

in such a way that the parts reflected the whole. A simply repeated subdivision of the square was primitive by comparison.

One last system of unit construction emerged in 1919. **Chequerboard with Light Colours 116** clearly reveals the regular grid in thin lines which again divide the canvas into 16 x 16 units. The rectangles are all of the same proportion as the whole. Only colour provides the irregular structure within this. The proportions are such that if the canvas is divided vertically the two vertical rectangles which result have the proportion of the Golden Section. As this proportion also applies to the units, the whole is pervaded by the Divine Proportion. Mondrian's mathematics were still mystical, and the movement relied upon proportion, as well as the kinetics of colour and position.

116 **Chequerboard with Light Colours** 1919
Oil on canvas, 86 x 106 cm
Gemeentemuseum, Slijper Collection, The Hague

117 **Chequerboard with Dark Colours** 1919
Oil on canvas 84 x 102 cm
Gemeentemuseum, Slijper Collection, The Hague

Paris : the mature style

5

118 The courtyard of 26 rue du Départ, Paris
Photograph
Rijksbureau voor Kunsthistorische Dokumentatie, The Hague

By 1919 De Stijl was in a position to pursue its aim of internationalism. Van Doesburg, like Mondrian, was making unit-based compositions, and the Belgian sculptor Georges Vantongerloo was exploring a mathematical basis for his sculpture. Their method of working seemed to be applicable anywhere. Once the war was over international travel again became possible. Later in 1919 Mondrian, now aged 47, left Holland once more for Paris, moving initially to 5 rue du Départ near Montparnasse station but ultimately returning to 26 rue du Départ **118**. He remained at this address until 1936.

Among Mondrian's early productions in this second phase in Paris was a text written like a play or discussion with three participants. In it he reflected on the dominant themes of his earlier work, outlining the progression of his painting and his thought.[54] He described the moon at late evening above the broad horizon of a flat landscape (see **14**); then followed an evocation of scattered clusters of trees silhouetted against a bright moonlit sky, and a broad expanse of sandy beach. 'Now,' said one of his protagonists, 'we can *see* that there is another "reality" above trivial human activity.'[55] In scene four he described 'a windmill, seen at very close range; dark, sharply silhouetted against the clear night sky; its arms at rest,

119 **Composition with Grey, Red, Yellow and Blue** 1920
Oil on canvas, 100.5 x 101 cm
Tate Gallery, London

120 Mondrian's studio at 26 rue du Départ, Paris showing the
arrangement of paintings and cards on the studio wall, 1926
Photograph
Gemeentemuseum, The Hague

forming a cross'[56] **66**. Scene six invoked the image of 'the facade of a church seen as a flat plane'[57] **65**. The seventh scene was set in the artist's studio and described the painter's freedom from domination by the objects he perceives.

Mondrian's studio in Paris became an extraordinary place. Immaculately orderly and austerely simple, its only decoration consisted of coloured rectangular cards placed upon the wall, and primary colour applied to the few objects that he possessed. He worked here in straitened financial circumstances and surroundings of uncompromising simplicity which startled, excited and impressed those who visited him. He seemed able to sell only the flower-pieces to which he reverted until the 1920s, but in his studio the only concession to natural form was an artificial tulip painted white. His simple bed was immediately behind an easel. Mondrian, in this austere studio, dedicated himself to austere paintings, full of rhythm, energy and life.

Writing about his 'trialogue' to Van Doesburg in December 1919, Mondrian said, 'My new piece deals among other things with the decorative as suggested by my present atelier, where I have been showing to some extent. Since I cannot paint directly on the wall I have merely placed painted cards on it. But I have come to see clearly that it is indeed possible for the New Plastic to appear in a room *in this way*. Of course, I had to paint the furniture as well...'[58]

The care with which Mondrian placed these coloured cards was characteristic. He worked upon them as if painting, rearranging the cards to form new combinations of rectangles, new rhythms; their primary colours, positions and proportions fed off his paintings and fed into his paintings, creating an extraordinary, and for Mondrian a fruitful environment, of which his paintings formed only a part, albeit the finalized and most important part.

Square paintings followed, exhibiting at first a surprising range of colours. **Composition with Red, Blue, Black and Yellow-Green 121** is 80 x 80 cm and employs an 8 x 8 unit grid, but has larger planes than earlier, divided by thin lines, the periphery defined by

121 **Composition with Red, Blue, Black and Yellow-Green
(Composition C)** 1920
Oil on canvas, 80 x 80 cm
The Museum of Modern Art, New York
Acquired through the Lillie P. Bliss Request

the narrowest planes again to 'present' the central arrangement. This shares many features with **Composition with Grey, Red, Yellow and Blue 119** which is a slightly larger square canvas probably without an underlying regular grid. A photograph of the studio **120** shows the latter hung high above the door among the rectangles of coloured card near the **Pier and Ocean** study **93**. The photograph, although black and white, apparently shows the painting in an earlier form than its present one, for the horizontal rectangle at the bottom left appears to have been repainted lighter in its present state. Similarly, the whole area to the left of centre appears to have been repainted in lighter pigment some time after the photograph was taken. In later life Mondrian certainly adjusted paintings after a term of several years, giving them, on occasions, two dates. He may have adjusted works over a period of time at this stage too.

In Mondrian's first Parisian period **83-92**, the interlocking rectangular planes were associated with the city and the vitality of urban life as distinct from the vitality of natural form in the landscape. Celebrating the energies of the cityscape had fascinated the Italian futurists, as well as Delaunay and Léger. Marinetti, the mouthpiece of the futurists, sent Mondrian his *Mots en liberté futuristes*, poems in which sounds and a dynamically unconventional layout expressed an energetic deluge of noise and movement. The Italian painter Gino Severini, formerly an ardent futurist, had joined De Stijl at its outset. Back on the great boulevards of Paris, Mondrian was again among the urban energies which, from a different point of view, excited his own enthusiastic contemplation, and he wrote a graphic account of the boulevards' activity in which the kaleidoscopic fusion of impressions bears direct comparison with the futurists' 'simultaneity'. After evoking noises directly, he described 'a multiplicity of sounds, inter-

penetrating, automobiles, buses, carts, cabs, people, lamp-posts, trees . . . all mixed; against cafés, shops, offices, posters, display windows; a multiplicity of things. Movement and standstill: diverse motions. Movement in space and movement in time. Manifold images and manifold thoughts.' Mondrian observed change, continuity and stillness intersecting and interrelated. The boulevard itself remained motionless but it was full of change and movement. The whole remained still while the particularities, parts and details ceaselessly moved. This was the same vision that informed his paintings, for while the canvas as a whole was changeless, its parts appeared visually in ceaseless movement.

Van Doesburg visited Mondrian in Paris in February-March 1920, as did the De Stijl sculptor Vantongerloo in April and the architect J. J. P. Oud in August. The *Section d'Or* (Golden Section) Cubist exhibition which Van Doesburg saw there impressed him, and he arranged for part of it to be displayed in Holland with the inclusion of three of his own paintings, three paintings by Mondrian and a study by Huszar; he described the Dutch additions as neo-Cubist work.[59] In the *mélange* of connections developing two years after the war Van Doesburg became a key figure, and Dada had begun to attract his attention. He even became a Dadaist poet under the pseudonym of I. K. Bonset.

Mondrian published an important essay through the director of the gallery *L'Effort Moderne* in Paris. This was Léonce Rosenberg, who more than once proved his interest in De Stijl. The essay appeared as a pamphlet entitled 'Le Néo-Plasticisme', the name Mondrian had adopted for his new theory and practice of painting. Rehearsing the main tenets of his outlook and view of art, Mondrian explained that his was an art of relationships, since 'the coloured

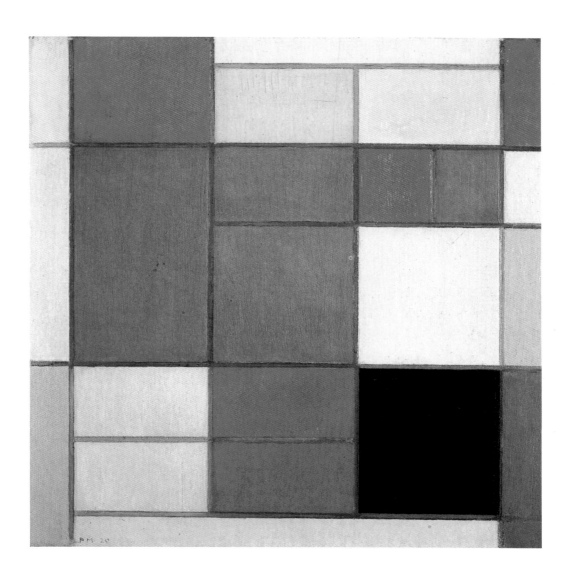

160

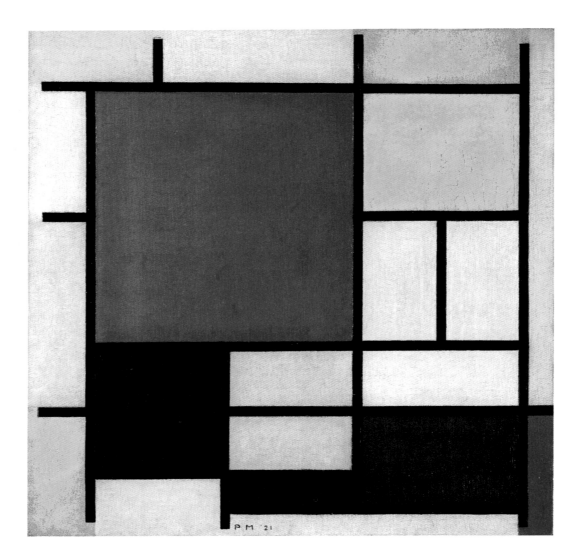

122 **Composition with Red, Yellow, Blue and Black** 1921
Oil on canvas, 59.5 x 59.5 cm
Gemeentemuseum, The Hague

planes, as much by their position and dimension as by the greater value given to colour, plastically express only relationships and not forms.'[60] There was no mention of Theosophy or Schoenmaekers. Mondrian had by now learnt from them what he needed, and he developed his theory through his researches in painting. Nevertheless, he wrote primarily about the nature and purpose of art, rather than painting specifically, and was convinced that 'the new art is born'.[61]

In June 1921 he attended a concert of futurist noise-music featuring the noise-instruments (the *intonarumori*) of the Italian futurist composer and painter Luigi Russolo. For one who lived within earshot of Montparnasse station, with its constant arrivals and departures, shunting and whistles, such a concert might have been superfluous, but Mondrian had long sustained an interest in music, and he may have listened to both the concert and the station with an awareness of these urban rhythms, too, in his mind.

Van Doesburg meanwhile continued to promote De Stijl abroad, particularly in Germany where he began a sustained intrusion into the Bauhaus at Weimar. He also met the Dadaist Hans Richter and took an interest in his geometric film experiments and those of Viking Eggeling. He produced pamphlets with the Dadaists Hans Arp, Tristan Tzara, Georges Ribbemont-Dessaignes, Kurt Schwitters and Raoul Hausmann. The revolutionary and geometric rectangularity of the De Stijl aesthetic could easily have been viewed as anti-art in its ruthless rejection of so much of the art of the past, and its champion, the former Charles Kupper, alias Van Doesburg, alias Dadaist I. K. Bonset, now became an Italian futurist, too, by adopting yet another name: Aldo Camini.

It was in 1921 that Mondrian's visual vocabulary crystallized into its definitive form. The square painting **Composition with Red, Yellow, Blue and Black 122** perfectly embodied it. Narrow lines mark out the rhythms fundamental to his philosophy and practice. Only one line here (vertical, far right) crosses the full span of the canvas and Mondrian stopped it just short of the canvas edge. Other lines cut across the canvas to be stopped by perpendicular lines or to cut through them, forming planes of primary colour or non-colour. The lines, colours and their proportions all suggest movement within the limited space of the canvas. They are interrelated and resolved into the dynamic balance of opposing forces that Mondrian discussed so frequently in his writings. The relationships no longer correspond to an underlying grid. Evolved by eye, they operate efficiently on the visual level. Neo-Plasticism in visual composition required only these elements. Imagery was no longer useful or permissible. Brushwork was prosaic.

Like the **Composition with Grey, Red, Yellow and Blue** of 1920 **119**, this painting has narrow marginal planes while the great red square dominates the remaining area which itself approximates to a square, although this is interrupted at the lower left. The red square also forms a strong diagonal as its right and lower lines cross over to form a smaller square or near-square, itself divided horizontally. A pair of identical rectangles above this restore the vertical theme, and a similar arrangement occurs to the left. Both are then blocked by larger rectangles, of which the one at the left is again square. There are numerous ways of reading the network of relationships. It can be seen, for example, as essentially two elevations, with the red square equally divided along its base into two squares of which that on the right is equally divided in turn but horizontally. The variety of spatial and proportional readings enables the eye to

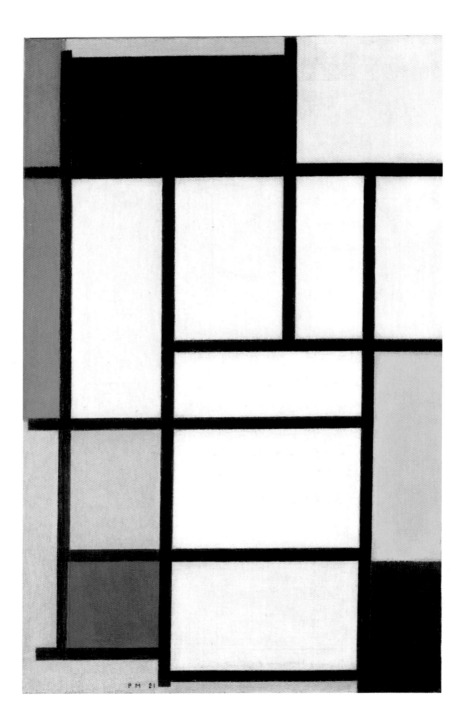

123 **Composition with Red, Yellow and Blue** 1921
Oil on canvas, 80 x 50 cm
Gemeentemuseum, The Hague

explore the relationships by following the lines until a stop occurs and the movement turns off at a right-angle to form a plane which may be filled with colour. The colours, too, balance visually within this dynamic framework, the large red being answered by a multitude of small planes with a cumulative supporting role.

The economy of means which provides this complexity makes the painting look simple when it is not. All is clear as it can be, but intricate in its visual dynamics and the complex network of its relationships. Lines depend upon other lines, planes depend upon other planes. The balance which comes from this leaves nothing superfluous or redundant. It is a closed system in which every element plays its part and each element is related to the next. Vertical balances horizontal in both line and plane; the parts balance within the whole; colour balances non-colour.

The square which **Lozenge with Grey Lines 108** first revealed as a deliberate choice - determined, as Mondrian would say - is now the subject, and the colours are employed for their unique 'determined' qualities too. The red, blue and yellow cannot be altered any more than straight lines or squares can be altered without losing their intrinsic identity. Consequently they are nothing other than what they are. There is no depiction, no qualifying tone or mixture of colour. There is no curve or diagonal. The identity of Mondrian's elements is now clear and is employed consciously. The grid-like construction of these paintings follows from the nature of the elements. All that changes is the number of elements, the proportions of the parts, and the rhythm they establish.

This was enough for Mondrian. Here were the fundamentals of his painting. Their relationships stood for all that existed, and he could see in those infinite relationships the visual evidence of his view

of the world, his own cosmology. By 1921, therefore, he had evolved a procedure which was to suffice for the remainder of his career. Rhythm, after all, was both one, a concept in itself, and many, different in each painting. This was *the* style (or *de stijl*) addressed only in terms of the ideal to the specific painting in hand. The variety of relationships, or rhythms, was, as he meticulously proved, quite inexhaustible, flexible and above all dynamic.

Composition with Red, Yellow and Blue became a recurrent title, effectively masking the great variety of Mondrian's work. A composition of 1921 **123** measures 80 x 50 cm, a Golden Section proportion, but the give and take of adjustments made by eye was his main working procedure by that date; each painting had in effect its own narrative in which primary colours were the protagonists, with new roles in each work. Here yellow escapes only to the right, so that this vertical plane would be horizontal in extension. Black, grey, red and yellow frame a cluster of ambiguous white planes which may be interpreted as a single white plane that flows continuously beneath black lines. Blue alone, the spiritual colour, is bounded by a square. Each colour holds its own position in the grid but moves in or out of the canvas visually. As Mondrian explained, these are not yellow, red or blue objects, but planes of colour. In consequence the colours glow like light in a space, disembodied, non-descriptive or revealing only their own qualities and their relationships by proportion and position to the other elements.

The framing of the white is remarkable. As the highest tone it glows and leaps forward; it appears a positive force, particularly beside the yellow. Yet, as the colour beneath the black lines, it falls back, like empty space, a hollow, receding background. Close inspection of the action of the white reveals that the central four

124 **Lozenge** 1921
Oil on canvas, 61.1 x 60.1 cm
Art Institute, Chicago

planes of white are brighter than the near whites that surround them. By optical contrast with the black lines and adjacent planes these whites appear to adjust to their surroundings.

As Seurat knew, and as Mondrian also knew, having once been a pointillist himself, colours and tones are affected by their surroundings. The colours visible are the result of relationships. Like Seurat before him, Mondrian isolated the elements of his art and the method with which to use them. Like Seurat again, he progressed from the landscape to the city, intent upon embodying its vitality in the rhythms of paintings that were, like city life, overtly artificial. Both light and form are reduced to their elements to make a painting that is expressive and alive. Mondrian does not mix his colours or turn his lines. He stops short to reveal the structure itself, the rhythm at work, the potential of complexity, the creativity caught in the process of action.

The paintings which followed were each balanced in their own terms but used the same vocabulary. During the early 1920s Mondrian generally reduced the number of elements to a minimum. After the complexity of his previous Parisian period, he tried to reduce his structure as far as possible. Once the elements of his painting were determined, their relationships developed and changed continuously. In this process the square continued to play an important part **124-5, 131, 135, 137-45**.

Taking up the lozenge format again in 1921, Mondrian began to use the space surrounding the canvas. **Lozenge 124** employs four horizontal and three vertical lines but only one fully enclosed plane. The other ten planes extend off the canvas, implying conjunctions of lines beyond the edge of the painting. This imaginary 'closing' of a plane is only possible in the lozenge format. There are three cate-gories of plane: first, the enclosed rectangle; secondly, those which would close off the canvas; and thirdly, those which extend off the canvas without any suggestion of closure. Mondrian in this way articulated space both on and off the canvas, even suggesting boundless planes extended infinitely beyond the canvas. Seen as either expansion outwards from a core of fixed relationships, or crystallization inwards, these paintings are unprecedented in their control of space and the relationship of the general to the specific: the painting acquires a nucleus and an edge, appearing to grow from its core outwards. As the framework of balanced colour planes and lines expands outwards into space, so space appears to penetrate the framework of the painting.[62] Superfluous lines would have obscured this. In a sense Mondrian focused upon the essential core of relationships so that their extension, for example that of the lines, is adequately grasped by the imagination. In other words, it followed logically from the basis provided by the artist, and no more information was needed. This essential core looks like a close-up view of the nucleus of an infinite structure which, though it is scaleless, is nevertheless rhythmically structured.

The lozenge also has new visual properties here. Only the enclosed plane is rectangular. The others in fact have three, four, five or six sides. They still, however, read as rectangular planes extending off the canvas. Moreover, the marginal 'framing' of central areas by narrow planes **123** is dispensed with altogether in **Lozenge 124**. Finally, the lozenge's longest vertical and horizontal are located between the opposite corners of Mondrian's canvas. They are not painted in but the expansion from corner to corner is visibly evident, as is the geometric centre of the canvas where these imaginary lines cross. There is therefore still a sense of regular, symmetrical structure

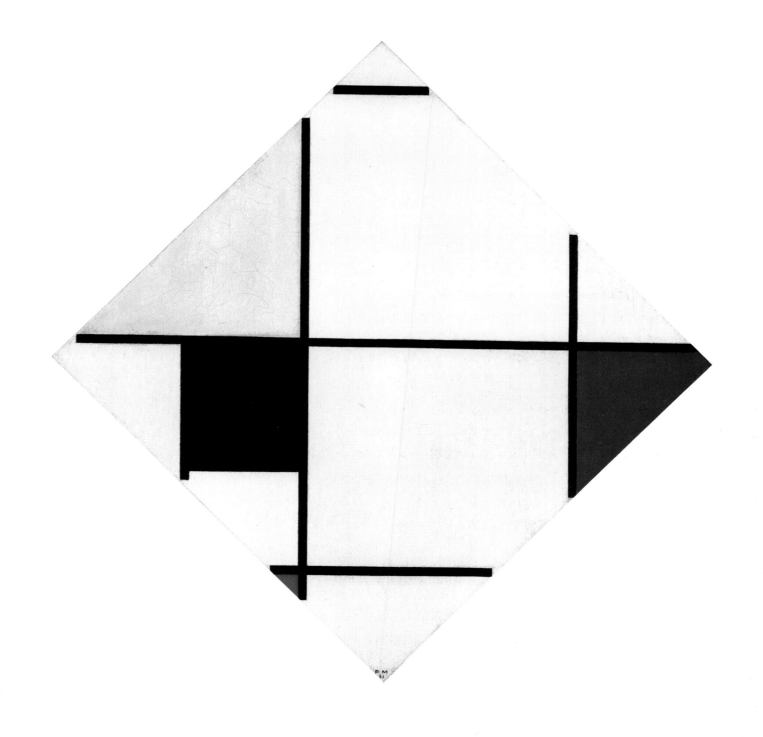

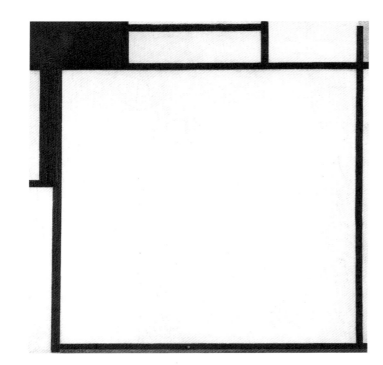

125 **Composition in a Square** 1922
Oil on canvas, 54 x 54 cm
Sidney Janis Gallery, New York

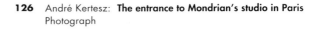

126 André Kertesz: **The entrance to Mondrian's studio in Paris**
Photograph

against which Mondrian's painted framework appears as an adjustment or variation. This in itself suggests movement located firmly in the perpendicular axis to which Mondrian attached so much significance. Each line, except one defining the closed plane, cuts two edges of the canvas. In doing so it makes an equilateral triangle with the edges receding at forty-five degrees towards the corner of the canvas. These can be read as a rhythmic intrusion of perpendicular, transparent planes moving towards or away from the centre, establishing planes and filling some of them with colour as they intersect. Almost nothing is solid or specific and yet everything is clear: it is indeed an art of relations.

This rhythm, which he called dynamic balance, was not restricted to painting. He sought it in music and was already finding opportunities to listen to jazz with the architect J. J. P. Oud. However, he criticized the Italian futurist noise-music, despite such new instruments as the *intonarumori*, for its imitative and 'animal-based' tendency.[63] On the other hand, as his essay of 1922, 'Neo-Plasticism: Its Real-

ization in Music and Futurist Theatre', indicated, he was interested in the possibility of planes of colour presented in time, by a kind of score, rather than spatially.[64] Similarly, he considered the architectural potential of such planes as a basic, though problematic, extension to the building of his concepts of balance and asymmetrical rhythm. Their use as decoration, as an applied afterthought, was inconceivable.[65]

A square painting of 1922 shows a return to the device of 'framing' the central area. **Composition in a Square 125** isolates a white, square plane, as if to present its empty perfection; attended or supported by other planes, it adjusts its rhythm by its setting and by articulating its asymmetrical position in relation to the canvas edge. This square is the focus of attention and asserts its primacy as a positive visual fact. The white is in effect pushed forward by this device, made into a positive plane and not mere empty space. It is a presentation of the square. As with the church tower, the large mill, the tree and even the sea, Mondrian essentially painted one subject.[66] Formerly a

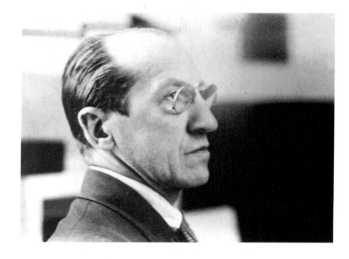

127 Michael Seuphor: **Portrait of Piet Mondrian** c.1929
Photograph
Gemeentemuseum, The Hague

single observed motif, it is here a geometric shape presented for its balanced, generic, rhythmic and proportional purity.

By 1922 Mondrian's theoretical and practical procedures were well defined. They were constructive in essence and looked to the future of man's organized life and environment. They showed no tendency whatsoever to mimic the outward appearance of nature; nor were they simply illustrations of philosophical, still less theosophical, theory, for Mondrian had by now evolved his own principles thoroughly. If his thinking had its roots in the philosophy of others, his exploration was now confidently conscious, visually determined, and aimed at an active and constructive role rather than a purely reflective or contemplative one. Mondrian in 1922 clearly found Theosophy inadequate. It had, he believed, discovered the 'basic symbol of equivalence'[67] but never achieved the experience of it. He, himself, by contrast, was undoubtedly in the position to achieve this experience. His paintings were not theories but objects. They moved beyond theory to practice, example, and experience.

In so far as this attitude involved rejecting the past, and along with it his own past work, it could be viewed as negative, although Mondrian rarely implied anything of the kind. His stance had much

in common with De Stijl theory and practice. Van Doesburg's internationalist ambitions were bearing fruit in 1922: he undertook a Dadaist tour through Holland; he lectured at the Bauhaus in Weimar; he attended the International Congress of Progressive Artists in Dusseldorf; and the *De Stijl* periodical illustrated the geometric *Story of Two Squares* by the Russian El Lissitzky. Mondrian meanwhile pursued his studies independently in Paris, in his austere and fruitful studio. 'In the spacious light, atelier, although right next to the Gare de Mont-Parnasse', he explained, 'I am happy here. Paris seems good to me, and the atelier pleases me'.[68]

Mondrian's writings make astonishingly few references to fellow members of De Stijl. He concentrated instead upon his own extraordinary conjunction of philosophy and practice. Yet De Stijl was diversifying vigorously by 1923, and although it found in the designer Rietveld a practitioner and theorist whose views were closely to echo Mondrian's concepts of space, Mondrian wholly refrained from publishing close discussion of other De Stijl members' work. Even when De Stijl work was displayed in Paris in 1923, he abstained from comment except on the general theoretical level. At this time, for example, Léonce Rosenberg exhibited architectural

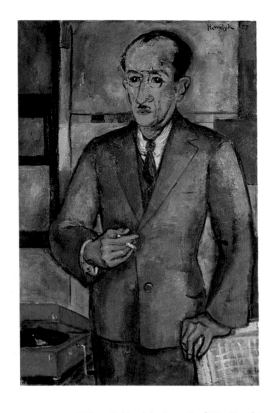

128 G. Hordijk : **Portrait of Piet Mondrian**
Oil on canvas, 115 x 73.5 cm
Gemeentemuseum, The Hague

projects by Van Doesburg and Van Eesteren[69] at his gallery *L'Effort Moderne*, yet Mondrian merely continued arguing the case for the development of architecture and painting together, according to his own 'neo-plastic' principles, for 'The new aesthetic of architecture is that of the new painting.' He believed that the two activities could 'dissolve into each other'.[70]

De Stijl was also diversifying in other ways, by reinforcing its link with Dada and engaging in related projects; for example, Van Doesburg collaborated with Hans Arp, Tristan Tzara and Kurt Schwitters to produce four numbers of the periodical *Mécano* in 1922-3.

Although Mondrian preserved his independence, he was by no means isolated and many artists, writers and friends visited his studio. The Belgian writer Michel Seuphor, who was to publish the first monograph on Mondrian, became a friend in 1923 and described his visit to the artist in April of that year **126**:

'The studio was quite large, very bright, with a very high ceiling. Mondrian had divided it irregularly, utilizing for this purpose a large black-painted cupboard, which was partially hidden by an easel long out of service; the latter was covered with big grey and white paste-boards. Another easel rested against the large rear wall whose appearance changed often, for Mondrian applied to it his Neo-Plastic virtuosity. The second easel was completely white, and used only for showing finished canvases. The actual work was done on the table. It stood in front of the large window facing the Rue du Départ. . . he had two large wicker arm-chairs, also painted white, and, on the scrupulously clean floor, two rugs, one red, the other grey. Such was the studio, where he was to receive so many visitors'.[71]

By 1924 De Stijl had found a thorough architectural formulation in Rietveld's *Schroeder House* in Utrecht. Van Doesburg, too, remained immensely active, exhibiting in Weimar and also lecturing in Prague, Vienna and Hanover. In 1925 the Bauhaus published books by both Mondrian[72] and Van Doesburg; these were followed by J. J. P. Oud's *Bauhausbuch* in 1926. With characteristic vigour Van Doesburg dedicated his volume to his 'friends and enemies',[73] and outlined a concept of growth in art from imitation to representation and then formation, a process not irrelevant to Mondrian's own development.

On the other hand, it was in 1924 that Van Doesburg profoundly disturbed Mondrian by the introduction of Elementarism.

129 Mondrian with friends at St. Germain-en-Laye, 1925
The sculptor Georges Vantongerloo is on the right
Photograph
Gemeentemuseum, The Hague

130 Mondrian (second from the left) at Paul Dermée's home
Beside him are the Belgian sculptor Vantongerloo and (bearded)
the Italian Futurist painter and composer Luigi Russolo
Photograph 1927
Gemeentemuseum, The Hague

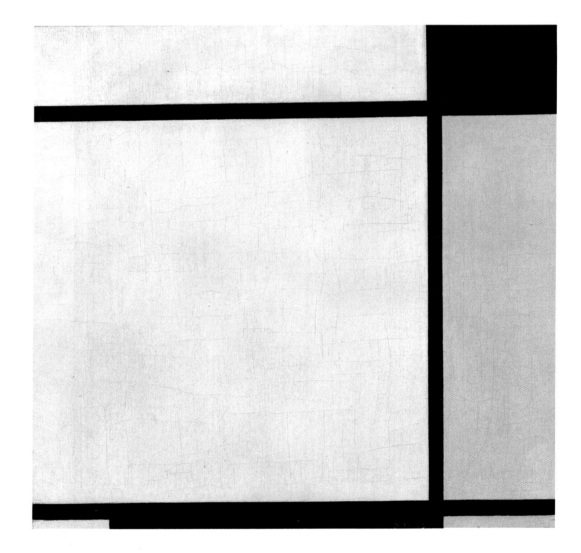

131 **Composition with Grey and Black (Painting No. 2)** 1925
Oil on canvas, 50 x 50 cm
Kunstmuseum, Prof. Max Huggler-Stiftung, Berlin

132 Mondrian (second from right) with friends
Photograph 1928
Gemeentemuseum, The Hague

Retaining much of the geometric framework so important to Mondrian, Van Doesburg turned it on to the diagonal axis. However dynamic the result, it shook Mondrian's profound belief in the separate, distinct qualities of horizontal and vertical and the significance of their junction. The contrast was completely undermined in a way which bore a deceptive and superficial resemblance to Mondrian's structures. The result was heretical and promised confusion concerning fundamental beliefs and means. This was made worse by Van Doesburg's willingness to spill the colour planes from the grid and even to include the tertiary mixture brown among his colours.

As **Composition with Grey and Black (Painting No. 2)** **131** reveals, Mondrian was not averse to innovation. His whole career was devoted to change and evolution, but in 1925 he was still dedicated to a ruthless simplification of his painting, reducing his means to the barest minimum, and even producing paintings devoid of colour. The heretical elaboration introduced by Van Doesburg from 1924 was anathema to Mondrian's minimal simplicity, poise and balance. He was still, for example, preoccupied by the stasis of the square, frequently, as here, employing a square canvas (see **131, 135, 137-45**).

In **Composition with Grey and Black** there are essentially only three lines all cutting across the full width of the canvas. Only the brief edge to the lowest planes (lower left) is added, and all planes expand off the canvas: no plane is fully defined on all four sides. The earlier procedure of enclosing an empty square with narrow planes to limit it and, by this framing device, to present it **125**, has now given way to greater spaciousness and expansion. Here the white square, the largest plane, is defined along its left vertical edge by the perimeter of the canvas. The effect is to produce a carefully ambiguous balance of retainment and expansion: it can be read as a square, a contained static proportion, or as flying off to infinity leftwards. The effect of this release at the left is that the lines alter their function: the crossing of vertical and upper horizontal creates four planes, of which the white square and diagonally opposite dark plane are in a special, emphasized relationship, expanding away from the point of crossing which defines them. As one grows, the other must reduce. It is the cross which is isolated and not the closed plane, since it is the cross which is fundamental in generating and relating these two planes. There is in this a reference to the diagonal, but it is implied by position and not explicit in the way that Van Doesburg used it.

133 Theo van Doesburg :
Counter-composition with Contrasting Colours
Gemeentemuseum, The Hague

134 Mondrian standing in front of the painting
by Theo van Doesburg **Dreieck** 1928
Kunsthaus, Fritz Glarner Archive, Zurich

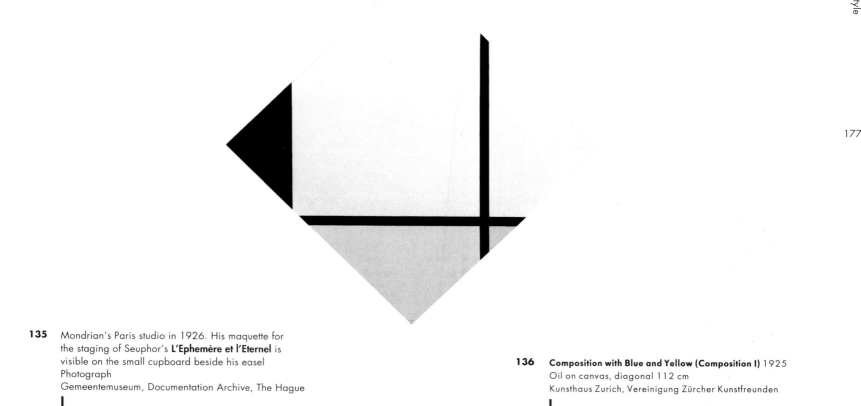

135 Mondrian's Paris studio in 1926. His maquette for the staging of Seuphor's **L'Ephemère et l'Eternel** is visible on the small cupboard beside his easel
Photograph
Gemeentemuseum, Documentation Archive, The Hague

136 **Composition with Blue and Yellow (Composition I)** 1925
Oil on canvas, diagonal 112 cm
Kunsthaus Zurich, Vereinigung Zürcher Kunstfreunden

Mondrian's lozenge paintings also employ the diagonal but only in the canvas edge. All painted lines and planes remain resolutely perpendicular and these, too, in the mid-1920s were to become as minimal as he could make them.

Composition with Blue and Yellow 136 has only three lines and two areas of colour. None of the planes which this creates is bounded on all sides. Consequently all the planes, whether white, blue or yellow, appear to expand off the canvas to infinity, and the crossing of the lines takes precedence over the limiting of the planes. The crossing is once again the generative conjunction which creates the planes. The largest plane is different in kind, since it is bounded upon three sides – or so Mondrian implies, for in fact he shows only one crossing point in this painting (lower right). The other is implied as occurring just off the canvas (lower left). The effect of bounding this large plane in this way is to suggest a firmness and positive solidity denied even to the coloured planes. As the painter Max Bill has pointed out,[24] Mondrian has in fact presented no rectangular planes but a hexagon, two trapezoids and two triangles. They only read as rectangular because they appear to extend beyond the edges of the canvas.

Mondrian's lines in the lozenge paintings cut the canvas edge to create areas which always form triangles: the canvas edges they intersect are always both the same length in any triangle formed in this way. They inevitably relate to the geometric axis of his canvas, so that they may appear to have shifted from that position (the longest possible line) towards the corners at which they would vanish. Alternatively, they may be read as lines approaching the centre laterally from infinity. Understood in this way, they illustrate Mondrian's long-sustained concern for the specific in relation to the infinite and appear to form overlapping transparent planes moving in and out and up and down. At the lower right of **Composition with Blue and Yellow 136** the overlapping of these planes produces yellow.

The position of this yellow has another characteristic: it is central to the lower right edge of the canvas. Suddenly the symmetry of this yellow and the lines either side of it is revealed. Were the axis of the painting turned so that the yellow was at its base, the symmetry would be immediately apparent, but the distinctness of vertical and horizontal would be lost. This yellow is not of course symmetrical about either the vertical or horizontal axis of the lozenge format, and this makes it less evident visually. The blue and its associated line

137 Composition with Black and Blue 1926
Oil on canvas, diagonal 84.5 cm
Museum of Art, The A E Gallatin Collection, Philadelphia

further distract from the symmetry and confirm the vertical rhythm. Mondrian plays off symmetry against asymmetry in a way comparable to the earliest lozenge paintings **108, 110**, in which, as here, the two possible divisions of his square canvas, either diagonal or perpendicular to its edges, are interrelated. They are distinguished in this case with an unprecedented economy of means in which nothing is superfluous and everything which is necessary is stated. In a framework of such reductive elegance it is perhaps not surprising that the colours employed are yellow and blue, the colours of intellect and spirituality.

Although it was never executed, Mondrian evolved a design for an interior in 1925-6. Known as the **Salon of Mme B... at Dresden**, it was commissioned by the collector and patron Ida Bienert who had purchased work by Mondrian the previous year.[5] It

related to the division of his own studio into planes of colour and non-colour. His friendship with the writer Seuphor led Mondrian into a comparable project during 1926 – a stage set, never realized beyond the maquette **135**, for Seuphor's *L'Éphémère est l'éternel*. Mondrian was evidently willing to contemplate three-dimensional works, but his studio interiors, which were of direct relevance to his paintings, remained the only full-scale executed projects of this kind. These projects were also signs of a widening interest in his work. New buyers were few but significant and they were accepting Mondrian on his own terms. Moreover in 1926 the American Société Anonyme displayed a painting at the Brooklyn Museum; this was the first sign of American interest in his work.

Meanwhile Mondrian's painting continued to pursue the most minimal form. **Composition with Black and Blue 137** is a lozenge

138 **Composition in Black and White (Painting I)** 1926
Oil on canvas, diagonal 113.7 x 111.8 cm
The Museum of Modern Art, Katherine S. Dreier Bequest, New York

with only two lines. Mondrian never used fewer, and could not use fewer without losing the opposition he so valued. As in **Composition with Blue and Yellow 136**, the cross is symmetrical if the coloured triangle, here blue, is seen as the base line, but the artist has presented the painting in the lozenge format. No enclosure of planes is permitted at all. All planes extend to infinity. The only area in which two triangular shapes cross is now coloured blue; into this minimal painting, which is almost entirely white, it is the spiritual colour that is inserted. This is the most rarified of the sequence, although it does incorporate one primary colour. The larger canvas, **Composition in Black and White 138**, has no colour at all. Here the lozenge is crossed by four lines which almost form a square. There is only one crossing but three others are implied at different distances beyond the canvas edge. The remaining two lines cut the canvas without

uninterruption and are of differing width, which suggests that thick lines are nearer and thinner lines more distant. A strong diagonal axis is implied (upper left/lower right).

In 1927 Mondrian formally left De Stijl. His work was increasingly recognized internationally and the aims of the group coincided less and less with his own. With geometrical construction in painting and sculpture spreading vigorously, he perhaps no longer felt any attachment to De Stijl or any need of its moral support. The American collector Katherine S. Dreier had acquired paintings by Mondrian for the Société Anonyme exhibition at the Brooklyn Museum in 1926, Lissitzky incorporated two of his canvases into his display of non-representational works at the Landesmuseum in Hanover in 1927, and he was beginning to find buyers in Germany and Switzerland.

Composition with Red, Yellow and Blue 139 indicates a new

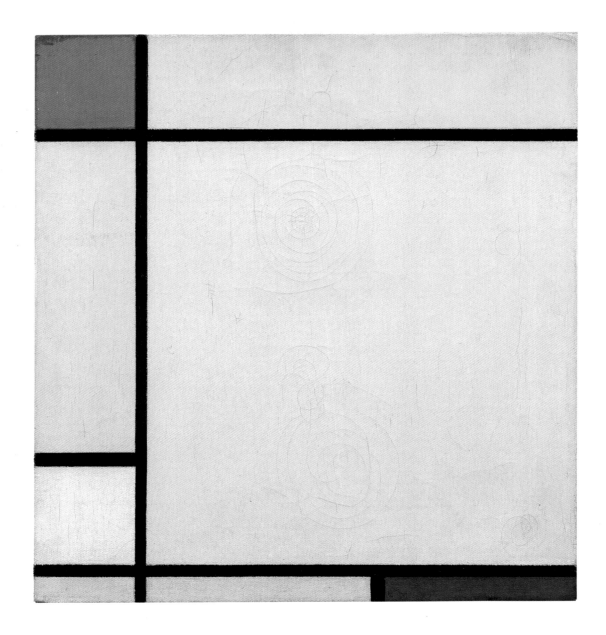

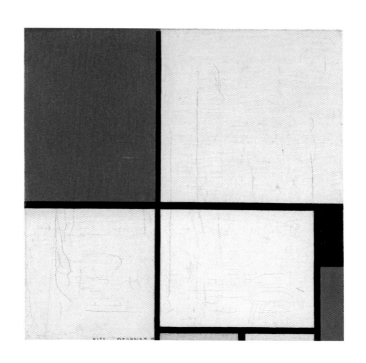

139 **Composition with Red, Yellow and Blue** 1927
Private Collection

140 **Composition with Red, Yellow and Blue** 1928
Oil on canvas, 45 x 45 cm
Wilhelm Hack Museum, Ludwigshaven am Rhein

attitude and a gradual return to complexity, playing off the balance of the 'dominant cross' format and the 'presented square' format. There are also thicker short lines and slenderer long lines. The cross-over of the longest lines again largely determines planes diagonally opposite, balancing a large white square against a small coloured plane which here extends down the left of the main white plane throwing its top left corner into relief, only to be stopped effectively by a thick short horizontal.

In 1928 a **Composition with Red, Yellow and Blue 140** lowers the long horizontal line below centre. The coloured plane (top left) has grown and its diagonally opposite white plane has correspondingly reduced. It is still bounded by black lines, but bringing the only crossing closer to the centre of the painting has released planes at

the top right and lower left which extend in an indeterminate way beyond the canvas. These two paintings are nevertheless closely related, and the thickness of the black lines varies in both. The bounded area remains white while all other planes are red, yellow, blue, grey or black. Red dominates as blue and yellow are reduced.

The square was an important proportion in these canvases, and the geometric arrangement of Mondrian's painting appeared increasingly in sympathy with the aims of several groups in the late 1920s, especially *Cercle et Carré* founded by Mondrian's friend Michel Seuphor and the South American Joaquin Torres-Garcia in 1929-30. At its first exhibition in 1930, Mondrian exhibited with Arp, Sophie Taeuber-Arp, Huszar, Kandinsky, Schwitters, Pevsner, Vantongerloo and others.

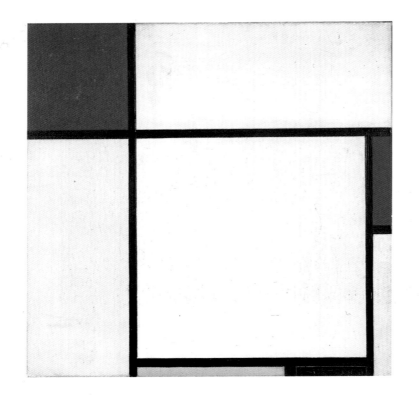

141 **Composition** 1929
Oil on canvas, 45 x 45 cm
Solomon Guggenheim Museum, New York

142 **Foxtrot B** 1929
Oil on canvas, 44 x 44 cm
Yale University Art Gallery, New Haven

Four more paintings of 1929 confirm the continuing significance of the square. **Composition** and **Foxtrot B 141-2** again present the large empty plane with a coloured plane corresponding to it diagonally beyond the single cross-over. **Foxtrot B**, which indicates by its title Mondrian's continuing interest in jazz, employs a dramatically thickened line (at left). Comparable themes followed. **Composition in a Square 143** has no bounded planes but the square is again present as the dominant plane, now extending off to the right and below. All planes remain open here, as they do in **Composition 145**. Here the horizontal stretches the full canvas width below centre,

and the long vertical is decisively to the right. The large plane still approaches square but does not correspond to a coloured plane diagonally opposite and is bounded at the upper left by colour, terminating like **Foxtrot B** in a thick horizontal line along its lower edge. Openness abounds and no closure of planes occurs.

By 1930 this dominant cross had again been reduced and rarefied. **Composition with Yellow 146** has a smaller bounded plane opposing three large open planes in the other sectors of the cross, while colour, yellow only, supports it in attendance, small but significant at the right, again bounded below by a thick black line.

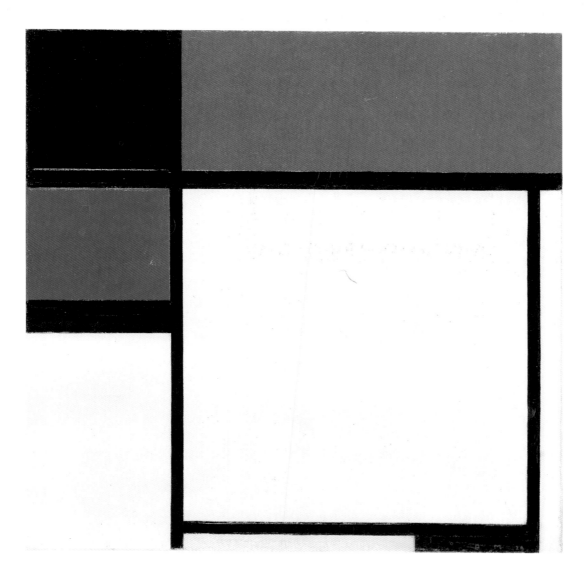

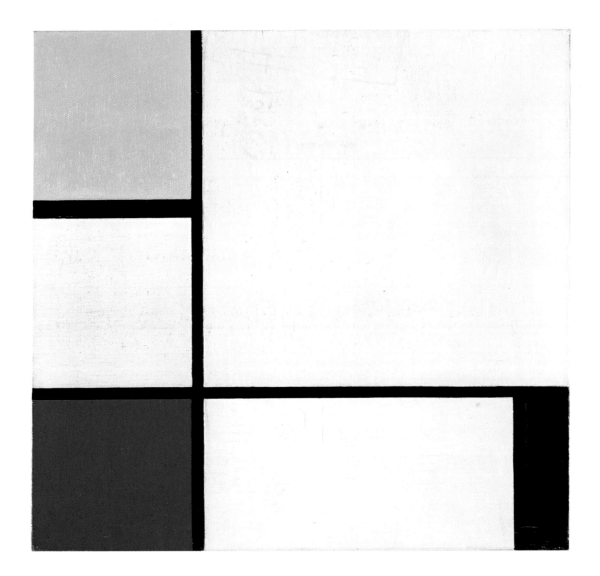

143 **Composition in a Square** 1929
Oil on canvas, 52 x 52 cm
Yale University Art Gallery, New Haven

144 Paintings by Mondrian in his studio with an
arrangement of cards on the wall, 1930
Photograph
Gemeentemuseum, The Hague

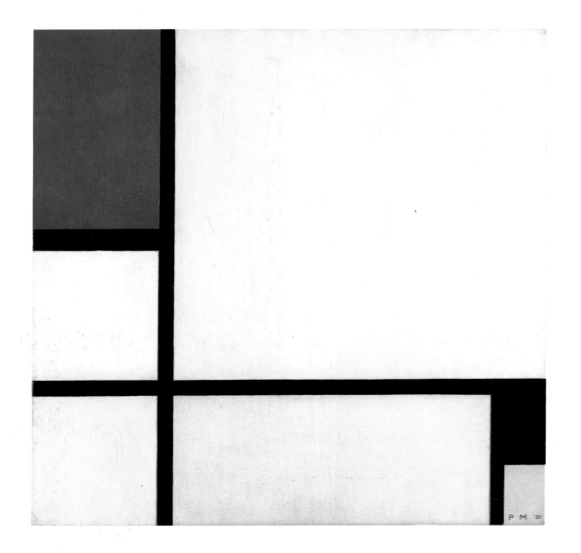

145 **Composition** 1929
Oil on canvas, 52 x 52 cm
Kunsthaus, Basle

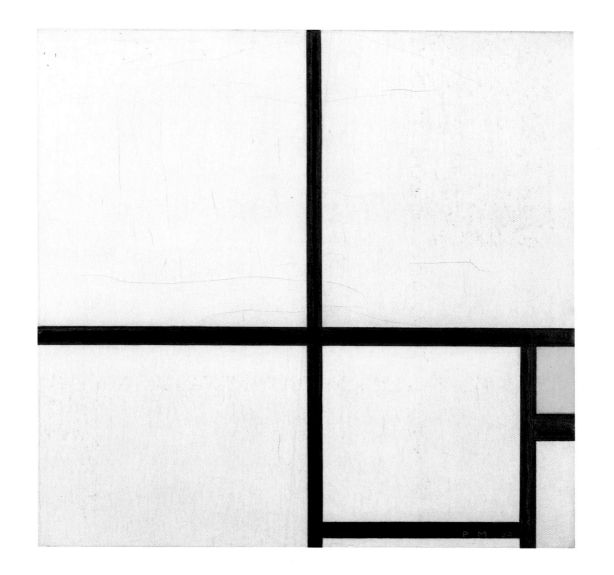

146 **Composition with Yellow** 1930
Oil on canvas, 46 x 46.5 cm
Kunstsammlung Nordrhein-Westfalen, Dusseldorf

188

147 Composition II with Black Lines 1930
Oil on canvas, 41 x 32.5 cm
Stedelijk van Abbe Museum, Eindhoven

148 Foxtrot A 1930
Oil on canvas, diagonal 114 cm
Yale University Art Gallery, New Haven

The minimal, reductive attitude had swiftly returned and a ruthless abolition of closed forms followed in the period 1930-2. **Composition II with Black Lines 147** omits colour altogether and presents only three lines. There is only one crossing and a stopped line which emphasizes the edge of the large plane. Mondrian's device of enclosing the middle right plane on three sides gives it a degree of positive force as it abuts the large plane, further throwing this area

into clarity of resolution. The long extension of the horizontal line leftwards is balanced by a heavier, less extended assemblage at the right.

Lozenges also recur in 1930-1 in colourless works related closely to the lozenges of 1925-6. **Foxtrot A 148** is comparable to **Composition with Blue and Yellow** of 1925 **136** but replaces the blue emphasis at left with a heavier short vertical line. One crossing

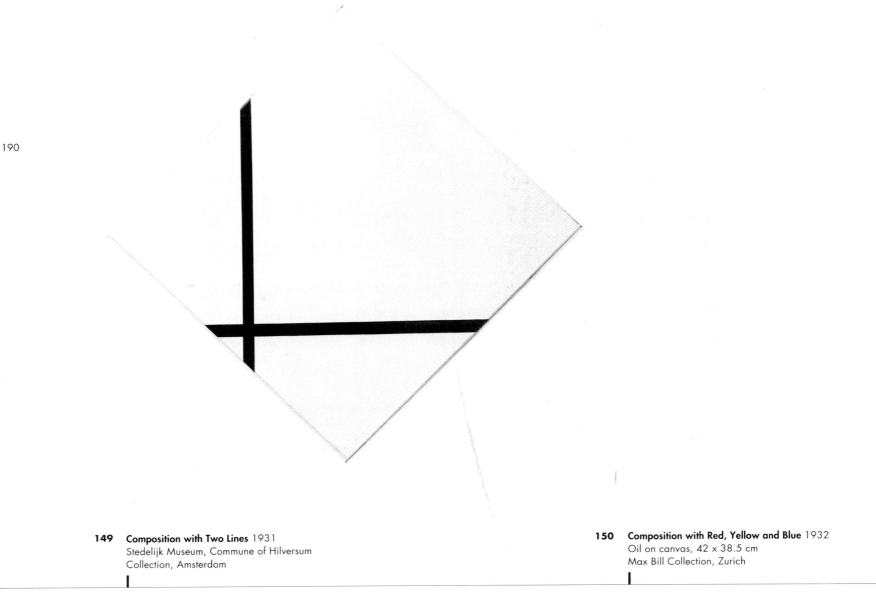

149 **Composition with Two Lines** 1931
Stedelijk Museum, Commune of Hilversum
Collection, Amsterdam

150 **Composition with Red, Yellow and Blue** 1932
Oil on canvas, 42 x 38.5 cm
Max Bill Collection, Zurich

occurs right at the canvas edge, while the other is implied beyond the canvas. The lozenge **Composition with Two Lines 149** is the artist at his most minimal – one vertical crosses one horizontal near the canvas edge. Mondrian could not reduce these means any further, but even here there is interaction and complexity. He has represented the interplay of symmetry and asymmetry in which a near-symmetrical structure is tipped into the lozenge format so that its lines are vertical and horizontal. In this painting, commissioned by the architect Willem M. Dudok for Hilversum Town Hall, Mondrian uses no colour, no enclosed space, no visible complexity.

After the death of Van Doesburg in 1931, Mondrian paid tribute to him in the last (memorial) issue of *De Stijl* magazine.[76] With Van Doesburg and the periodical gone, De Stijl had ended. But its

demise in no way affected Mondrian's development; indeed, he became a founder-member of a new association known as *Abstraction-Création*, and continued to produce paintings of refinement, balance and great simplicity. For all his creative reserve, he was well aware of the need to exhibit in order to make his work known, to sell paintings, and to promote his views and achievements.

Composition with Blue and Yellow 151 still recalls Vermeer after so many years. Its clear, restricted purity of colour and its dominant whites are an inexhaustible means of embodying balance. One crossing is accompanied by one small attendant plane, limited at its base by a short stopped line. All is open and relationships are reduced to their utmost clarity. Three lines and two colours were all that he needed.

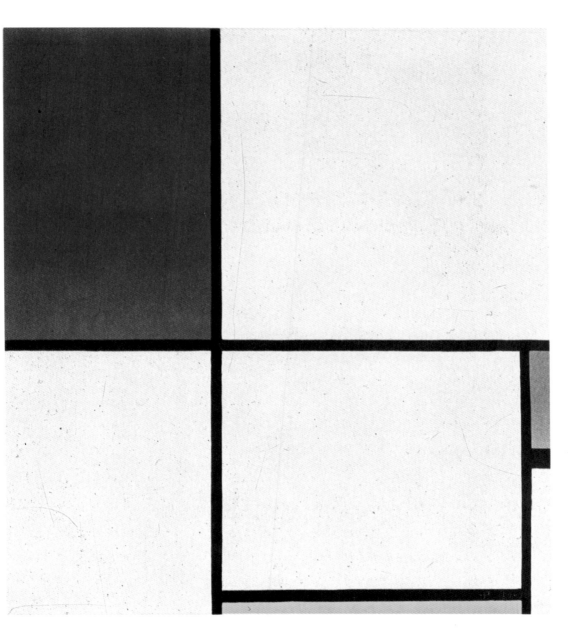

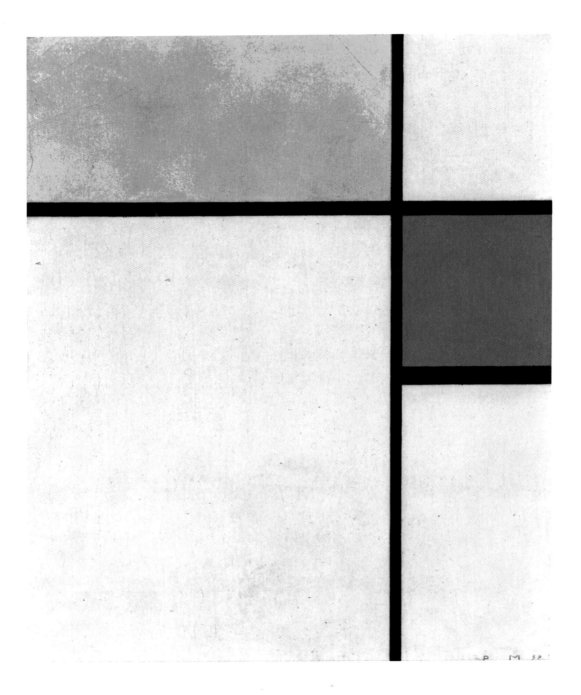

151 **Composition with Blue and Yellow** 1931
Oil on canvas, 41 x 33 cm
Museum of Art, Gallatin Collection, Philadelphia

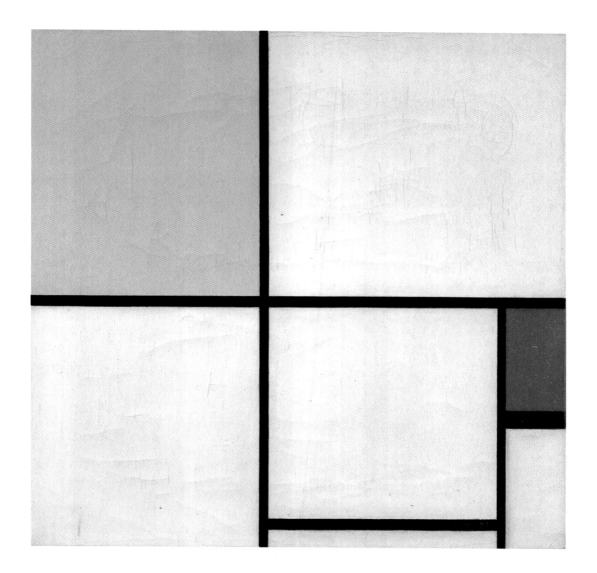

152 **Composition C with Red and Grey** 1932
Oil on canvas
Private Collection

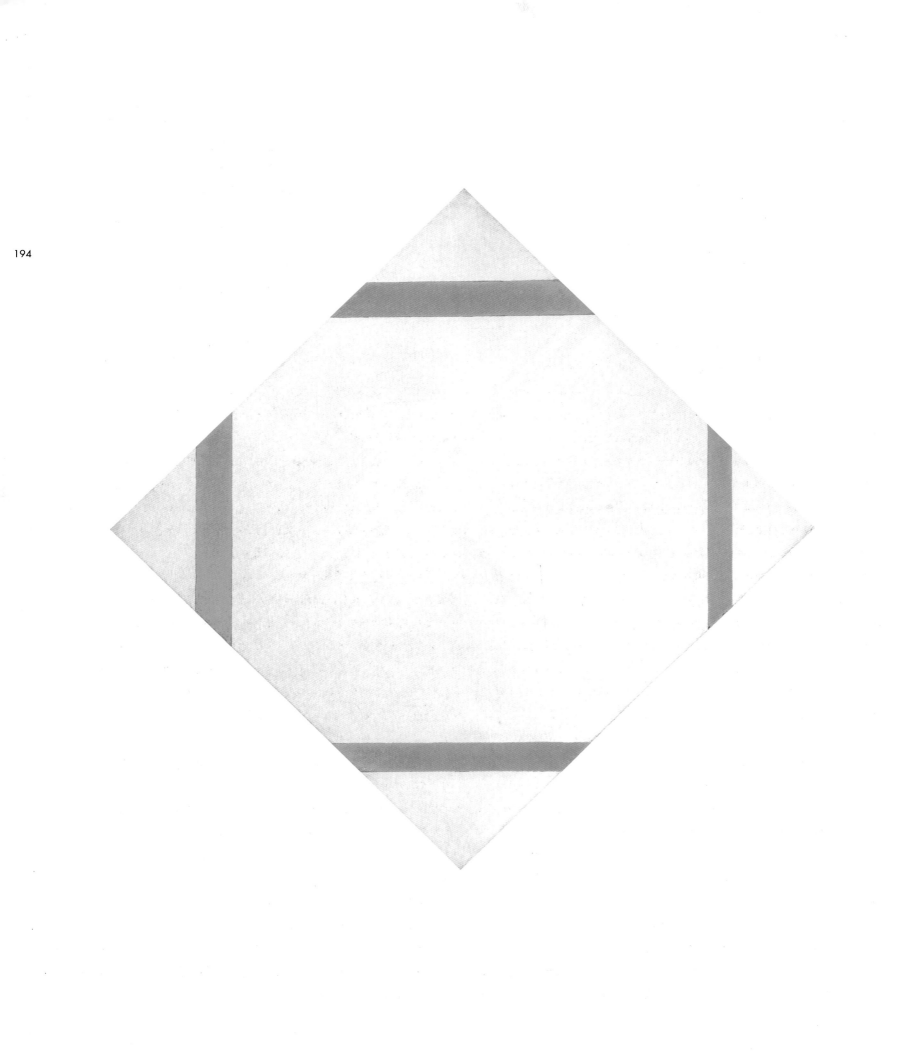

153 **Composition with Yellow Lines** 1933
Oil on canvas, diagonal 113 cm
Gemeentemuseum, The Hague

154 **Composition with Yellow** 1935
Oil on canvas, 58.3 x 55.2 cm
Whereabouts unknown

Mondrian seems to have wanted his lozenge canvases hung high. On one occasion he requested that the bottom corner be at eye-level so that the viewer necessarily looked upwards to his painting.[77] The painting concerned was a remarkable work, unique in Mondrian's long career. **Composition with Yellow Lines 153** is innovative in two ways at least: the lines are yellow, and they do not touch anywhere on the canvas. By extension they meet off the canvas to form a rectangle which is only approximately square. The lines are broad and of varying widths and lengths. Each yellow band cuts off an equilateral triangle, and still appears as the edge of a plane. The white central space appears to expand, positively pushing the bands outwards; conversely, the bands press inwards to enclose the rectangle. In this centralized and centrifugal composition, Mondrian fully acknowledged the main axes of his canvas and the expansion they suggest. It is this that the bands counteract. At top and bottom they counteract the vertical expansion, and at left and right they counteract the lateral expansion. The level plane they imply remains undefined, however, since the bands do not meet on the picture surface but actually form an octagon with its edges. In contrast to this hovering and empty plane, the triangular corner areas establish a lively and explosive rhythm which is heightened by the clear yellow. No other painting so forcefully articulates the peripheral space around the canvas. Expansion outwards alternates with condensation inwards. The actual corners and the imagined meeting points of the lines articulate the balance of general space and pictorial space, in effect establishing between them an ambiguous limit to the painting, an outer periphery that is part real and part imagined.

Despite its minimal structure **Composition with Yellow Lines** was light and expansive. Mondrian's earnest seriousness did not prevent his paintings from expressing vitality and radiance. Indeed, adopting yellow lines increased this effect. Their economy was severe, but their impact revealed their efficiency.

From the mid-1930s Mondrian's painting swung again towards elaboration. Even **Composition with Yellow 154** which comprises only three lines, white and a plane of yellow, has an optimistic, light-filled dynamic to it. The sense of rising and elevation is clear. There is another important development here which provided the route to the much more complex rhythms and increased tempo that were steadily to replace the meditative calm of these reductive works. Mondrian has increased the crossings, which, even when only two occur, as here, increases the tempo of the painting by forming a greater number of planes and by causing a visual repetition. The two lines running unimpeded across the canvas so closely resemble each other that the eye can assess them as a double line. Repeating lines closely in this way also makes suggestions of overlapping planes and planes subdividing larger planes. The possible readings of these relationships are rapidly multiplied to provide a more active interplay, and a greater visual dynamism results. Every plane here still expands off the canvas and the yellow encourages this expansion without adding significant weight to the plane that it pervades. It is an elegant achievement.

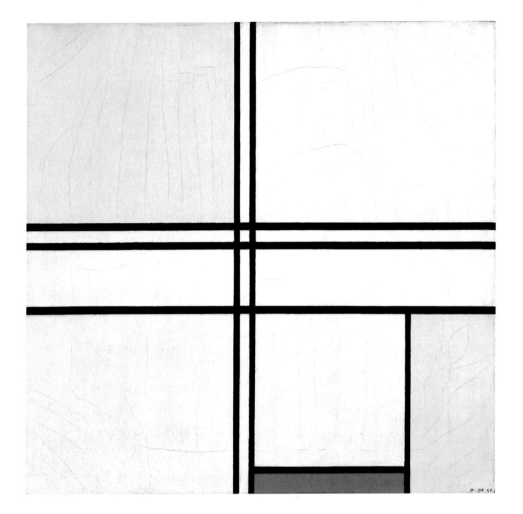

155 **Composition with Grey-Red** 1935
Oil on canvas, 55 x 57 cm
Art Institute, Chicago

The double line ushered in a whole new period of Mondrian's development. **Composition in Grey-Red 155** of 1935 redefines the perpendicular in double lines that form a small white square at the core of the painting from which the narrow corridors of white stream rapidly away, becoming lines themselves and scarcely planes at all. The third, lowest, full horizontal line has a relationship with each of its companions suggesting depth, overlap, transparency and movement. The structure was rapidly enriched, with increased complexity of relationships and rhythm accompanying every additional line. The enclosed plane by contrast appears static, particularly as it is anchored by a red band which almost forms a line in itself. Again the horizontal, female, emphasis is dominant and the whites are activated by the inclusion of a single colour. The expansive yellow departs upwards **154**, the solid red anchors this composition down when its energy might otherwise be uncontrollable. The cross has re-emerged in a more dynamic context.

By the mid-1930s Mondrian had shown his work in New York, Zurich, Stockholm and Chicago. Exhibiting with the *Cercle et Carré* group and, from 1931, with *Abstraction-Création* increasingly brought recognition; American collectors began to acquire works in these years, particularly after his inclusion in the exhibition *Cubism and Abstract Art* at the Museum of Modern Art, New York, in 1936. In addition there was the cumulative effect of his publications to increase his repute.

156 Mondrian with his brother and future sister-in-law in the
studio at 278 Boulevard Raspail, Paris, August 1936
Photograph
Rijksbureau voor Kunsthistorische Documentatie, The Hague

Numerous artists sought out Mondrian in the mid-1930s. For example, Ben Nicholson and Barbara Hepworth visited his studio,[78] and the American painter Harry Holtzman was welcomed by Mondrian in December 1934.[79] The visitors were impressed, and though they could not know it, the two men were to prove important to Mondrian in the near future.

The English painter Winifred Nicholson, the wife of Ben Nicholson, was also among Mondrian's visitors. Although there was no lift, no water and no heating, she was evidently much struck by the studio. 'What there was', she recalled, 'was clarity and silence.'[80] So close to Montparnasse station the silence must have been fleeting, and Mondrian's enthusiasm for jazz was unabated. 'Anyhow,' commented Winifred Nicholson, 'he had a cheap square little squeaky gramophone painted a vivid dutch red and on it he played the hottest blue jazz – only jazz, never that classical stuff. I don't remember any other objects in the studio except that gramophone.'[81] The other objects were in fact as few as possible: a bed behind the easel, a few impromptu constructions for shelves, and no decorations except his coloured cards, but then there were the paintings to which Mondrian's spartan dwelling was almost exclusively dedicated.

A 1936 photograph of the artist with his brother Carel and future sister-in-law **156** shows him with his cards and paintings in a new studio. The building at 26 rue du Départ had been recently expropriated, and after so many years there Mondrian was obliged

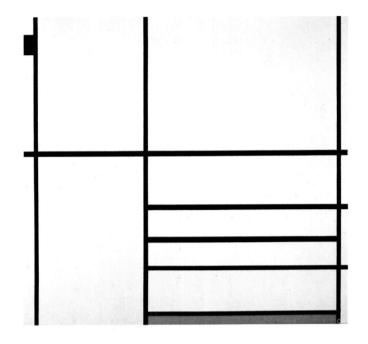

157 **Composition with Red and Black**
(Composition in White, Black and Red) 1936
Oil on canvas, 102 x 104.1 cm
The Museum of Modern Art, New York
Gift of the Advisory Committee

158 **Composition with Blue** 1937
Oil on canvas, 80 x 77 cm
Gemeentemuseum, The Hague

to move to a studio nearby at 278 boulevard Raspail. At the upper right in the photograph hangs the recent **Composition with Red and Black 157**. Only one horizontal crosses the whole canvas, cut through by three full verticals. This is a new motif in itself. Verticality does not dominate, however, since a ladder-like assemblage of three horizontals joins the two right verticals; the central line of this trio is stopped at either end, while the others pass through to the right edge. The enclosure of the ladder-like structure is confirmed by the heavy red which reiterates it at the bottom. The horizontal lines form a vertical ladder, and the planes that these subdivisions create overlap and interconnect visually. To the left the canvas is simpler, and the vertical thrust modulated only by the long horizontal. The painting frames these two tall features by placing the outer verticals very close to the edge of the canvas so that they scarcely establish planes there, and a small block of black (upper left) adds the final touch of punctuation which balances the complexities opposite.

Mondrian had long embraced an art that was urban, in which construction was implicit. This architectonic theme dominated the rest of his career. Constructing his compositions in paint was different from constructing buildings or cities, yet these paintings irresistibly assert the human urge to construct.

Composition with Blue 158 has a framework of seven lines, all of which, like scaffolding, run the full height of the painting. They accummulate into a tense group at right, but at left the two lines remain separate and firm. Against this substantial framework Mondrian constructed only one thicker horizontal which crosses the whole canvas. This structure established, other horizontals join various verticals in three lesser structures. The multiplicity of relationships, overlapping planes, stopped lines and unimpeded lines, creates staccato effects among a fast-flowing structure. It is an urban rhythm, perhaps architectural, perhaps musical, but first and foremost clear in pictorial terms. The ladder effect is visible through the wide vertical section, and through the broad horizontal section which crosses it. Remniscent of ground-plans and girders, it is neither of these but an example of a more basic energy in human organization which architecture and music can share. Here is clarity in complexity.

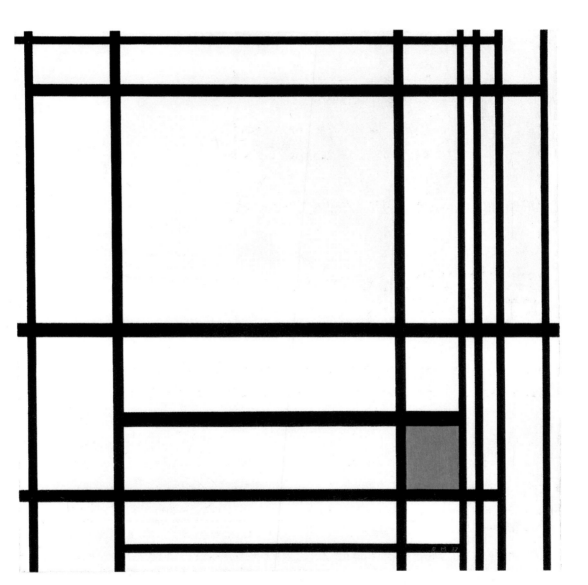

In flight:
London and New York

6

159 **Composition with Red** 1939
Oil on canvas, 102 x 104 cm
Peggy Guggenheim Collection, Venice

As political conditions worsened in Europe, Mondrian became anxious. Though reluctant to abandon the city where so much of his work had been achieved, he was finally persuaded by his friends that he should leave Paris, and on 21 September 1938 the painter Winifred Nicholson took him by train and boat to London. The Nicholsons and Naum Gabo, the sculptor, welcomed his arrival, finding him a studio near their own at 60 Park Hill Road in Hampstead. The furniture was duly painted white and cards of primary colours appeared on his walls. They were an essential part of his painting process, allowing him to consider themes and compositional aims temporarily and in advance of committing himself to paint on canvas. Mondrian stayed for two years, until after the outbreak of war. Its eventual arrival in London and the bombing of nearby buildings finally drove him away.

Composition with Red 159 is dated 1939 but its structure is close to the late Parisian paintings. It shares with **Composition with Blue 158**, for example, the framework of long vertical lines cut through by a single line running from side to side. The ladder-like framing of shorter horizontals also persists, and so too does the inclusion of a small plane of a single primary colour. The luminosity of

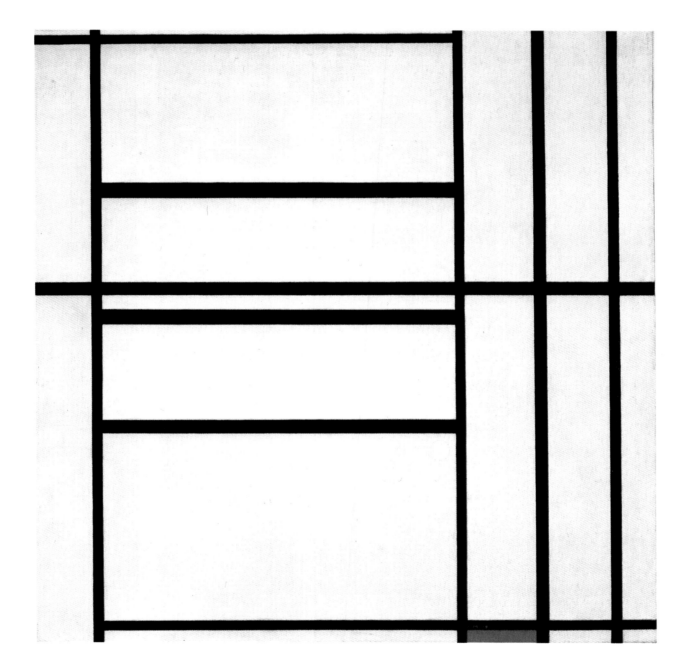

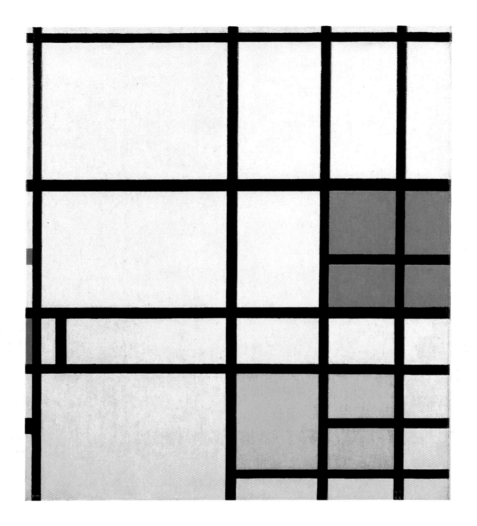

160 **Composition, London** 1940-2
Oil on canvas, 80 x 70 cm
Allbright-Knox Art Gallery, Room of Contemporary Art Fund,
1944, Buffalo, New York

these paintings required meticulous and repetitious labour. Their visual intensity was assessed by eye and only slowly achieved; as the critic Herbert Read recalled:

'I once noticed, through a period of two or three visits, that he was always engaged in painting the black lines in the same picture, and I asked him whether it was a question of the exact width of the line. He answered No; it was a question of its intensity, which could only be achieved by repeated applications of the paint'.[82]

In **Composition, London 160** the ladder-like structure is further elaborated by planes of blue and yellow which appear to pass beneath the black lines joining several adjacent rectangles. This sug-

gestion of transparency and overlap encourages the eye to see other lines as passing above or beneath each other, thereby building up layers of space in the painting. There is also a small inclusion of red in the narrow margin at the far left. Mondrian, having established the procedures of his mature work, had never felt the need to duplicate colours: it added nothing to their contrast in the painting. Duplication could not assist in the resolution of opposing elements and it had scarcely appeared in his paintings since the First World War. The duplication of red is different from the colour in adjacent cells here given to blue and yellow, for they retain a single rectangular unity whereas the reds have space separating them. In this time of

161 Mondrian (second from the left, back row) with emigré artists in New York, 1942
Photograph taken (by Pierre Matisse?) in George Platt Lynes' studio in February 1942
The artists are: (front row, from left) Matta, Zadkine, Tanguy, Ernst, Chagall, Léger,
(second row, from left) Breton, Mondrian, Masson, Ozenfant, Lipschitz, E. Berman,
(at the back, from left) Tchelitchew, Kurt Seligmann

upheaval and warfare Mondrian's output was reduced, and numerous paintings, **London** among them, were begun only to be completed several years later, after his departure from London in 1940. The young painter Harry Holtzman had suggested the move to New York, and Mondrian sailed for America by convoy on 20 September, arriving there on 3 October; his canvases followed. Harry Holtzman welcomed him and took him on vacation. He then settled down to steady work, initially on First Avenue and then on East 89th Street. Mondrian had returned to painting, and was to have a profound effect on art in New York.

He was not isolated in New York **161**. He met Peggy Guggenheim whom he had known in Europe, and lunched with her together with Max Ernst, André Breton and Marcel Duchamp. As well as becoming particularly friendly with Ernst, he was also a frequent visitor to Peggy Guggenheim's gallery *Art of This Century*. Moreover, he had immediate access to American contacts through Harry Holtzman and he was soon introduced to the American Association of Abstract Artists, which he joined. Mondrian had become part of that artistic exodus from war-torn Europe which interreacted with American painting in New York.

He worked on the unfinished canvases which had followed him from Europe, adding blocks of primary colour, unbounded by black

162 Cecil Stephenson's portrait of Mondrian
at the Mall studios in Hampstead, London
Photograph c.1930-40
Gemeentemuseum, The Hague

163 **Composition with Red, Yellow and Blue** 1935-42
Oil on canvas, 100 x 51.3 cm
Whereabouts unknown

164 **Rhythm of Black Lines** 1935-42
Oil on canvas, 72.2 x 69.5 cm
Kunstsammlung Nordrhein-Westfalen, Dusseldorf

lines, but it would be greatly to underestimate his tenacity or flexibility to expect no more than this. Mondrian responded to New York with an inventiveness and vigour that made his last years there among the most remarkable of his life.

Composition with Red, Yellow and Blue 163, which is dated 1935-42, was in itself a remarkable work; its vertical thrust was unprecedented in his painting, as was the uninterrupted plane of white which appears to rush so swiftly through the canvas. This column of white seems pushed forward as a positive plane and is not simply background. The effect is achieved partly by leaving the plane uninterrupted but also by the correspondence of the lines at the right and left of it which appear to pass beneath the white and thereby thrust it forward.

Architectonic paintings completed in New York had a new fast tempo. **Rhythm of Black Lines 164**, dated 1935-42 to mark its initiation and completion, illustrates this. As the lines multiplied they contained fewer and fewer short, stopped lines. As a result the multiple display of small planes increased in visual intensity, establishing an optical dazzle as potent in its energy as the areas of colour which Mondrian kept small and few. The structure disperses and spreads through repeated lines up, down and sideways, its numerous subdivisions filling the canvas evenly without distinct ladder- or column-effects.

As groups of lines, almost all reaching right across the canvas, congregated around the central axis of his paintings, larger spaces moved to the corners. This is visible in **Composition II with Blue 165**,

165 **Composition II with Blue** 1936-42
Oil on canvas, 62 x 60 cm
National Gallery of Canada, Ottawa

dated 1936-42. The format resembles the Greek cross of Orthodox Christian architecture, but the sheer number of crossings formed here by seven verticals and six horizontals makes a dazzling central rectangle of thirty interreacting cells. The fundamental conjunction of opposing forces which Mondrian embodied in the perpendicular, and which he understood as the source of all diversity, appears here in both microcosm and macrocosm. Evident at each crossing and all of its alternatives, the conjunction is evident too in the larger cross that all of these long lines create *en masse*: the individual part and the whole structure reflect the same pervasive principle. Only the variations employing short horizontals (lower right) disturb this and, by the inclusion of the blue, assert enough visual presence to balance the force of so many crossing lines. The change in tempo is at once evident by comparison with a painting of comparable but much simpler and quieter structure completed in Europe, **Composition with Blue** of 1937 **158**.

Another painting finished in New York was **Composition with Red, Yellow and Blue**, now in the Tate Gallery, London **166**. Here all

166　**Composition with Red, Yellow and Blue** 1937
Oil on canvas, 72 x 69 cm
Tate Gallery, London

vertical lines travel the full distance across the canvas. But their thrust is balanced by the fact that these eight lines are spread laterally across the near-square of the painting. They appear to assemble together and separate again into groups. There is already a synthesis of vertical and horizontal rhythms in these lines. The four long horizontal lines, however, congregate more evenly towards the centre, vacating the top and bottom areas in which Mondrian inserted other devices - the plane of colour at top left and the shorter horizontal lines at lower right, with their own plane of colour. The broad cross-effect,

evident in **Composition II with Blue 165**, disperses. The dazzle caused by the density of overlapping lines is heightened by the purely optical effect of a lighter patch appearing at every crossing which is not directly looked at. The strips of red and blue at the bottom were additions made in New York to complete the painting. Mondrian acknowledged the double period of work on the painting in the dates which he gave the canvas, 1939-42.

The short strips or blocks of colours were again evident in **Composition in Black, White and Red (Painting No. 9) 167**, dated

167 **Composition in Black, White and Red (Painting No. 9)** 1939-42
Oil on canvas, 79.4 x 73.6 cm
Phillips Collection, Washington DC

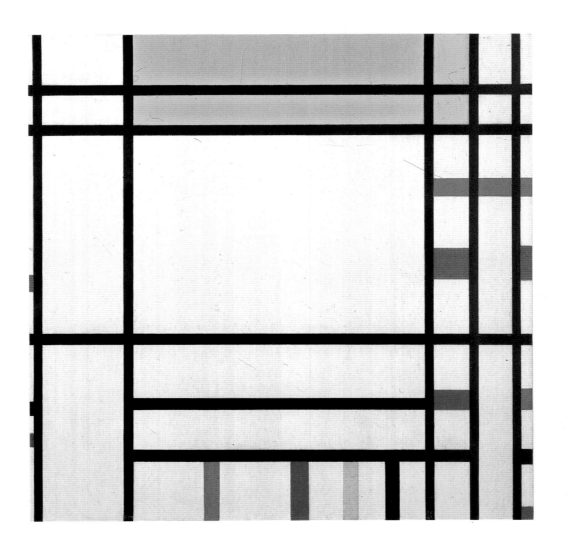

168 **Place de la Concorde** 1938-43
Oil on canvas, 94 x 95 cm
Museum of Art, Foundation for the Arts Collection, Dallas

169 Mondrian at the opening of the exhibition **Masters of Abstract Art** at H. Rubenstein's New Art Center, New York, 1 April 1942, with (left to right) Burgoyne Diller, Fritz Glarner, Carl Holty and Charmion von Wiegand Gemeentemuseum, The Hague

1939-42. This elegant canvas sums up in a single work many of Mondrian's last compositional innovations. The close proximity of three long verticals (far right) and three long horizontals (across the central area) elaborates the double-line effect visible in 1935 (see **155**) by enclosing areas which can be read as white lines. This gives them a strong aura of direction and speed. The ladder -like construction, visible, for example, in 1936 (**157**), reappears, contrasted to an emptier vertical series of planes to the left; again Mondrian uses short horizontals to consolidate this 'ladder', as in 1936, adding the area of red to establish this reading decisively. While the five long verticals are spread laterally across the whole width of the canvas, the horizontals group nearer the centre, as in **Composition with**

Red, Yellow and Blue 166 of 1937, so that the 'Greek cross' motif is dissipated. Finally, the small inserted blocks of his New York phase serve to link smaller groupings of lines, and in two cases link peripheral lines to the canvas edge. The long lines in these paintings still imply construction, but pictorially, because so many of them cut across the whole canvas, they appear in stripes. However, **Composition in Black, White and Red** does not form a multitude of similarly proportioned cells (compare **166**). Instead, the larger white planes are balanced dramatically against a framework that is sometimes wide, spacious and slow, and sometimes fast and narrow.

Mondrian's elements had remained the same for two decades, but his use of them never ceased to develop. The steady drift from minimal simplicity, evident in **Composition with Black and Blue** in 1926 **137**, to swifter syncopated rhythm found its fullest expression in America. Whether his paintings were now inspired by architecture, jazz or the city plan of New York is not directly relevant because

Mondrian's means remained strictly pictorial: he was not illustrating what he saw. His study of rhythmic balance remained dominant. That is to say, his rhythm may have been distinctly urban (indeed, it may in the passing years have had a pervasive influence upon architecture and design), but this was because his aims remained focused upon the underlying structure and organization of what he observed, evident in jazz and in the movements of traffic or the soaring lines of New York's skyscrapers.

Mondrian lived in capital cities for most of his career. His first period in Paris confirmed this bias in his outlook and his theoretical writings explained it. The man-made environment was erected against nature and, for Mondrian, it was the material of evolution. He looked to a future that made this evolution harmonious and balanced. Every part was to play its role within the whole, dynamically, effectively and without loss of identity, and so create elaborate, smoothly functioning constructions which were both coherent and full of vitality. Mondrian was not a designer. He worked·on plans that were prototypes for Utopia, not designs for useful objects. His aims were ambitious. They addressed the generality of a harmonious and dynamic organization of human life; they were, in their way, a model for human harmony. He still believed that the elements of his art and philosophy were fundamental to man's place in the universe, and in this sense the means of reconciling man and nature.

This is not to say that he was unaware of his urban surroundings. He observed them closely, but relinquished the recording of detail for the embodiment of energy. Seeking harmony among these forces was the optimistic Utopian aspect of his career. By providing concrete examples of this energetic harmony in his paintings,

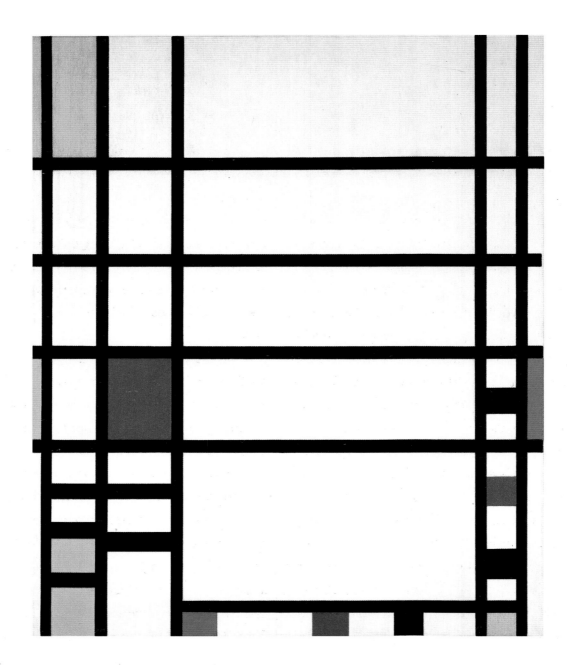

170 **Trafalgar Square** 1939-43
Oil on canvas, 145.2 x 120 cm
The Museum of Modern Art, New York
Gift of Mr and Mrs William A M Burden

Mondrian asserted its possibility in a whole range of human activity that included architecture, music and even the whole organization of society.

A trio of paintings completed in New York refers to the three capital cities where Mondrian had recently lived: Paris in **Place de la Concorde 168**, London in **Trafalgar Square 170**, and **New York 171**. **Trafalgar Square** is larger, perhaps forming the centre panel of a triptych arrangement of the paintings together,[83] and is the only one of the three to have an enclosed plane of colour. All three are full of activity and all incorporate the short strips of colour which were an innovation of his time in New York. The dates given by Mondrian indicate that the paintings were begun in Paris, London and New York respectively but they were all completed in New York.

Place de la Concorde 168, in referring to the great square at the centre of Paris, is the most specific title recently used by Mondrian. The square is an example of geometry at the heart of the city on the great, straight artery that bisects Paris from the Louvre to the Arc de Triomphe and beyond, rectifying, in Mondrian's terms, the meandering river which at the Place de la Concorde makes its closest contact with this axis. This city square is a vast open space, every perpendicular axis of which is important, and most of which is full of the bustle of human activity, traffic and the energy of urban life. In Mondrian's painting the five dominant verticals all cross the full height of his almost square canvas. As in other recent paintings, lines group either side to vacate the central space. The three long horizontals are more sparsely placed, with the high group of two separate from the remaining line below, so that their extra weight is balanced by the additional shorter horizontals that link the groups at right and left. In addition to this framework with its broad open space above

the centre, Mondrian has added strips of colour which suggest the underpassing and overpassing of white planes and abut the central area from below. This peripheral traffic of colours isolates the calm simplicity of the broad central areas. Here is a new use of colour which is not bounded by black but acts as both line and plane. The composition unites a calm, broad space with a dynamic bustle of activity around the edge. The energies of the Place de la Concorde are succinctly assessed without any recourse to illusionistic representation.

Trafalgar Square 170 is comparable but different. Five verticals are given their full length, forming a lateral shift to the canvas edges, three to the left and two to the right. The central area is therefore dominated again by a broad expanse of space which is now clearly directional, rising like a ladder through the whole painting. The peripheral activity assembles in stacks also intruding upwards into the area defined by the two lowest full horizontals. Above that, all is open spaces; all of the staccato rhythms are in the lower half of this painting. The importance of the piece for Mondrian may be indicated by its larger scale. It is confident and assertive, and at almost a metre and a half in height it has nothing of the study or experiment about it. It is an imposing work. Its spatial system is quite distinct from that of **Place de la Concorde** and its energies are differently assembled. While **Trafalgar Square**, too, is a focal point at the heart of a metropolis, its relation to the city surrounding it is utterly different from that of the great square at the heart of Paris.

The third painting, **New York 171**, does not refer to a square in its title. The grid plan of New York pervaded the city with Mondrian's fundamental confrontations of perpendicular junctions. Nevertheless, he used full-length vertical lines across his almost square

171 New York 1941-2
Oil on canvas, 95.2 x 92 cm
Hester Diamond, New York

canvas, grouping two at the left and isolating one at the right to form margins around the broad expanse of open space which placidly asserts its presence in the painting's central area. Here, however, four full horizontals also move to the margins to increase the central space, accompanied in the lower grouping by one shorter horizontal linking the peripheral verticals. This results in broad planes within broad planes throughout most of the painting, emphasized by a peripheral traffic of short bands of unbounded red, blue and yellow strips. There is in addition Mondrian's most unexpected and dramatic innovation of full-length red lines, one vertical and two horizontal. The energy of colour is added to the swift energy of direction in a technical breakthrough with the widest possibilities.

As noted above, the short bands of unbounded colour began in New York. Mondrian added them in order to complete paintings brought from Europe, the **Place de la Concorde** and **Trafalgar Square** among them. In **New York** their potential was vastly extended: the coloured line had dynamic possibilities all of its own. Without for a moment undermining the fundamental premises of his philosophy, Mondrian had devised a new configuration which in New York was to provide a new lease of energy, a vitality he found in the life of the city which had welcomed him from the war in Europe. This vitality was assertively optimistic at a time of world war. He adopted the term 'boogie-woogie' for the sheer energetic beat of his latest paintings. When the gallery director Sidney Janis visited Mondrian in his New York studio, the seriousness with which he was pursuing this lightness, energy and vigour was evident: 'In reply to my comment that he had made changes in his first New York picture since I had previously seen it, Mondrian said: "Yes, now it has more boogie-woogie."'[84]

After the sudden discovery of the weightless vitality of the line of primary colour, with which Mondrian had resolved both the directional linear conjunction central to his philosophy and the issue of the relationships of the three primary colours, he produced works of unprecedented originality and vigour. Solidity vanished and rhythm was wholly released from the enclosed form.

A second trio of works concentrated solely on the theme of the great American metropolis. **New York City I 172**, **New York City II 173** and **New York City III 174** are an unprecedented achievement. **New York City I** is a large painting for Mondrian. Almost square, it measures 120 x 144 cm. It uses only coloured lines, all cutting across the whole height or width of the canvas. Yellow dominates with fifteen lines; blue and red each have four. The lines are wide enough on this scale for their breadth to be substantial and noticeable. The red structure is simplest: two vertical and two horizontal bands of red form a near-square which dominates the upper right. As two red lines are near the canvas edge the effect is spacious. The red forms also a second and smaller rectangle, open on two sides (lower left). The four lines of blue are predominantly horizontal, three streaming to the right from the single blue vertical at the left margin which balances the red at the right. Woven through all of this is a mass of yellow lines, congregating in a group of two verticals at left, five at right, and one relatively isolated vertical left of centre. This leaves wide spaces near the centre and centre left. The horizontal yellows are more evenly distributed with some closer towards the lower edge of the canvas, thus producing wide open spaces in the network of yellows in the upper right of the painting, elongated spaces at upper right and lower left and an intricate grid of yellow over yellow at bottom right.

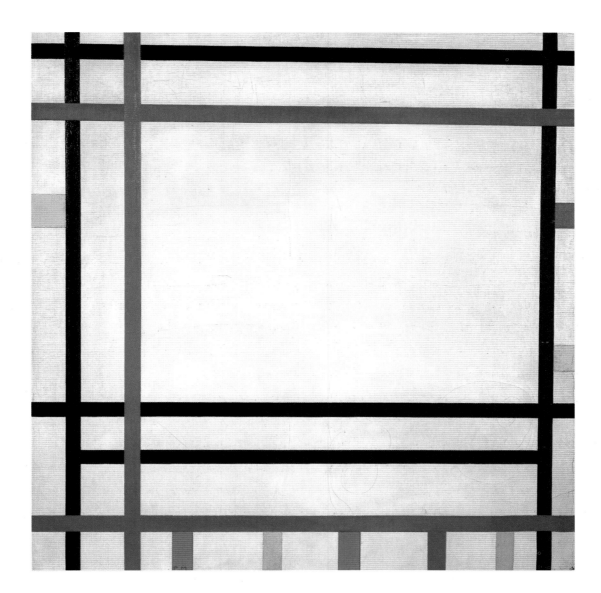

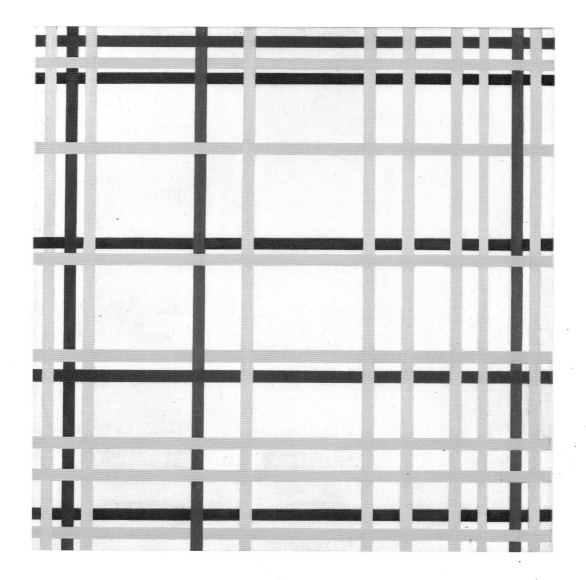

172 **New York City I** 1941-2
Oil on canvas, 120 x 144 cm
Musée National d'Art Moderne, Centre Georges Pompidou, Paris

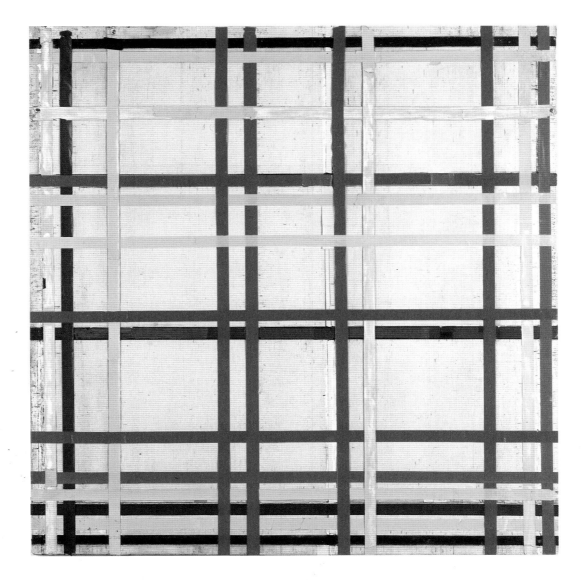

173 **New York City II** c.1942
Oil and tape on canvas, 119.4 x 114.3 cm
Kunstsammlung Nordrhein-Westfalen, Dussseldorf

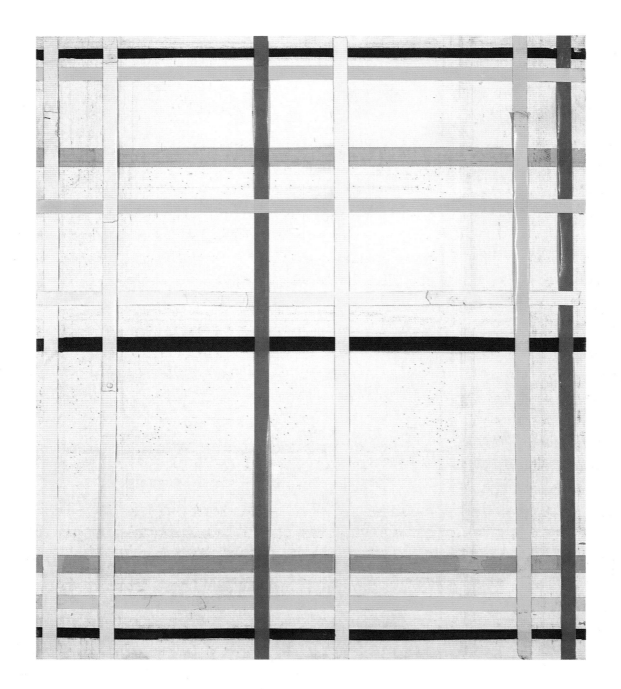

174 **New York City III** c.1942
Oil and tape on canvas 113.5 x 97.5 cm
Sidney Janis Gallery, New York

These three coloured grids each have a specific relationship with each other. There are single colour crossings in yellow, red and blue, plus all their combinations; but the assemblage is also interwoven. Blue seems the lowest framework, passing under both yellow and red except at a single point, above centre left, where it passes over yellow, pulling this section of blue into the front plane. Red increases the use of this device. At most points it crosses under yellow and always over blue, but along the vertical at left of centre it weaves downwards over yellow, under two yellow lines, over yellow, under two more yellow lines and finally over yellow. The red horizontal, below centre, passes under the yellow at left, then over yellow, then under the remaining six yellow bands.

This interweaving of bands upsets the simple layering of colours to create a changing sense of depth which bends the lines in and out of the picture space. Each line is interrupted by colour so that an intricate sense of priorities is established. Only where a colour crosses a line of the same colour is this avoided, just as the black lines of earlier paintings avoided it. Considered this way the red/red crossover left of centre appears flat, but the upward route bridges yellow while the rightwards route ducks beneath yellow. Yellow is given priority. White nowhere pushes forward but creates a spacious light behind the coloured grids. As each of these three primary colours also has a spatial effect, blue receding, red firm and yellow advancing, the painting exhibits enormous activity in which each colour-crossing constitutes a pictorial incident.

New York City II and **New York City III** are unfinished but reveal Mondrian's continuously accelerating development. The paintings were evolved firstly by means of charcoal lines with colour and white added subsequently, once positions were well estab-

lished. However, on the advice of the painter Carl Holty, Mondrian used strips of coloured paper which could be tried and adjusted into place before he moved into paint. The dealer Sidney Janis reported in 1941 that he 'uses a technical shortcut which he learned in this country, laying out the composition with strips of adhesive. However, he still spends months on a painting.'[85] This procedure was embraced with enthusiasm and it is in this preliminary form that **New York City II** and **New York City III** have survived. The dominant yellow of **New York City I** is replaced in **New York City II** by a balance of red and yellow frameworks, meticulously interwoven so that neither is clearly the foremost colour. In addition, four dark horizontals and one dark vertical cut through the canvas beneath the interwoven red and yellow. In the lowest part of the canvas five horizontal tapes amass into bands so close that they almost touch for the first time.

Mondrian's working procedure is evident in the numerous adjustments still visible, but paper tapes now allowed for judgements of space and rhythm to be assessed more quickly. The spaces apparently await white paint in **New York City II**. But in **New York City III** this is by no means obvious, since the pale grey canvas is also crossed by white lines; only white and yellow cross their own colour. To what extent these two compositions were finished at the surviving arrangement of lines is unknown, but the burgeoning growth of Mondrian's inventiveness is evident. These radical revisions of his technique reveal a doctrinaire painter opening up wide new possibilities with every canvas.

Just as Mondrian had responded throughout his life to practising painters whose work held out the prospect of useful developments in his own work - from The Hague School, to Cubism, De Stijl, and so

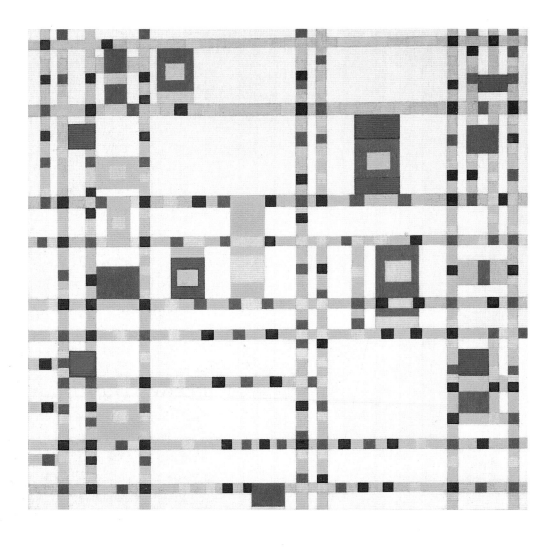

175 **Broadway Boogie-Woogie** 1942-3
Oil on canvas, 127 x 127 cm
The Museum of Modern Art, New York. Given anonymously

on - so he responded to the opportunities of New York where he was welcomed by younger painters. In 1942, for example, he was invited by the Association of American Abstract Artists to read his essay 'A New Realism' (finally published in 1946), and in the early months of the same year he held a one-man show at the Valentine Dudensing Gallery in New York. This exhibition, which was in effect a retrospective of his earlier output, nevertheless included twenty-eight works begun in Europe and completed in New York.[86] His subsequent exhibition in spring 1943 included recent innovations.

It was quite clear that Mondrian at the age of 71 was developing fast, seizing opportunities and launching new techniques at a rate which outstripped that of earlier years. He continued to live in great simplicity, devoting his life, as he always had done, to painting – it was a simple fact of his personality and priorities; but he did go to jazz clubs with Harry Holtzman. He was not a recluse, and jazz had boogie-woogie. His last two paintings use this jazz term in their titles. Both were revolutionary developments in his work and both revealed immense potential for further development. They are precisely square and almost the same size. The first is in the level format, the second is in the lozenge format to which he had returned again and again since 1919.

Broadway Boogie-Woogie 175, the last painting Mondrian completed, is luminous, dynamic, urban and innovative; the artist employs many techniques never before used, but handles them with

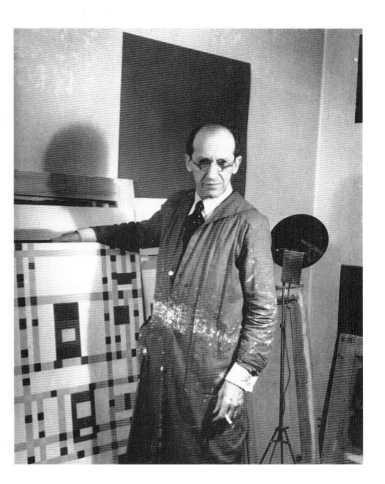

176 Mondrian with **Broadway Boogie-Woogie**
in his New York studio, c.1942-3
Photograph
Kunsthaus, Fritz Glarner Archive, Zurich

the refined judgement of a lifetime's work. **Broadway Boogie-Woogie** is too complex to sum up, yet it nowhere loses its clarity. As in **New York City I**, yellow dominates the composition. The grid forms no closed coloured planes, and the lines (ten vertical, ten horizontal) are repeatedly interrupted by small pulses of red, blue and white, marking every crossing and forming an agitated rhythm along the full length of each line. Mondrian has in addition bridged the gaps between lines by blocks of colour which do not fill the whole vacant plane. Within these 'bridge' panels, which are sometimes themselves subdivided into bands, he has in certain cases inserted smaller panels of yellow or white, placed symmetrically around the vertical axis of each grouping. Thus red surrounds white (top left,

middle right); yellow surrounds white (three examples at left); blue surrounds yellow (centre left) and red surrounds yellow (upper right). These microcosmic assemblies form paintings within the painting, vying with and complementing the ceaseless pulse of action which circulates along the lines. These blocks rise like buildings among the stopping and starting traffic of the city, or rear like hoardings above the tumult of the street, static and erect among the visible buzzing of the lines to which they are connected it is as if the coloured cards on the walls of Mondrian's New York studio **176** have resolved into the congregating and dispersing planes of **Broadway Boogie-Woogie**.

A photograph of 1943 shows Mondrian tuning the radio or gramophone; outside his window was the city. Such components as

177 Mondrian's New York Studio with **Victory Boogie-Woogie** on the easel, c.1943-4
Photograph
Kunsthaus, Fritz Glarner Archive, Zurich

these were the generative tools of his trade. The studio is stark, bare and luminous. On the easel **177** stands his last painting, his biggest and most intricately painted lozenge-format canvas, **Victory Boogie-Woogie 178**. The work was evolved with the aid of tapes, many small pieces of which still adhere to the surface of the painting, and Mondrian here pursued the integration of line and plane to a wholly new synthesis. The innovations are numerous and every one of them has potential for further paintings. Even the white rectangles, which establish a calm presence among the wealth of activity, here appear positive planes and not mere background space. The tapes reveal constant shifts and adjustments among the smallest rhythmic divisions of the lines. These are no longer dominated by any single colour but are assembled from small blocks of red, yellow, blue, black, grey and white. They form straight lines which are filled with their own irregular rhythm. Eight of these form firm horizontal divisions of the lozenge, while only one long vertical (right of centre) is clearly established. Shorter vertical lines expand to the width of whole planes, enlarging outwards to the left so that line and plane are indistinguishable. Background and foreground cease to exist as plane abuts plane of colour directly. At the right, for example, is a yellow near-square the breadth of which surmounts two columns of smaller planes in red, blue, grey and white, and beneath the grey further subdivisions lead down to the small unit blocks of colour on the long horizontal. Lines subdivide and planes, too, shatter into subdivisions of great intricacy, the microcosm which reflects the macrocosm.

At every point this canvas seethes with energetic life. In the lowest section the planes between the pulsing horizontals sit side by side to form a wider band of larger rhythms which also form horizontal bands. At the left and right of the painting they stack tower-like

and retain their upward elevation even while splintering into smaller units. Only the white appears broad and calm, and even here (left of centre) the crossing of a horizontal band of colours and a complex vertical line appears to divide a large white plane into four, like a further painting within the painting. The planes within planes, carried over from **Broadway Boogie-Woogie 175**, do this too: red surrounds yellow, blue surrounds yellow, and in a chequerboard arrangement at lower right the units constructing lines comprise a plane instead.

That the areas of white can be viewed as positive planes is confirmed by the vertical white plane which surrounds a rectangle of red and yellow (upper left). Seen as positive planes, the whites form towering sequences up the canvas and dominate the centre of the painting. Around them and between them the hectic profusion pours out its vitality with a ceaseless, glittering energy. It is the whites which provide monumental stillness. Calm amid movement, diversity in simplicity, inventiveness with control are all in balance. The individual finds a place within the whole, the specific exists within the general, as the individuals construct the whole. At every point new arrangements emerge. It is the embodiment of creativity in action.

Mondrian's creativity in producing the painting cannot be doubted, but this was an aim throughout his career. His higher ambition, which informs so much of his writing, was both philosophical and practical. The diversity of the observed world came from the conjunction of opposing forces that were simple. Relationships, through their rhythmic interaction produced the colours, shapes and rhythms of life. Using only primary colours with black, white and grey assembled up and down and across his canvas, Mondrian presented their interaction, their simplicity and their diversity. He pursued this consistently from 1919 to 1944 knowing that the diversity and the

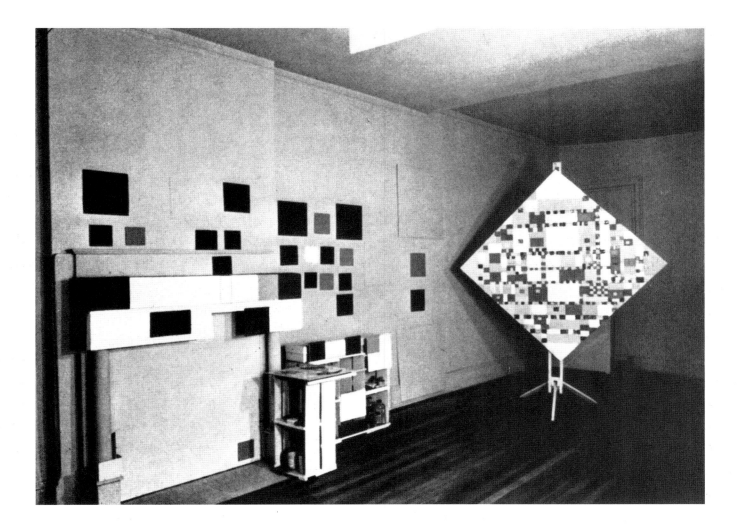

178 Victory Boogie-Woogie 1943-4
Oil and scotch tape on canvas, diagonal 177.5 cm
Private Collection

simplicity were both inexhaustible. The paintings were not illustra-
tions of a theory, but visible evidence of its functioning in paintings.

Victory Boogie-Woogie is full of new beginnings. It is a tireless
painting which at every point seeds new configurations. It is also
urban. Mondrian was committed to the development of human
understanding of form, space and construction. In this city, in New
York, he could see it all around him. In this he was Utopian and still,
despite the war, believed in the 'future men' to whom he dedicated
his essay 'Neo-Plasticism' in 1920. In the harmonic relations of
geometry and music, the human mind could find the means to make
dynamic balance, in which the whole never overwhelmed the part
and in which order never stifled the individual. 'The new art is born'
was no empty assertion by Mondrian in 1920. He spent the remain-
der of his life proving its existence in paintings that constantly devel-
oped and evolved. The myriad new beginnings in **Victory Boogie-
Woogie** show Mondrian at the height of his powers. The creativity it
embodies was not wholly his own: it reflected the world of the
growing, living city around him. This was human evolution for Mon-
drian, the forces of a wider creativity made visible in his paintings.

Early in 1944 Mondrian caught a cold and developed pneumo-
nia; the painter Fritz Glarner found him weak and ill in his studio.
Although he was speedily removed to Murray Hill Hospital, he died,
aged 72, on 1 February, and was buried at the Cyprus Hill Cemetry,
Brooklyn. His application for United States citizenship was still pending.

Realizing its importance, Harry Holtzman opened Mondrian's
New York studio to the public for six weeks after his death. With Fritz
Glarner he documented it in photographs, film and tracings of the
cards upon the wall. This simple act was a homage to a friend and a
sign of Mondrian's impact upon American art.[87] A memorial retro-
spective exhibition followed at the Museum of Modern Art, New
York, in 1945. The first monograph, by Mondrian's friend Michel
Seuphor, appeared nine years later.

Even in his early years Mondrian had been convinced that he
was old. There was a mystical aspect to his mind which directly com-
plemented the practical activity of painting. He apparently had no
doubt that he had lived other lives,[88] and the mystic, the philosopher,
the Utopian and the painter were all united in the Mondrian whose
career we have followed here. His vision, as he repeatedly insisted
in his writings, was universal. It was a vision of harmony in the uni-
verse, uniting man with the cosmos. 'The abstract,' he wrote in 1917,
'like the mathematical − is actually expressed in and through all
things...'[89] This he wished to make evident to the conscious mind:
'The truly modern artist consciously perceives the abstraction of the
emotion of beauty: he consciously recognises aesthetic emotion as
cosmic, universal. This conscious recognition results in an abstract
plastic − limits him to the purely universal.'[90]

Mondrian expressed this idea in his writings, but he put it into
practice in the long succession of canvases that sought the rhythm,
balance and energy of life. In the paintings which he adjusted so
meticulously, he consciously revealed the rhythms of the universe
as he perceived them in the life he observed around him − by the
river in Holland, by the mill against the darkening sky, in an arching
tree or a railway terminus, and in the ceaseless movement of the
living, growing city.

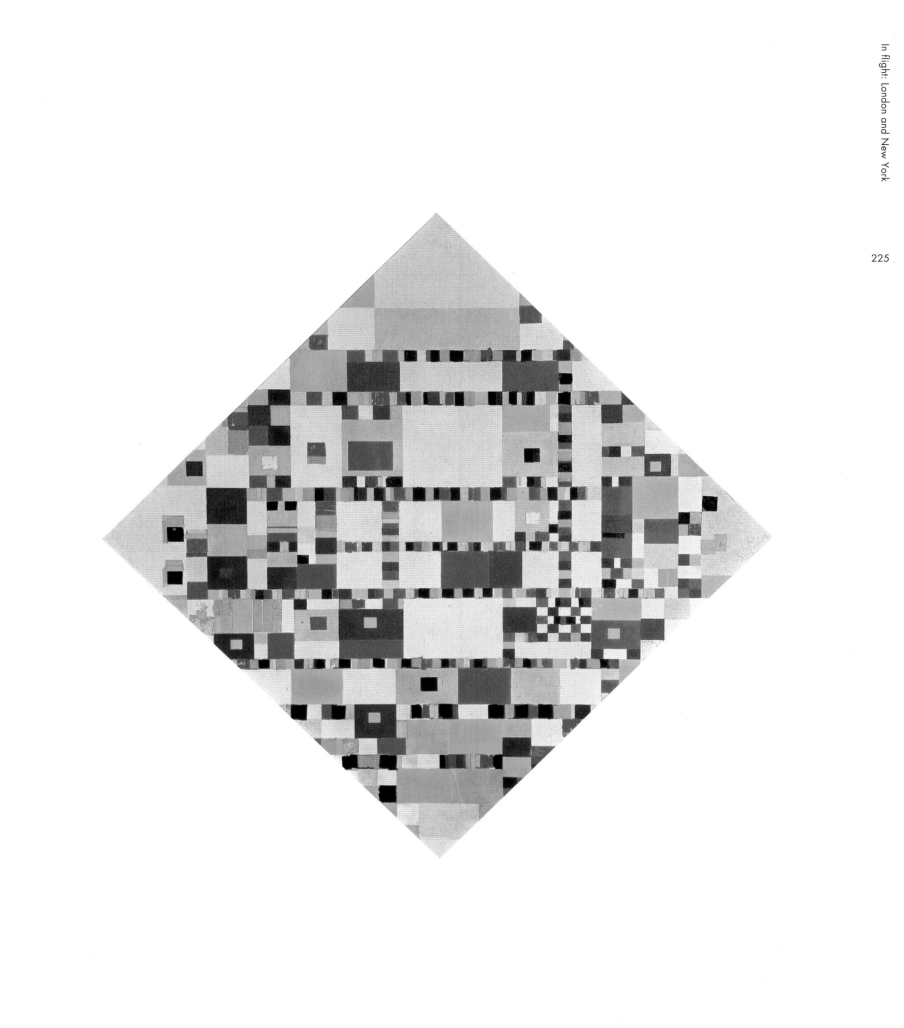

notes

1 Mondrian deleted the second letter *a* from his name after settling in Paris, but apparently he continued to employ the original spelling throughout the 1920s on works destined for Holland. This is discussed in David Shapiro, *Mondrian:Flowers* (New York, 1991), 13.

2 H. P. Blavatsky, *The Secret Doctrine: The Synthesis of Science, Religion and Philosophy* (London, 1888). References here are to the edition republished verbatim by the Theosophical University Press, 2 vols. (Pasadena, 1970). Her first major text was *Isis Unveiled* (New York, 1877).

3 The study of Vermeer began on the scholarly level only in 1866 when Thoré-Burger's article 'Van der Meer de Delft' appeared in the *Gazette des Beaux-Arts*. Further studies were published in 1908, including material on Vermeer in Cornelis Hofstede de Groot, *Catalogue of the Works of the Most Eminent Dutch Painters of the Seventeenth Century*, ix. (London), 587-607. Vermeer's *Little Street* was acquired as a gift from Sir Henry Deterding in 1921. The comparison made in the present text is not meant to imply a specific source for Mondrian's painting, but is quoted as an example to illustrate Vermeer's use of pictorial conventions and to compare this with Mondrian's approach. A detailed chronology of Vermeer's reputation is given in Christopher Wright, *Vermeer* (London, 1976).

4 The Anthroposophical Society was established by Rudolf Steiner in 1913. He had dissociated himself from the Theosophical Society in the previous year.

5 Blavatsky, in the preface to *The Secret Doctrine*, thus defined the aim of Theosophy: 'to gather the oldest tenets [of religion] together and to make them one harmonious and unbroken whole' (p. i).
Karma is a principle governing reincarnation and envisaged as active at all times. Spiritual perfection and goodness affect the next incarnation beneficially. Worldliness and lack of spirituality have an adverse effect. Karma is therefore essential to the process of *evolution* as understood by theosophists.

6 A precise examination of the chronology and significance of Mondrian's interest in Theosophy is given by Robert P. Welsh, 'Mondrian and Theosophy', in *Piet Mondrian 1872-1944*, Centennial Exhibition catalogue, Solomon R. Guggenheim Museum (New York, 1971), 35-51.

7 Ibid. 39.

8 *The New Art - The New Life: The Collected Writings of Mondrian*, ed. Harry Holtzman and Martin S. James (London, 1987), 13. This letter is discussed in the article by Martin S. James, 'Piet Mondrian - Art and Theory to 1917', ibid. 13-14.

9 Ibid. 13.

10 Blavatsky, *Secret Doctrine*, i.590ff.

11 Ibid. 575.

12 Ibid.

13 Ibid. 590ff.

14 This sign was also used by the sculptor Bourdelle on

his bronze *Heracles the Archer* (1909) and other works including a version of his portrait bust of Krishnamurti (Bourdelle Museum, Paris). Mondrian's study of Krishnamurti's writings is discussed in L. J. F. Wijsenbeek, *Piet Mondrian* (London, 1968), 32. See also Erik Saxon, 'On Mondrian's Diamonds', *Artforum*, Dec. 1979, 40, and Robert P. Welsh, 'Mondrian and Theosophy', in *Piet Mondrian 1872-1944*, Centennial Exhibition catalogue, Solomon R. Guggenheim Museum (New York, 1971), 43ff.

15 Blavatsky, *Secret Doctrine*, i. 592: 'The spiritual line is vertical - the differentiated matter line is horizontal; the two forming the cross…'.

16 See Blavatsky's discussion of the 'Mundane Egg' in *The Secret Doctrine*, i. 64-6, 359ff.

17 Guillaume Apollinaire, review of the 29th Salon des Indépendants, Paris, in *Montjoie*, 18 Mar. 1913. Cited in L. J. F. Wijsenbeek, *Piet Mondrian* (London, 1968), 71.

18 According to Blavatsky, T is tau (also the Egyptian cross), while for the Jews and Samaritans it signified completion, termination; *The Secret Doctrine*, i. 587.

19 This is discussed in Robert P. Welsh, 'The Birth of De Stijl', *Artforum*, Apr. 1973, 50.

20 Holtzman and James (eds.), *The New Art*, xxi.

21 Robert. P. Welsh, 'The Birth of De Stijl', *Artforum*, Apr. 1973, 50.

22 Holtzman and James (eds.), *The New Art*, 17.

23 Ibid. This observation occurs in a sketchbook of 1914-16.

24 See Holtzman and James (eds.), *The New Art*, 17. A Note by Mondrian in Sketchbook 1:65 of 1914-16.

25 This is cited and discussed in J. Joosten, 'Abstraction and Compositional Innovation', *Artforum*, Apr. 1973, 55.

26 Ibid.

27 *Het Nieuwe Wereldbeeld* (*The New Image of the World*) (Bussum, 1915); *Beeldende Wiskunde* (*Plastic Mathematics*) (Bussum, 1916).

28 Cited and discussed in H. L. C. Jaffé, *De Stijl* (New York and London), 1971, 57.

29 Ibid. 60.

30 This important photograph was reproduced and discussed authoritatively by J. Joosten, 'Painting and Sculpture in the Context of De Stijl', in Mildred Friedman (ed.), *De Stijl: 1917-1931, Visions of Utopia*, exhibition catalogue, Walker Art Center, Minneapolis (Minneapolis and Oxford, 1982), 59.

31 Drawings indicate a close connection between these paintings and the image of the facade of the church of Notre-Dame des Champs in Paris.

32 See Theo van Doesburg, Introduction to *De Stijl*, No. 1, 1917; discussed in Jaffé, *De Stijl*, 11.

33 Cited and discussed in Jaffé, *De Stijl*, 11.

34 The extensive literature on De Stijl includes Jaffé, *De Stijl* (n. 28 above), and Friedman (ed.), *De Stijl: 1917-1931* (n. 30 above).

35 The essay is translated and discussed in Holtzman and James (eds.), *The New Art*, 27ff.

36 Piet Mondrian, 'The New Plastic in Painting', trans. and discussed in Holtzman and James (eds.), *The New Art*, 27ff; this quotation, p. 28.

37 Ibid.

38 Ibid.

39 Ibid.

40 Ibid.

41 Ibid. 30.

42 Ibid.

43 Ibid. 33.

44 Ibid. 35.

45 Discussed by Mondrian, ibid. 37.

46 See, for example, the *Self-Portrait*, sometimes dated c.1913, charcoal, 49.5 x 73.5 cm, unsigned,

179 Vilmos Huszar: **De Stijl** magazine cover, 1917

Gemeentemuseum, The Hague (S. B. Slijper Bequest).

47 Jaffé, *De Stijl*, 17.

48 Piet Mondrian, 'Dialogue on the New Plastic' ('Dialog over de Nieuwe Beelding'), *De Stijl*, Feb/Mar 1919. Discussed and trans. in Holtzman and James (eds.), *The New Art*, 75.

49 Discussed in J. Joosten, 'Abstraction and Compositional Innovation', *Artforum*, Apr. 1973, 57.

50 Blavatsky, *Secret Doctrine*, i. 580.

51 Lozenge is a misnomer. These canvases are square, but the term is now in general use and therefore retained here. C. Blotkamp refers to Mondrian's 'Diamond Compositions' but this does not make clear that they are square, although it does emphasize their orientation (see, for example, C. Blotkamp, 'Mondrian's First Diamond Compositions', *Artforum*, Dec. 1979, 35).

52 C. Blotkamp, 'Mondrian's First Diamond Compositions', *Artforum*, Dec. 1979, 33-9.

53 See also Van Doesburg's use of the 'lozenge' form in stained glass discussed by C. Blotkamp in 'Mondrian's First Diamond Compositions', *Artforum*, Dec. 1979, 38.

54 Piet Mondrian, 'Natural Reality and Abstract Reality: A Trialogue (while Strolling from the Country to the City)', trans. and discussed in Holtzman and James (eds.), *The New Art*, 83ff.

55 Ibid. 89.

56 Ibid. 99.

57 Ibid. 101.

58 Ibid. 83.

59 This whole episode is discussed by J. Joosten, 'Painting and Sculpture in the Context of De Stijl', in Friedman (ed.), *De Stijl: 1917-1931*, 60.

60 Piet Mondrian, 'Neo-Plasticism' ('Le Néo-Plasticisme'), trans. and discussed in Holtzman and James (eds.), *The New Art*, 132-47; this quotation, 137.

61 Ibid. 147.

62 Mondrian was not alone in achieving this interpenetration of space and object. It was, for example, a feature of the architecture of Gerrit Rietveld, and was germane to the sculpture of Naum Gabo.

63 See Piet Mondrian, 'The Manifestation of Neo-Plasticism in Music and the Italian Futurist "Bruiteurs"', trans. and discussed in Holtzman and James (eds.), *The New Art*, 148ff.

64 Ibid. 163.

65 See Piet Mondrian, 'The Realisation of Neo-Plasticism in the Distant Future and in Architecture Today', in Holtzman and James (eds.), *The New Art*, 166ff.

66 David Sylvester made this point in 'A Tulip with White Leaves: An essay on Mondrian', *Studio International*, Dec. 1966, 293.

67 Piet Mondrian, 'The Realisation of Neo-Plasticism in the Distant Future and in Architecture Today', in Holtzman and James (eds.), *The New Art*, 169.

68 'Bij Piet Mondrian', in *Nieuwe Rotterdamse Courant*, 22 Mar. 1922. This is cited in N. J. Troy, 'Piet Mondrian's Atelier', *Arts Magazine*, Dec. 1978, 83. Nancy Troy discusses Mondrian's studios extensively and in detail.

69 Cornelis van Eesteren joined De Stijl in 1923. The exhibition at *L'Effort Moderne* ran from 15 October to 15 November 1923.

70 Piet Mondrian, 'Is Painting Inferior to Architecture?', published in *De Stijl*, late 1923; trans. and discussed in Holtzman and James (eds.), *The New Art*, 174. The architect J. J. P. Oud, who had won Mondrian's *Composition with Red, Blue and Yellow-Green* in a De Stijl raffle in 1920, also became an organizer of an exhibition of his work at the Stedelijk Museum, Amsterdam, in 1922, to mark his fiftieth birthday.

71 Cited and discussed in N. J. Troy, 'Piet Mondrian's Atelier', *Arts Magazine*, Dec. 1978, 83, and in Michel Seuphor, *Piet Mondrian: Life and Work* (New York, 1956), 156.

72 Piet Mondrian, *Neu Gestaltung, Neoplastizismus, Nieuwe Beelding*, (Bauhausbucher, no. 5; Munich, 1925).

73 Theo van Doesburg, *The Principles of Neo-Plastic Art*, new (Eng.) edn., trans. by Janet Seligman (London, 1969), dedication; originally published as *Grundbegriffe der neuen gestaltenden Kunst* (Munich, 1925).

74 Max Bill, 'Composition I with Blue and Yellow, 1925, by Piet Mondrian', in *Piet Mondrian 1872-1944*, Centennial Exhibition catalogue, Solomon R. Guggenheim Museum (New York, 1971), 74-6.

75 This is discussed in detail in N. J. Troy, 'Mondrian's Designs for the Salon of Mme B . . . at Dresden', *Art Bulletin*, 62, 1980, 640-7. His third personal exhibition was held in Dresden at the Kühn Gallery in 1925.

76 Mondrian's tribute, dated April 1931, appeared in the memorial issue of *De Stijl* of January 1932. It is translated and discussed in Holtzman and James (eds.), *The New Art*, 182-3.

77 Discussed in Erik Saxon, 'On Mondrian's Diamonds', *Artforum*, Dec. 1979, 41.

78 Discussed in Charles Harrison, 'Mondrian in London', *Studio International*, Dec. 1966, 285. Paintings by Mondrian were displayed in Oxford in 1936. In 1937 Mondrian contributed to *Circle: International Survey of Constructive Art*, ed. J. L. Martin, B. Nicholson and Naum Gabo. His importance for English art was established before his arrival the following year.

79 Discussed in Holtzman and James (eds.), *The New Art*, 1. Holtzman recalled meeting Léger, Gabo,

Pevsner, Hélion, Le Corbusier and Duchamp through Mondrian's assistance. American collectors were also showing increased interest after 1936, including Mr and Mrs Walter C. Arensburg, A. E. Gallatin and Peggy Guggenheim.

80 Winifred Nicholson, 'Reminiscences of Mondrian', *Studio International*, Dec. 1966, 286.

81 Ibid.

82 Herbert Read, 'Reminiscences of Mondrian', *Studio International*, Dec. 1966, 289.

83 This is proposed in Joseph Maschek, 'Mondrian the New Yorker' *Artforum*, Oct. 1974, 58-65.

84 Sidney Janis in *Decision*, Nov.-Dec. 1941, 89-91, cited and discussed in Robert J. Welsh, 'Landscape into Music: Mondrian's New York Period', *Arts Magazine*, Feb. 1966, 33-9. The article is reprinted in Mondrian in the *Sidney Janis Family Collection, New York* (Haags Gemeentemuseum; The Hague, 1988), 89ff.

85 The technique is discussed in 'Interview with Charmion von Wiegand by Margit Rowell, June 20, 1971,' published in *Piet Mondrian 1872-1944*, Centennial Exhibition catalogue, Solomon R. Guggenheim Museum (New York, 1971), 77-86; this point is made on p. 79. Sidney Janis's discussion is in his article 'School of Paris Comes to U.S' *Decision*, Nov.-Dec. 1941, 89-91.

86 Discussed in Robert J. Welsh, 'Landscape into Music: Mondrian's New York Period', *Arts Magazine*, Feb. 1966, 33-9.

87 Rectangular cards of red, blue, yellow, grey and white were attached to off-white walls. These wall-works were exhibited at the Museum of Modern Art, New York, in summer 1983. They are discussed in Holtzman and James (eds.), *The New Art*, 5. For a discussion of Mondrian's impact upon American painters, see Barbara Rose, 'Mondrian in New York', *Artforum*, Dec. 1971, 54-63. Few works by Mondrian were acquired by major public museums in his lifetime but his posthumous reputation grew rapidly.

88 This was discussed by Charmion von Wiegand in interview with Margit Rowell, 20 June 1971: 'I once said to him, "Mondrian, what were you like when you were young?" and he replied, "I was always the same, Charmion, I was born old!" He meant what they call in Theosophical terms to have "an old soul" which indicates that one has been reincarnated many times. Mondrian was convinced that he had already lived other lives' (*Piet Mondrian 1872-1944*, Centennial Exhibition catalogue, Solomon R. Guggenheim Museum (New York, 1971), 77-86; this quotation, p. 80). Mondrian may have embraced the mystical view that the zodiacal sign associated with his birth-date was an indication of this. He was born under Pisces, the end of the cycle, implying many incarnations.

89 Piet Mondrian, 'The New Plastic in Painting', trans. in Holtzman and James (eds.), *The New Art*, 35.

90 Ibid. 28.

bibliography

In chronological sequence

Note
The definitive publication in English of Mondrian's own writings is *The New Art - The New Life: The Collected Writings of Piet Mondrian* edited and translated by Harry Holtzman and Martin S. James (London, 1987).

1956
Jaffé, H. L. C., *De Stijl 1917-1931: The Dutch Contribution to Modern Art* (London).

Seuphor, Michel, *Piet Mondrian: Life and Work* (New York and Amsterdam).

1957
Holty, Carl, 'Mondrian in New York: A Memoir', *Arts*, 31 September: 17-21.

Lewis, D., *Mondrian* (London).

1958
Hunter, S., *Mondrian* (London and New York).

1961
Wiegand, Charmion von, 'Piet Mondrian: A Memoir of his New York Period', *Arts Yearbook*, 4: 55-7.

1962
Ragghianti, C. L., *Mondrian* (Milan).

1963
James, Martin S., 'Mondrian and the Dutch Symbolists', *Art Journal*, 23/2: Winter: 103-11.

1965
Piet Mondrian 1872-1944, exhibition catalogue, Santa Barbara Museum.

1966
Nicholson, Winifred, and others, 'Mondrian in London: Reminiscences', *Studio International*, 172, December: 285-92.

Rosenblum, Robert, 'Mondrian and Romanticism', *Art News*, 64, February: 33-7, 69-70.

Welsh, Robert P., 'Landscape into Music: Mondrian's New York Period', *Arts*, 40/4, February: 33-9.

Welsh, Robert P., *Piet Mondrian 1872-1944*, exhibition catalogue, Art Gallery of Toronto, February-March.

1968
De Stijl, facsimile of the complete periodical (Amsterdam).

Jaffé, H. L. C., *Piet Mondrian* (New York).

Piet Mondrian, exhibition catalogue, Nationalgalerie, Berlin, September-November.

1968-9
Wijsenbeck, L. J. F., *Piet Mondrian* (New York and London).

1969
Seuphor, Michel, Introduction to the exhibition catalogue *Mondrian*, Orangerie des Tuileries, Paris, January-March.

1970
Holtzman, Harry, 'Some Notes on Mondrian's Method: The Late Drawings' and 'Piet Mondrian's Environment', in *Mondrian: The Process Works*, exhibition catalogue, Pace Gallery, New York, April.

1970
Tomassoni, Italo, *Mondrian* (London).

1971
Jaffé, H. L. C. (ed), *De Stijl* (New York).

Piet Mondrian Centennial Exhibition, exhibition catalogue, S. R. Guggenheim Museum, New York.

Rose, Barbara 'Mondrian in New York', *Artforum*, 10/4: December: 54-63.

Sweeney, James Johnson, 'Mondrian, the Dutch and De Stijl', *Art News*, 50/4: December: 25-7, 62-4.

1973
Welsh, Robert P., 'Piet Mondrian: The Subject Matter of Abstraction', *Artforum*, 11/8, April: 50-3.

Joosten, J. M., 'Abstraction and Compositional Innovation', *Artforum*, 11/8, April: 55-9.

1974
Baljeu, Joost, *Theo van Doesburg* (New York).

Masheck, J., 'Mondrian the New Yorker', *Artforum*, 13/2, October: October: 58-65.

Ottolenghi, Maria Grazia, *L'Opera completa di Mondrian* (Milan).

1977
Welsh, Robert P., *Piet Mondrian's Early Career: The 'Naturalistic' Periods* (New York).

1978
Troy, Nancy J., 'Piet Mondrian's Atelier', *Arts*, December: 82-8.

1979
Blotkamp, Carel, 'Mondrian's First Diamond Compositions', *Artforum*, 18/4, December: 33-9.

1980
Mondrian: Drawings, Watercolours, New York Paintings, exhibition catalogue, Staatsgalerie, Stuttgart,

Sillevis, J., and Herbert Henkels, *Mondrian and The Hague School*, exhibition catalogue, Whitworth Art Gallery, University of Manchester, Manchester.

Troy, Nancy J., 'Mondrian's Designs for the salon de Mme B. . . à Dresden', *Art Bulletin*, 62/4, December: 640-7.

1981
Friedman, Mildred (ed.) *De Stijl 1917-1931: Visions of Utopia*, exhibition catalogue, Walker Art Center, Minneapolis (Minneapolis and Oxford).

1983
Troy, Nancy J., *The De Stijl Environment* (Cambridge, Mass.).

1984
Holtzman, Harry, Introduction to the exhibition catalogue *Piet Mondrian: The Wall Works: 1943-44*, Carpenter and Hochman Gallery, New York.

1987
Holtzman, Harry, and Martin S. James, *The New Art - The New Life: The Collected Writings of Piet Mondrian* (London).

1990
Bowness, Sophie, 'Mondrian in London: Letters to Ben Nicholson and Barbara Hepworth', *Burlington Magazine* 132/1052 November: 782-8.

1991
Meuris, Jacques, *Mondrian* (Paris).

chronology

1872 Born at Amersfoort in Holland on 7 March and christened Pieter Cornelis Mondriaan, the same name as his Calvinist father who was a schoolteacher at Amersfoort but also a printmaker. The second of five children, he was preceded by his sister Johanna, born in 1870. His brothers were Willem, born 1874, Louis, born 1877, and Carel, born 1880.

1889 Attained a diploma to teach in elementary schools.

1892 Having attained a diploma to teach in secondary schools he turned instead to a career as an artist, and enrolled at the Royal Academy in Amsterdam in November.

1903 Visited Brabant in August.

1904 Settled at Uden in Brabant in January. Active as a landscape painter.

1905 In February he returned to Amsterdam where he joined the Guild of St Luke; he exhibited with the guild up to 1910.

1908 His first visit to Domburg on the island of Walcheren, Zeeland. He was by now aware of Theosophy and had become interested in clairvoyant experiences.

1909 In January he exhibited with Jan Sluyters and Cornelis Spoor at the Stedelijk Museum in Amsterdam. He joined the Theosophical Society of Holland in May.

Returned to Domburg and stayed until 1911. Made studies of dunes on the beach (1909) for which he employed a modified pointillist technique.

1910 A founder-member of the *Moderne Kunstkring* (Modern Art Circle) with Jan Sluyters and Jan Toorop. The society's adventurous exhibitions familiarized him with much that was current and innovative in art in Paris.

1911 Sent work to the Salon des Indépendants in Paris and contributed to the first *Moderne Kunstkring* exhibition which incorporated 28 works by Cézanne as well as Cubist paintings. Late in the year he moved to Paris on the invitation of the painter Conrad Kickert, and took up residence at 26 rue du Départ in Montparnasse where Kickert and the Cubist painter Lodewijk Schelfhout also lived.

1912 Rapid assimilation of Cubist techniques applied to trees and facades (which were increasingly difficult to recoginize).

1913 Guillaume Apollinaire noted his work at the Salon des Indépendants in Paris. He also exhibited at the First German Autumn Salon in Berlin.

1914 Visited Holland to see his father who was ill, and war prevented his return to Paris. Black and white paintings on the theme of the sea were constructed entirely from horizontal and vertical lines.

1915 Exhibited with the *Rotterdamse Kunstkring*. At Laren near Amsterdam he met Salomon B. Slijper, who

was to buy some 200 works over the next few years, and H. P. Bremner, who made a financial arrangement with Mondrian which lasted until 1919. He became interested in the theories of the priest and philosopher Schoenmaekers.

1917 Exhibited rectilinear compositions with the *Hollandse Kunstenaarskring* at the Stedelijk Museum in Amsterdam. With Theo van Doesburg, Bart van der Leck and others he was a founder-member of the group De Stijl, whose journal first published Mondrian's theoretical writings.

1918 Paintings based upon a regular grid overlaid with asymmetrical variations.

1919 Exhibited five works with the *Hollandse Kunstenaarskring* and returned to Paris, settling at 26 rue du Départ for almost all of his second Paris period.

1920 Evolved the early versions of his characteristic asymmetrical grid compositions. Léonce Rosenberg published Mondrian's pamphlet *Le Néo-Plasticisme* in Paris.

1921 Established the compositional format with black lines and planes of colour that was to form the basis of the rest of his work in Paris.

1923 Friendship with the Belgian writer Michel Seuphor. The *Galerie de l'Effort Moderne*, directed by Léonce Rosenberg, exhibited De Stijl architectural projects.

1925 The Bauhaus published Mondrian's *Die neue Gestaltung*. Ida Bienert commissioned him to design a salon interior at Dresden.

1927 Resigned from De Stijl. Two paintings were included in the abstract art collection at the Landesmuseum, Hanover, in an installation designed by El Lissitzky.

1930 Exhibited in Paris with the group *Cercle et Carré* founded by Michel Seuphor and the Uruguayan painter Joaquín Torrès-García.

1931 Wrote a tribute to Van Doesburg (published in *De Stijl* in January 1932). Joined the group *Abstraction-Création*.

1933 *Composition with Yellow Lines* (now in the Gemeentemusuem, The Hague) introduced the coloured line.

1934 Visited in Paris by Harry Holtzman, whom he introduced to Léger, Gabo, Pevsner, Hélion, Le Corbusier and others.

1936 Visited by Ben Nicholson. Moved his studio to 278 boulevard Montparnasse. Employed multiple arrangements of lines in increasingly complex paintings.

1937 Published the essay 'Plastic Art and Pure Plastic Art' in the compendium *Circle* (London).

1938 Left France for London where he lived at 60 Park Hill Road, Hampstead, near Ben Nicholson, Barbara Hepworth and Naum Gabo.

1940 Wartime bombing persuaded him to leave London for New York on 20 September. Arrived in New York on 3 October. Welcomed by Harry Holtzman, he met émigré European artists and attracted the attention of American painters.

1941 A number of paintings begun in Europe were completed by the addition of small lines of colour. His compositions gained in complexity.

1942 Used tapes to establish compositions and also introduced coloured lines. One-man exhibition at the Valentine Dudensing Gallery, New York. Lectured at to AAA (American Abstract Artists) in New York.

1943 Second one-man exhibition at the Valentine Dudensing Gallery.

1944 Died of pneumonia in New York on 1 February.

acknowledgements

Courtesy of Christie's, Amsterdam: 11, 36, 41, 58, 60
Stedelijk Museum, Amsterdam: 102, 111, 115, 190 (Commune of Hilversum Collection)
Colorphoto Hans Hinz, Basle: 149, 186
Kunstmuseum, Professor Max Huggler-Stiftung, Berlin: 172
Albright-Knox Art Gallery, Room of Contemporary Art Fund, Buffalo: 202
Art Institute, Chicago: 165 (Gift of Edgar Kaufmann, Jr.,1957.307), 196 (Gift of Mrs Gilbert W Chapman, 1949.518)
Museum of Art, Foundation for the Arts Collection, Dallas: 209
Kunstsammlung Nordrhein-Westfalen, Düsseldorf: 187, 205, 217
Stedelijk van Abbe Museum, Eindhoven: 105, 188
Groninger Museum, Groningen: 15
Mrs W van Eck, The Hague: 18
Gemeentemuseum, The Hague: Title page, 12, 17, 21-29, 32-35, 37, 40, 43, 44, 45, 48, 49, 51-55, 57, 59, 61-66, 68-79, 81-84, 87, 89, 90, 91, 93-95, 97-99, 101, 113, 116, 130, 135, 139, 142, 152, 153, 155, 157, 160, 162,

168-171, 173, 174, 176, 185, 194, 197, 199, 204, 211, 229
The Bridgeman Art Library, London: 13, 180, 191, 207
Courtesy of Christie's, London: 193
Marlborough Fine Art, London: 151
Courtesy of Sotheby's, London: 16, 30, 31, 103
Tate Gallery, London: 156
Wilhelm Hack Museum, Ludwigshaven am Rhein: 181
Dayton Collection, Minneapolis: 56
Yale University Art Gallery, New Haven: 183 (Gift of Collection Société Anonyme), 184, 189
Courtesy of Christie's, New York: 47
Hester Diamond, New York: 215
Gagosian Gallery, New York: 225
Solomon Guggenheim Museum, New York: 182
Sidney Janis Gallery, New York: 106, 166, 218
Museum of Modern Art, New York: 19, 104, 112, 119, 159, 179, 198, 121, 220
Courtesy of Sotheby's, New York: 107
State Museum Kröller-Müller, Otterlo: 108, 124, 128, 131, 132, 147, 148
National Gallery of Canada, Ottowa: 206

Musée National d'Art Moderne, Paris: 216
Museum of Art, Philadelphia: 146 (Louise and Walter Arensberg Collection), 178, 192 (The A.E. Gallatin Collection)
Carnegie Museum of Art, Pittsburg, Patrons Art Fund, 61.1: 100
Courtesy of The Jane Corkin Gallery, Toronto, © Estate of André Kertesz: 167
Munson-Williams-Proctor Institute, Museum of Art, Utica: 181
Peggy Guggenheim Collection, Venice: 201
Phillips Collection, Washington DC: 9, 208
Platt-Lynes Collection, Smithsonian Institution, Archives of American Art, Washington DC: 203
Kunsthaus, Zurich: 175, 177, 221, 223

With special thanks to Peter Couvée at the Gemeentemuseum, The Hague, for his invaluable help.

index of works

index